Mary Kelly

PHAIDON

30
15

Publisher's Acknowledgements
Special thanks are due to Ray
Barrie, Los Angeles. We would also
like to thank the following authors
and publishers for their kind
permission to reprint texts: **Klaus
Otttmann**, New York; **Griselda
Pollock**, London; **Serpent's Tail**,
London; **Lynne Tillman**, New York;
University of Chicago Press; and
the following for lending
reproductions:. **Bettmann
Archive**, Rochester, New York;
Judy Chicago, New Mexico;
Barbara Gladstone Gallery, New
York; **Hans Haacke**, New York;
Jenny Holzer, Vermont; **Knoll
Galerie**, Vienna; **Barbara Kruger**,
New York; **Malmö Konstmuseet**;
Henry McNeill Gallery,
Philadelphia; **New Museum of
Contemporary Art**, New York;
Anina Nosei Gallery, New York;
Postmasters, New York; **Yvonne
Rainer**, New York; **Mel Ramsden**,
Banbury; **Tate Gallery**, London;
Vancouver Art Gallery.
Photographers: **Kelly Barrie; Ray
Barrie; Robert Bean; Patricia
Blake; Steve Lehmer; Trevor
Mills; Ingrid Nilsson; Anthony
Peres; E. Rahs; Fred Scraton;
Helene Toresdotter;** and **Donald
Woodman**

Artist's Acknowledgements
Special thanks to Ray Barrie for
help in preparing materials and to
Iwona Blazwick, for
commissioning the book and for
her advice throughout its
production.
Thanks also to Homi Bhabha,
Douglas Crimp and Margaret
Iversen, for their insightful
contributions, and to Gilda
Williams, Clare Stent, Stuart Smith
and Veronica Price for realizing
this project.

All works are in private collections
unless otherwise stated.

Phaidon Press Limited
Regent's Wharf
All Saints Street
London N1 9PA

First published 1997
© Phaidon Press Limited 1997
All works of Mary Kelly are © Mary
Kelly.

ISBN 0 7148 3661 3

A CIP catalogue record of this
book is available from the British
Library.

Printed in Hong Kong

cover, backcover, **Post-Partum
Document Introduction** (details)
1973
Perspex units, white card, wool
vests, pencil, ink
2 of the 4 units, 20 × 25.5 cm each

page 4, **Post-Partum Document:
Documentation III, Analysed
Markings and Diary-perspective
Schema** (detail)
1975
Perspex units, white card, sugar
paper, crayon
10 units, 35.5 × 28 cm each
Collection, Tate Gallery, London

page 6, **Ray Barrie**
Portrait of Mary Kelly working on
Interim
1985
Colour photograph

page 32, **Post-Partum Document:
Documentation VI, Pre-writing
Alphabet, Exerque and Diary**
(detail)
1978
Perspex units, white card, resin,
slate
15 units, 20 × 25.5 cm each
Collection, Arts Council of Great
Britain

page 86, **Gloria Patri** (detail)
1992
Etched and polished aluminium
1 of the 5 shields,
73.5 × 61 × 6 cm each

page 100, **Interim Part III:
Historia** (detail)
1989
Oxidized steel, silkscreen,
stainless steel on wood base
4 units,
152.5 × 90 × 72.5 cm each
Collection, Mackenzie Art Gallery,
Regina Saskatchewan

page 144, Mary Kelly with Artists
Union banner, London
1973

Margaret Iversen Douglas Crimp Homi K. Bhabha

Mary
Kelly

Φ

8.11.75 R1

.1 Put it away, dat one (helping
me with tape)

.2 No, da weedies gone, not now
morrow (referring to the
fudge)

.3 I wan milk (crying for drink
of milk)

.4 I got my nose, Mummy's got my
nose (looking at a nose in
the story book)

.5 Where's his gun (referring to
a man without a gun in the
Jessie James)

.6 That's my shovel (answer-
ing 'Is that your shovel?')

8.11.75

I'M PLEASED ABOUT GETTING HIM TO
PUT AWAY THE TAPES WITHOUT ANY
MORE TROUBLE.

HE'S SO PREOCCUPIED WITH THE SWEET
HE DOESN'T EVEN WANT TO READ
STORIES. I'M SURPRISED HE REPEAT
'TOMORROW' AND SEEMS TO UNDERSTAND.

HE TOOK HIS NAPPIES OFF AGAIN WHIL
I WAS OUT GETTING THE MILK BUT I
DECIDED TO LET HIM GO WITHOUT UNTI
HE FORGETS ABOUT IT.

I'M AMAZED THAT HE SEES FEATURES
IN RELATION TO THE PICTURE BUT HE
CONFUSES THE PRONOUNS. I CORRECT
HIM SAYING 'HER' NOSE.

HE LIKES THAT BOOK AND I THINK IT'
HORRIBLE.

I'M TRYING TO DISTRACT HIM FROM
THE FIRE BY TALKING ABOUT THE COAL
SHOVEL. SHOULD I SPANK HIM?

Contents

oidered bodice

below m

see me (I'

n I we

not and the

giv... him a hea

"look at my Mom

mothers

he ma

se con

ll feas

en Dwar

ite sure'

o.

Contents

Douglas Crimp in conversation with **Mary Kelly**

Douglas Crimp I want to talk initially about the reception of your work in the American context, which is how I came to know it. Because my interest in postmodernism and the critique of art institutions did not include, as it might have, the feminist critique of vision, my involvement with feminist art practices and with your work was somewhat delayed. Probably this has to do with how long it took me to take my own subjectivity, my sexuality, into account in my work, something that didn't begin until 1986, when, in the first of the 'Dia Conversations on Contemporary Art', I spoke about art and AIDS. My talk concerned what seemed to me a hierarchical division of political art in two simultaneous shows at the New Museum: the Hans Haacke exhibition and a small, ancillary show called 'Homo Video' organized by Bill Olander. The year before, the New Museum had organized the 'Difference' show, which included your work along with other British and American artists engaged with questions of sexual difference. But your work had been shown in the U.S. before that. When did you come to New York?

Mary Kelly **It was in 1983 when Jo Anna Isaak organized 'The Revolutionary Power of Women's Laughter', for the Protetch McNeil Gallery. Then the entire *Post-Partum Document* was shown at the Yale Center for British Art in 1984, and part of it was included in the 'Difference' show, curated by Kate Linker, at the New Museum of Contemporary Art, in that same year.**

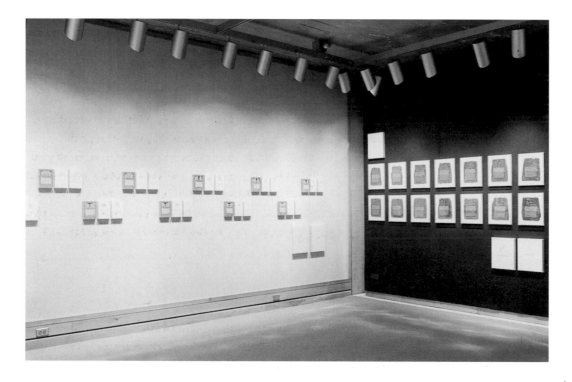

I think that's how my work became contextualized with what has been described by Benjamin Buchloh as a second group of conceptual artists, mainly women, even though I began working at an earlier period that has another history in Europe. Coming to the U.S. at a later stage in the 1980s meant that my work was historicized within a context that placed emphasis on institutional critique, on photographic work, and what was termed 'appropriation'. It was also a moment when so-called essentialist feminism was being questioned by what is now called social constructionism – not my term – but it's become a label that's applied to me as well as artists like Jenny

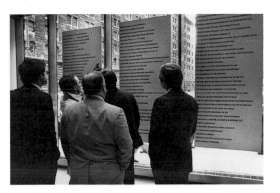

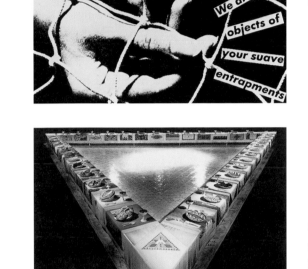

Holzer and Barbara Kruger. In the 1970s, though, that division between essentialism and constructionism wasn't so apparent.

If you go back to the founding period of the women's movement in Europe, in 1968, it was about not only changing our conditions – legally, practically, politically – but also trying to find a theoretical apparatus that recognized the subjective dimension of that process. And this led us to look at Freud and later Lacan, who hadn't even been translated yet. The work of that period was not really about establishing our difference from other kinds of feminisms …

Crimp But surely cultural feminism was known in Europe. In fact Juliet Mitchell engages with writers such as Kate Millett in *Psychoanalysis and Feminism*.

Kelly **I'm not sure she would have called Kate Millett a cultural feminist. Radical feminists and socialist feminists – that's how it broke down in England. Those feminisms were already inscribed in larger movements, except that radical feminism was separatist and socialist feminism used the slogan 'separate but not autonomous', meaning part of a broader movement for social change. What I think of as cultural feminism in the U.S. was perhaps best exemplified in projects such as Judy Chicago's *The Dinner Party* and not necessarily in the broader women's movement represented by organizations like NOW.**

Crimp But when you began working on the *Post-Partum Document*, were you not aware of the feminist art being made in the U.S., work like that at Woman House?

Kelly **No, because it hadn't been made. It was happening simultaneously on two fronts. I was aware that Judy Chicago was doing something, but it wasn't formed enough for it to be contentious. We were working in different ways on what we thought was the same project. 'Women of the World Unite' was the slogan that prevailed. There was a different political atmosphere in the 1970s, which didn't apply to the moment when you and I met in the 1980s. By then, there was a cultural movement developing in Europe and the U.S. that …**

Crimp … was reacting to essentialist feminism?

Kelly **Well, what I'm trying to say is that my work cannot be a reaction because it was part of a founding moment. What happened in the 1980s was the reaction of a second generation against the first generation of cultural feminism, and even though I was a part of the first generation I was identified with the second.**

Crimp It's true that much of the work which you came to be aligned with was in fact made in relation to your already existing work, and to the context in which your work had developed, knowledge of which came to this country largely through *Screen* magazine and feminist film theory.

Kelly **But for me the story doesn't begin there. First of all, I was an artist making systems work without any political content, if you like. When the**

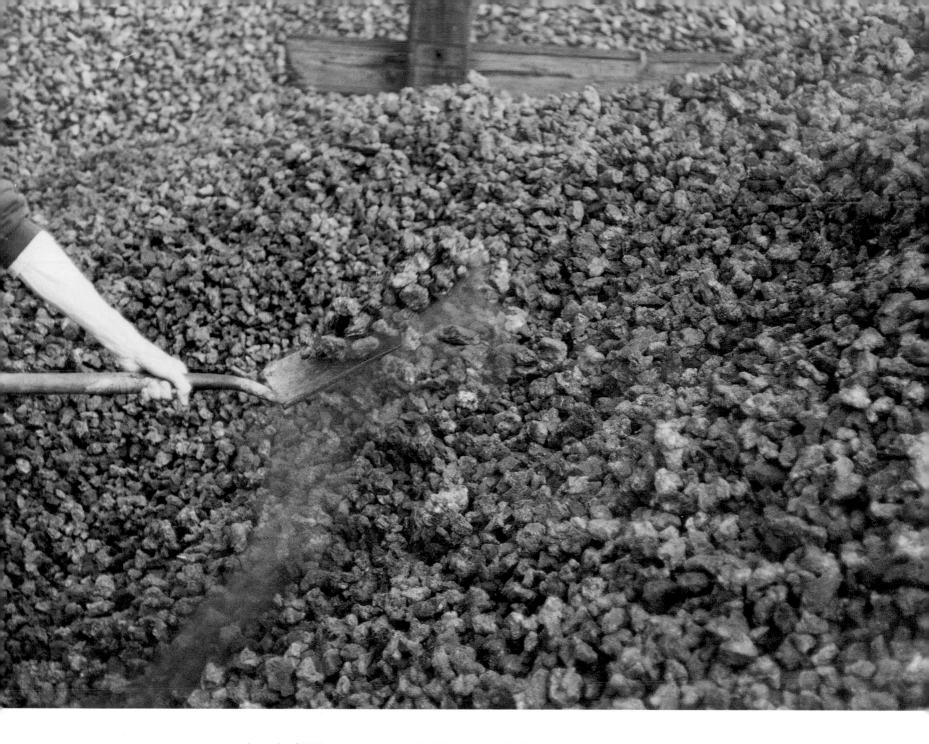

great upheavals of 1968 opened up areas of activism, none of us immediately responded at the level of our artwork. As Hans Haacke has said, for an interim period people just kept their art and their politics separate. For example, I did a performance in 1970 called *An Earthwork Performed* which involved shovelling coal. There was an obscure allusion in it to the miner's strike, but for the most part, it was just a systematic series of actions.

Then I started to move to film and photographic media, which were assumed to be inherently more progressive, as a way of addressing political issues. In 1970 I became part of the Berwick Street Film Collective as an artist and as someone involved in the movement. I was drawn to what was becoming the dominant aesthetic of the Left in Europe – coming from Benjamin, Brecht and Godard, trying to make a film which would be about its own processes as well as the issue of unionization and the historicization of the women's movement in that context. We shot hours and hours of film because of the emphasis on real time, getting rid of direct address, using blank spacing and no voice over – it's the sort of materiality of film that's also in the work of

opposite, **An Earthwork**
Performed
1970
Performance
London New Arts Lab

right, **An Earthwork Performed**
1970
Typewritten instructions
12 × 20.5 cm

```
Event.
Duration...one hour ten minutes.
Equipment. shovel,microphone,two eight millemetre film projectors,
tape recorder, video tape, amplifier, loudspeaker,coke.
Four hundred weight of coke is heaped on floor.
First film projector starts running off film of coke being shovelled.
(after 5 minutes)
Tape recorder,tape of coke being shovelled.
(after five minutes)
Microphone in shovel is switched on and shovelling started.
(after five minutes)
Video tape is started
(after 5 minutes)
Second film projector is switched on
Tape recording amplification switched from recorder to loudspeaker.
(same for duration of film,20 minutes)
Film ends
(5 minutes)
Video ends
(5 minutes)
Tape ends
(5 minutes)
Microphone in shovel switched off
Shovelling ends  one hour ten minutes after start of event.
end event.
```

Straub and Huillet or Mulvey and Wollen. That was extremely formative.

From 1968 to 1970 I was at St. Martin's School of Art in London because I was interested in the work there – people like Gilbert and George, Richard Long, Charles Harrison and Art and Language. But from the moment that this imposition of social issues occurred, there was also something very inadequate about the systemic approach to art, something wrong with the formula 'art interrogating the conditions of the existence of the object' and then going on to the second stage and interrogating the conditions of the interrogation itself, but refusing to include subjectivity or sexual difference in that interrogation.

The people who *were* interested in doing that kind of theoretical work happened to be in film and *not* in the St. Martin's post-Caro conceptual group. Also, formally, when I saw Straub and Huillet's *Othon*, the long take going into Rome – you know they run the whole reel, it's ten minutes – I was knocked out, it just took my breath away, and I thought: why should all the interesting work be in film? Why can't you do that in an exhibition? Why couldn't I think about drawing the spectator into a *diagetic* space: the idea of

Art and Language
Index 01
1972
8 filing cabinets, text, photostats
Dimensions variable
Installation, 'Reconsidering the
Object of Art: 1965-1975',
Museum of Contemporary Art, Los
Angeles, 1996

Jean- Marie Straub
Othon (Les yeux ne veulent pas en
tout temps se fermer ou peut-être
que un jour Rome se permettra de
choisir à son tour)
1969
83 mins., colour
Film still

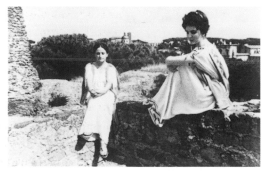

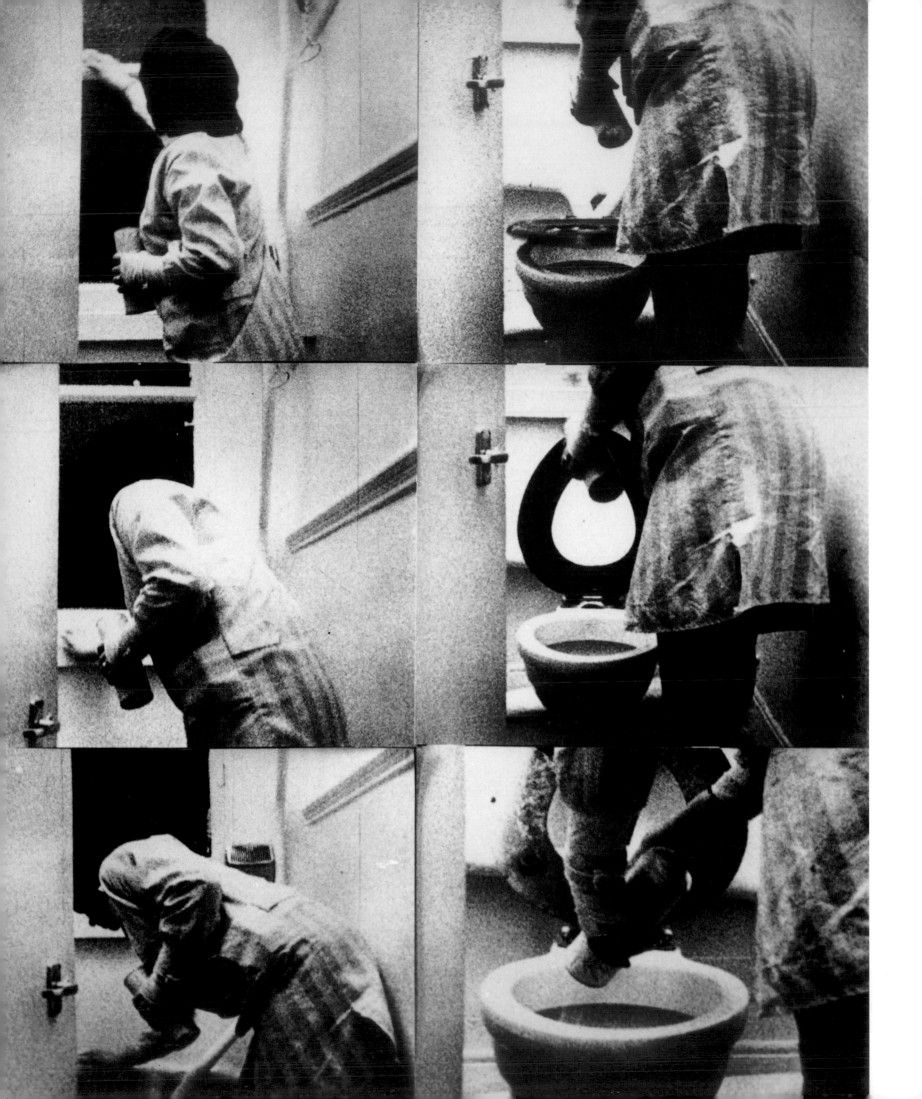

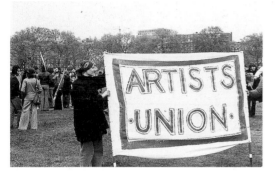

real time or what you might call the *picture* in the expanded field. And that's what I eventually got back to in *Post-Partum Document*.

Crimp I'm not familiar with your work prior to the *Post-Partum Document*. The film, *Nightcleaners* was done before the *Women and Work* project?

Kelly **The film project started first, in 1970, but wasn't finished until 1975; the *Women and Work* project was begun in 1973 and ended in 1975. *Post-Partum Document* also started in 1973, and was shown in 1976, so there was an overlap. There are elements from all of this activity that condense in the *Post-Partum Document*.**

Crimp You have said that, at that time, many thought of photography and film as being inherently more progressive, which is a position that I came to later in a different context, through reading Walter Benjamin and Roland Barthes in relation to new photographic work produced by younger artists. But when you were working on those three projects, there was something else happening in

opposite, **Nightcleaners**
1975
90 mins., 16 mm, black and white
Film still

above, Mary Kelly with Artists
Union banner, London
1973

right and below, **Women and
Work,** with Margaret Harrison and
Kay Hunt
1973-75
Black and white photographs,
charts, tables, photocopied
documents, film loops, audiotapes
Dimensions variable
Installation, South London Art
Gallery, London, 1975

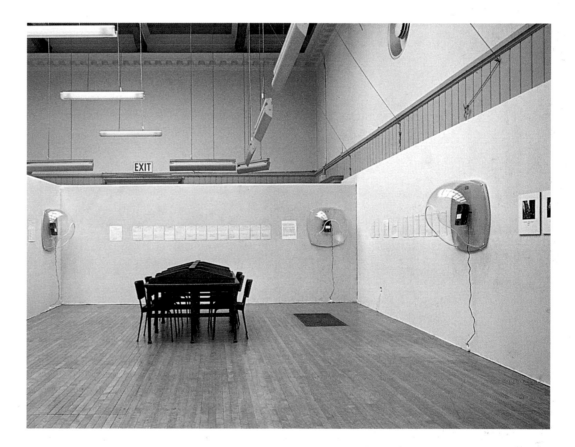

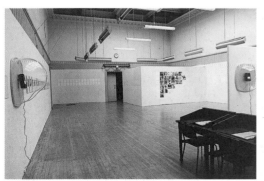

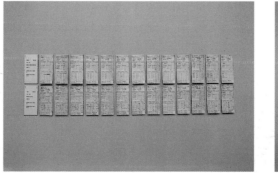

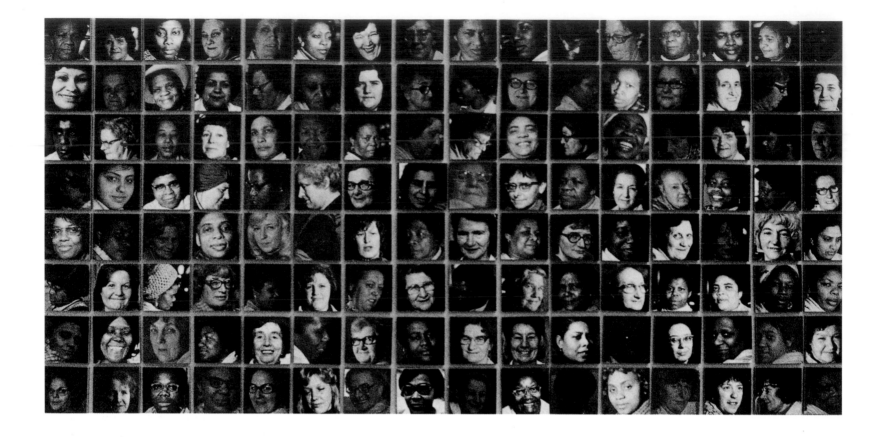

```
 5:30 AM: START BREAKFAST FOR FAMILY
 7:15 AM: LEAVE FOR WORK
 8:00 AM: START WORK
 5:00 PM: FINISH WORK
 5:45 PM: ARRIVE HOME
 6:00 PM: START DINNER
 7:00 PM: WASH UP, SEE
          DAUGHTER TO BED
 8:00 PM: IRONING
 9:30 PM: SIT DOWN
10:30 PM: MAKE DRINK
11:30 PM: GO TO BED, IT'S
          A LONG DAY

JEAN ALEXANDER, AGE 40
1 SON  AGE 18  1 DAUGHTER  AGE 11

DOUBLE SEAMER OPERATOR
FULL TIME    8:00 AM - 5:00 PM
```

```
 6:00 AM: GET UP, GET BABY
          DRESSED, FED
 7:00 AM: TAKE BABY TO
          MINDER
 7:15 AM: GO TO WORK
 8:00 AM: START WORK
12.30 PM: DINNER BREAK
          GO SHOPPING
 1:30 PM: START WORK
 5:00 PM: FINISH WORK
 5:30 PM: GET BABY FROM
          MINDER
 6:00 PM: PREPARE BABY'S .
          MEAL
 7:30 PM: PUT HIM TO BED
 8:00 PM: PREPARE MEAL FOR
          HUSBAND AND SELF
 9:00 PM: BABY'S WASHING
          CLEAN UP
12:00 PM: GO TO BED

JOANNA MARTIN, AGE 21
1 SON  AGE 1

SHRINK WRAP OPERATOR
FULL TIME   8:00 AM - 5:00 PM
```

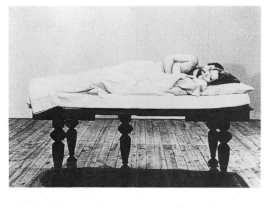

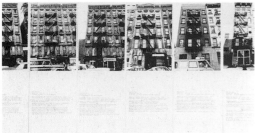

Yvonne Rainer
Film About a Woman Who ...
1974
105 mins., black and white
Film still

Hans Haacke
Shapolsky et al. Manhattan Real
Estate Holdings, a Real-Time
Social System, as of May 1, 1971
(detail)
1971
Black and white photographs,
data sheets, charts
Dimensions variable

opposite, **Women and Work**, with
Margaret Harrison and Kay Hunt
(details, above, **Portraits**; below,
Daily Schedules)
1973-75
Black and white photographs,
charts, tables, photocopied
documents, film loops, audiotapes
Dimensions variable
Installation, South London Art
Gallery, London, 1975

the U.S. in the context of Conceptual Art and of post-Minimal Art more generally: many artists began to turn to a range of mediums, especially film. So, for example, a number of sculptors made films – Robert Morris, Richard Serra, Robert Smithson – and Yvonne Rainer moved from dance to performance art to film. I don't think this was done because of a sense that film was more progressive; rather, the specificity of modernist mediums was being broken down. It was no longer considered the task of art to investigate the terms and conditions of one's chosen medium. Whatever medium seemed useful for a particular investigation would be used. So it's interesting to me that you moved in the opposite direction. That is to say, you had worked on a film, but wanted to take what you had learned from that medium and apply it to the artwork. Even if the *Post-Partum Document* is related to Conceptual Art or to installation work, it also takes its concerns from other mediums.

Kelly **You can see that the *Women and Work* project looks a lot like Haacke's 'Shapolsky piece' (*Shapolsky et al. Manhattan Real Estate Holdings, A Real-Time Social System, as of May 1, 1971*); in the display of documents, the time that we took to investigate the conditions in the factory, and the way that we used all the forms of information and visual display that would give the viewer a way of weaving through and understanding the problem of that factory and its means of implementing equal pay.**

But something wasn't working in the strategy. For instance, when we were in the factory trying to record the conditions of work, we interviewed the men and they told us everything that happened on the job, but the women wouldn't even talk about what they did at work. They just said, 'Went to work, came back', and then they talked about what they did at home, about their children and about work in the home.

Because there was a question about domestic labour emerging in the women's movement at that time, as well as my own experience of being pregnant, I thought: well, I'm going to see what really is going on in the home. What kind of labour is this? At first I looked at it very sociologically but it became more and more obvious that you couldn't get rid of the irrationality of this event, the question of desire and questions of the social and psychic constructions of maternal femininity. But in the installation itself, regarding the impossibility of conforming to what might be the limits of a site-specific project, we weren't even getting information at the centre of it that referred us back to that site. The site shifted to the domestic space, and once again, when we got there, we found that it was even more radically dispersed at a psychic level. It was the specificity of *debate*, or discursive sites, that became increasingly important for me.

Crimp There is a visual similarity to the 'Shapolsky piece' in the first part of the *Post-Partum Document*, in the use of text for example, but there are also some very obvious differences.

Regarding the representational strategies of the *Post-Partum Document*, both its refusal to image the woman and the deliberate use of fetish objects, you introduced the necessity to counter the fetishistic nature of representation in visualizing the woman's body, which also arose in the theoretical work of that period.

Kelly **In the mid 1970s, a number of women used their own bodies or images**

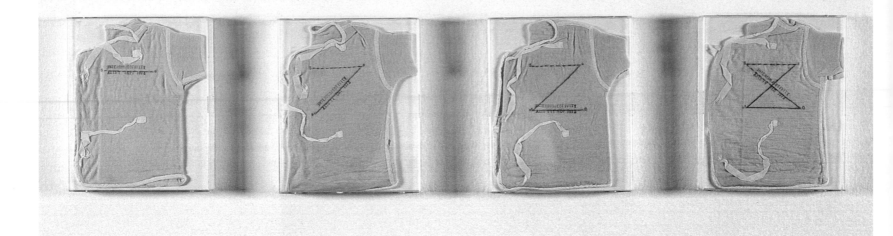

to raise questions about gender, but it was not that effective, in part because this was what women in art were expected to do. Men were artists; women were performers. Yvonne Rainer says that she and Simone Forti were called 'the dancing girls'. The field was absolutely divided according to hetero-sexual imperatives. I wanted to question those essential places. But when I started the *Document*, it was much more intuitive than it appears now. For instance I decided to use the vests in the *Introduction* because I couldn't really 'figure' the woman in a way that would get across what was going on, the level of fantasy that was involved, in an iconic way. I needed something that was more indexical, more like a trace. Then, because of my collaboration with Laura Mulvey, and the theoretical understanding that we began to develop through psychoanalysis about voyeurism and fetishism, it made a lot of sense to displace that element of iconicity, to take the woman's body and estrange it somehow, in order to create an effect of critical distance.

Crimp Most Conceptual Art consists largely of text. For that matter, there was even indexical work in Conceptual Art. There was a general avoidance of iconicity. But you don't usually speak about this in relation to your work of this period. When you refer, for example, to Norman Bryson's term 'aniconic', it's in relation to avoiding or reconfiguring the festishistic nature of representation and the problem of representing Woman. On the one hand, *Post-Partum Document* looks like Conceptual Art; on the other hand, it's parodic of Conceptual Art. But surely no one else involved with Conceptual Art at that time would have spoken of the necessity to avoid iconic representation, or the necessity of using a multiplicity of sign types – the symbolic, the indexical, along with the icon – in the same way and for the same reasons that you do now.

Kelly **The text of *Post-Partum Document* is still quite conceptual, diaristic. There's no attempt to correct the spelling mistakes or anything; it's just another found object. But there is a process in the *Document* that's beyond rationality, too, and something that I see looking back is that in distancing myself from the child, the work becomes more premeditated. By the time you get to *Documentation VI*, the work becomes more constructed and also becomes more heavily narrational, and then, I had to end it because there**

above, **Post-Partum Document Introduction**
1973
Perspex units, white card, wool vests, pencil, ink
4 units, 20 × 25.5 cm each

opposite, **Post-Partum Document: Documentation I, Analysed faecal stains and feeding charts (prototype)**
1974
Perspex units, white card, diaper lining, plastic sheeting, paper, ink
1 of the 7 units, 28 × 35.5 cm

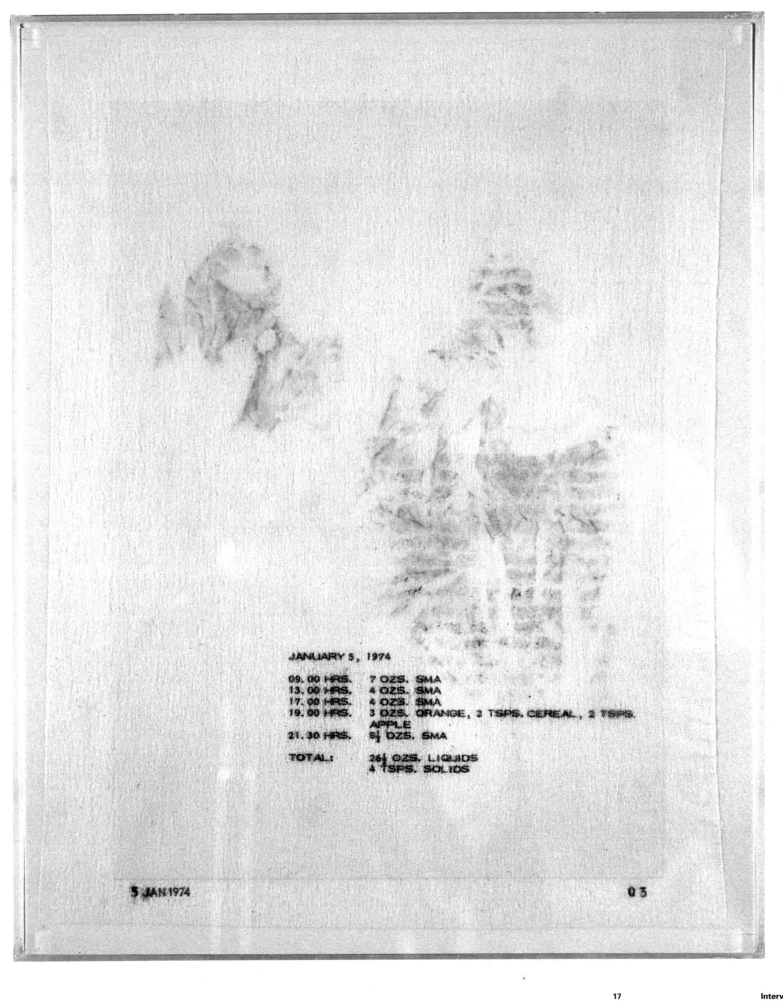

JANUARY 5, 1974

09. 00 HRS. 7 OZS. SMA
13. 00 HRS. 4 OZS. SMA
17. 00 HRS. 4 OZS. SMA
19. 00 HRS. 3 OZS. ORANGE, 2 TSPS. CEREAL, 2 TSPS.
 APPLE
21. 30 HRS. 8½ OZS. SMA

TOTAL: 26½ OZS. LIQUIDS
 4 TSPS. SOLIDS

5 JAN 1974 03

JANUARY 6, 1974.

09.00 HRS. 5 OZS. SMA, 2 TSPS. CEREAL
11.00 HRS. 2 OZS. ORANGE
14.15 HRS. 6 OZS. SMA
16.00 HRS. 1 OZ. ORANGE, 2 TSPS. APPLE
19.00 HRS. 6 OZS. SMA, 2 TSPS. CEREAL
21.30 HRS. 8 OZS. SMA
23.00 HRS. 1 OZ. WATER

TOTAL: 29 OZS. LIQUIDS
 4 TSPS. SOLIDS

6 JAN 1974 0 3

JANUARY 7, 1974.

08.30 HRS. 7 OZS. SMA, 1½ TSPS. CEREAL
13.15 HRS. 7 OZS. SMA
17.30 HRS. 3 OZS. ORANGE, 2 TSPS. APPLE
19.30 HRS. 5 OZS. SMA, 2 TSPS. CEREAL, ½ BANANA
21.30 HRS. 7 OZS. SMA

TOTAL: 29 OZS. LIQUIDS
 5½ TSPS. SOLIDS

7 JAN 1974 0 3

was a moment when there were two very autonomous subjects and it terrified me. The last proposition, that appeared in the form of the algorithm, was: 'What will I do?' – from the mother's point of view, but also as an artist. It's the debate or the question – both aesthetic and political – that propels me into the next work.

Later, I became more concerned with the question of pleasure. How a woman – I mean a spectator in the position of the woman, not the biological woman – finds a place not just in front of the picture but behind it too, a space where a certain parody of the feminine masquerade is possible, or perhaps a gap that evokes the pleasure of the joke.

Interim is much more self-conscious in this regard of course. I use unabashed stories with endings which are probably as seductive as the iconic image, but I think unexpected in that context. The subject of ageing, too, got me much more interested in the idea of a community of women than I had been in the previous work; the erotic pleasure that women share, what they do together, how they dress for each other, all the things that the narratives in *Corpus* take up. So the problem of the sign was linked to redefining visual pleasure. That's when I introduced the strategy of shifting from looking to listening and formulated more clearly for myself the issue of the spectatorial gaze.

opposite, **Post-Partum Document: Documentation I, Analysed faecal stains and feeding charts**
1974
Perspex units, white card, diaper lining, plastic sheeting, ink
28 units, 28 × 35.5 cm
Installation, Anna Leonowens Gallery, Halifax, Nova Scotia, 1981
Collection, Art Gallery of Ontario

Crimp It s not entirely clear to me what you mean when you say listening. Why not from looking to reading?

Kelly **I'm referring to Freud, and what he said about his hysterical patients, what is seen as the founding moment of psychoanalysis, that is, the therapeutic practice of listening rather than looking, which is aligned with Charcot and his theatre of hysterics. This concept of listening was interesting to me as an artist because Freud dismissed Charcot as a *visuel*. In turn, I thought: 'Could an artwork mime analysis?' What's more, hysteria no longer seemed relevant for clinical practice. Yet, in feminist debate, it has become a way of staging the protest against the fathers, as it were – hysteria as the discourse that cuts across or transgresses the mastery of analysis or indicates a refusal to take up the position assigned to the woman – the question of the hysteric is after all: am I a man or am I a woman?**

So I started *Corpus* with a little theatre of passionate attitudes. The clothes, presented as photo laminates, verge on the iconic, but they're dark, shadowy, and induce a certain kind of paranoia, a fear of being seen to be looking or in this case reading. But, although there's a literal reading involved, I really thought of it more as a texture of writing, as evidence of the body. The use of first person indicative feels as if you're listening to someone speaking. It's about that experience of the voice.

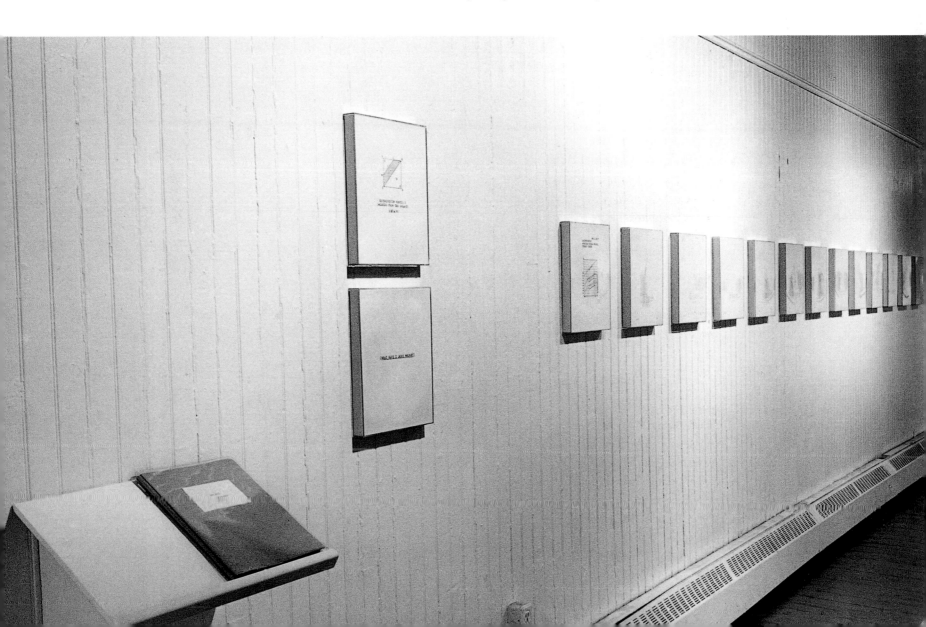

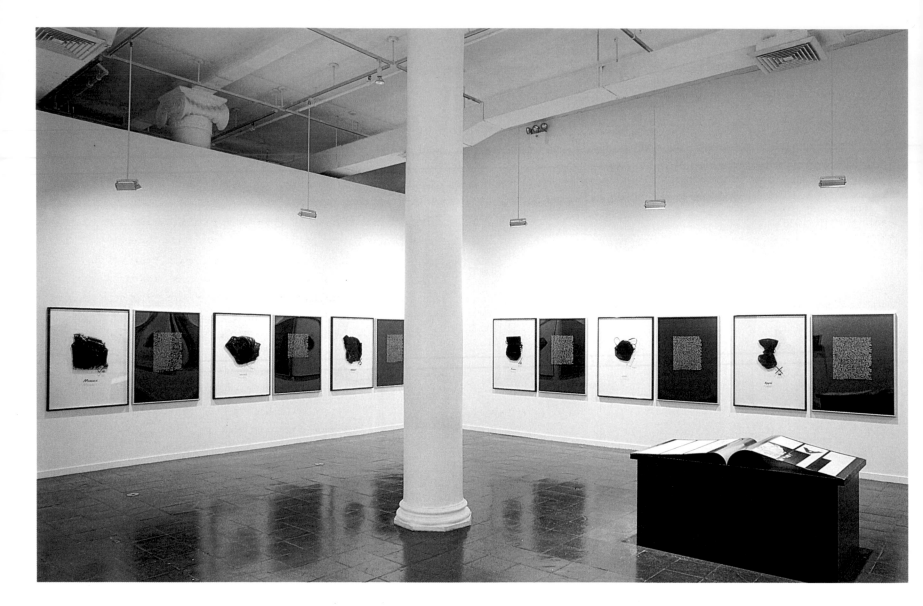

Crimp Why do you use Latin?

> **Kelly** I wanted a language that represented language rather than a language
> that was spoken. My initial thoughts were that it would provoke reflection on
> a certain moment of Western civilization and the instigation of patriarchal
> social relations. For example, in *Potestas*: to use *populus*, *laboris* or *bona*,
> instead of, say, 'population', 'labour' and 'wealth' – they don't translate
> exactly – suggests that it's not a literalization of content, but a reflection on
> linguistic construction. In *Pecunia* I use *mater*, *conju*, *soror*, *filia*, instead of
> 'mother', 'wife', 'sister', and 'daughter' because they're not tied to a
> particular historical-cultural moment. This is not to say they're outside of it,
> but I wanted to take it away from the familiar in order to say something about
> the way a category is constructed which produces the woman as agent,
> rather than the biologically determined and experiential subject.

Crimp In your work there is a very strong relation between feminism as a
movement, feminist discourse, and artistic production, which I don't see so
clearly in queer work. This is particularly clear to me with *Interim* because of my
own interest in ageing as a gay man, for which there is little or no discourse at

Interim
background, **Part I: Corpus**
1984-85
Laminated photo positive,
silkscreen, acrylic on Plexiglas
30 panels, 90 × 122.5 cm each
foreground, right, **Part III:**
Historia
1989
Oxidized steel, silkscreen,
stainless steel on wood base
4 units, 152.5 × 90 × 72.5 cm each
Collection, Mackenzie Art Gallery,
Regina Saskatchewan
Installation, New Museum of
Contemporary Art, New York, 1990

all. The older gay man doesn't exist in gay culture, except as a couple of horrible stereotypes – the dirty old man, the sad old queen. The founding moment of psychoanalysis in the shift away from the visibility of the hysteric has its parallel in relation to homosexuality. The third-sex theories of homosexuality with which Freud was grappling in his *Three Essays* are also about what can be seen, the physiognomy of the homosexual, an anatomical hermaphroditism. And Freud's reply was to deny that the homosexual existed at all as a special sort of person. However, that insight was not taken up in gay work until much later, until the insights of psychoanalytic feminism were imported into queer theory.

Kelly **There being no place for the older gay man perhaps is not unlike the older woman who disappears from Freud's discourse. The analysand is always a young woman. Dora's mother doesn't interest him. Culturally, the gay man is pulled into the same representational space as the woman, I think, because what's represented as masculine in the psychic sense is going to be aligned in a number of ways – whether it be science vs. art, or technology vs. the handmade, all kinds of binarisms … with a certain display of power, which is not about the visible or the vulnerable, while the feminine turns, as we know, either towards the erotic or the abject.**

Crimp But it seems to me that gay men occupy shifting positions regarding masquerade and display, femininity and masculinity. In reading what you've written in relation to *Gloria Patri*, I couldn't help thinking that many gay men participate in the masculine display. One of the things the older gay man does in order to maintain any sort of position in gay culture is to don a uniform. There's

Mary Kelly working on **Interim**

following pages, **Interim Part I:**
Corpus (detail **Appel**)
1984-85
Laminated photo positive,
silkscreen, acrylic on Plexiglas
2 of the 30 panels,
90 × 122.5 cm each

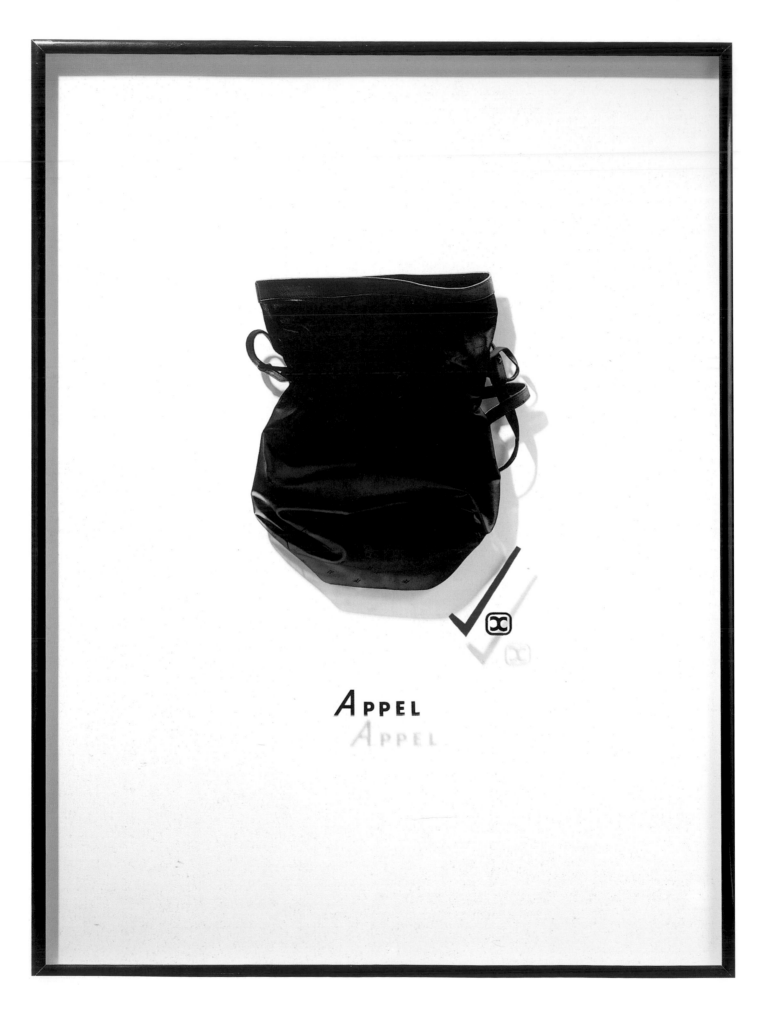

a stereotype about the leather scene, that it's where we end up when we get older. In order to maintain sexual desirability, we dress in leather uniforms.

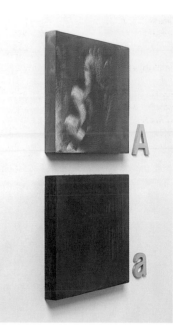

Kelly **But once the uniform is made prominent in that way, I think it's parodic. It reminds me of what Genet says about the policeman's badge – 'an object in which the quality of males is violently concentrated'. To be fetishized is once again to be in the space of the vulnerable, the visible, the psychically feminine. What's so intractable about the display and its implications for a certain psychic masculinity is exactly that it's *not* about being seen. A uniform is about a certain kind of obliteration. The uniform is like what you have on now, where you can *be* in the world, the art world in this case, and have a voice. The use of leather is certainly not about this, of course there's power in seduction, but it's not the same thing as authentication.**

Crimp What about the so-called gay clone, who wears the traditional uniforms associated with masculinity and makes himself indistinguishable from the other gay men around him?

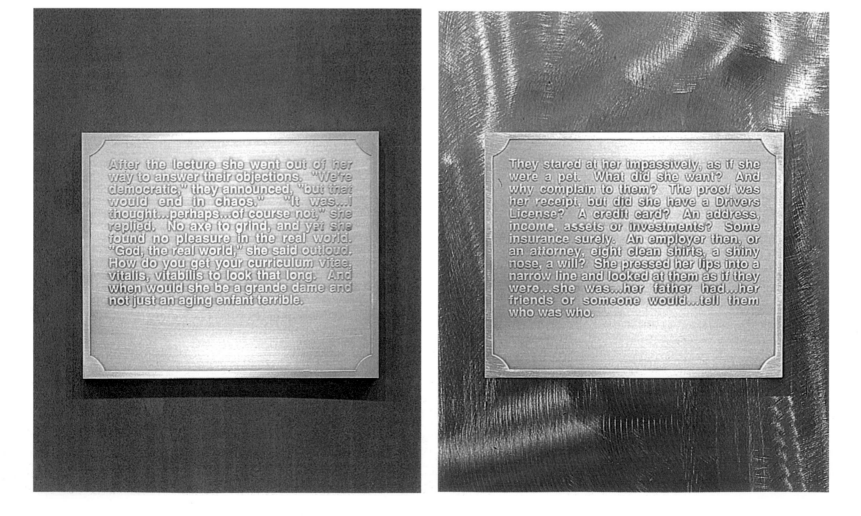

opposite, **Interim Part IV:**
Potestas (detail)
1989

Interim Part IV: Potestas
1989
Etching, brass and mild steel
14 units, 250 × 285 × 5 cm overall
Installation, New Museum of
Contemporary Art, New York, 1990
Collection, Helsinki City Art
Museum

Interim Part IV: Potestas
(details)
1989
Etching, brass and mild steel
2 of the 14 units, 250 × 285 × 5 cm
overall
Collection, Helsinki City Art
Museum

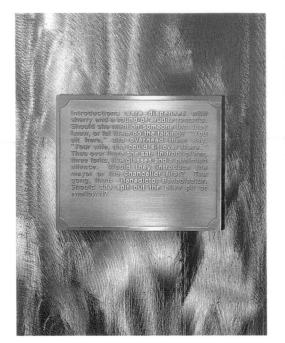

Kelly **I actually think the guys who don't get involved in that are the ones occupying this masculine space, because they allow the others to be Other, and their shield as it were, their protection, is their normalized masculinity, not a sensational, gorgeous or masqueraded, muscle-bound parody of it.**

The way I first started to think about this was in relation to women. The last part of *Interim*, *Potestas*, is about women's relation to power. Even though I figured it in a didactic way with the bar graphs, across those graphs are stories. One of them in particular might remind you of the Joan Rivière case about the woman who, after her lecture, felt that she had to ingratiate herself to everyone, use 'womanliness as a mask'. But then I became more interested in the historical shifts that have caused another kind of identification for the woman with the masculine ideal. That's the question *Gloria Patri* took up, and the Gulf War simply became a convenient way to frame or discuss it.

Crimp Your work has consistently taken the form of installation, a form that hasn't been much interrogated or theorized. It's now become a genre or medium more or less equivalent to traditional media. You come out of the moment in Conceptual Art when installation was being invented as a means of questioning the autonomy of the art object and investigating the context and site of the artwork's exhibition. But that initial impetus for installation seems to have been lost. The ease with which installation has been naturalized as just another mode of working is disturbing.

Kelly **That's an interesting point, but I don't see why it should be disturbing to say that the installation can be discussed as a genre or discipline. You could say that until recently the field of fine art was dominated by the paradigm of painting and everything that didn't conform to it was called sculpture. The refinement of our understanding of the implications of a brushstroke, the degree of impasto, *scriffito* or whatever, has never been applied as rigorously to sculpture, much less to the 'expanded field' or to the installation. If you were going to discuss it with the same kind of precision,**

Interim Part IV: Potestas
(details)
1989
Etching, brass and mild steel
14 units, 250 × 285 × 5 cm overall
Collection, Helsinki City Art
Museum

you might take up the frame or its absence for painting as a secondary level of non-mimetic signification. With the installation, framing infers such a complex spatial and even temporal structure, that you could say it supersedes a work's mimetic or internal system of meaning.

What's characteristic of all forms of installation is that the spectator is in varying degrees an element within the frame, so obviously it would be imperative to consider not only your phenomenological presence, but also you subjective positioning, as effects of that signifying order (or disorder).

Crimp I'm curious about the current disposition of your works? I know that some of your work is owned by museums; if the parts of *Post-Partum Document* are dispersed in different institutions, how do they come together for an installation? What is its meaning when dispersed? As a work conceptualized as a single installation, what happens to it when it no longer takes that form in its current locations? Do your works come with installation instructions? Could *Gloria Patri* be installed differently?

Kelly **Let's go back to *Post-Partum Document* and what I called debate-specific work. The site wasn't so important in terms of installing it as the different discursive contexts in which it was made. I still try to insist on a linear presentation of the work because that has temporal and diagetic implications, and ideally the entire work should be shown together. I refused to split up individual sections, and because they're in public collections you can always get the parts together again. With *Interim*, each section was done over such a long period that for me it feels like it has the autonomy of an individual work. It you bring together *Corpus*, which is thirty panels, it's practically an installation in itself, and I have shown it that way.**

Gloria Patri though, can't be split up. It was done as one complete installation. I became more self-conscious about using that phenomenological dimension of installation which involves the positioning of the spectator. When I install _Gloria Patri_, although I have placed it all on one wall, usually it's on three walls in three registers surrounding the

With
each contraction
he told her to suck in a
deep breath and let it out quickly.
He'd learned this in the exercise class and was
determined to use it, to play his part in the mystery of life, including its
mundane sequel. A profound experience, he thought, almost religious.
Sometimes he pictured a divine experiment in the romantic laboratory of
the woman's body; but, more often, he saw a holy war – 600 million
megaspores of DNA dropped on Fallopiana; the victorious bombardment
annihilating both sides in the nucleated fusion that would become a
fetus. The miraculous semen, the unique production of his body, had
been put to the test. All the rest was observation. He had observed
her growing outward and inward, growing distant and more self-
contained in her voluminous repletion. He was diminutive indeed,
but nonetheless he vowed to be the consequential father of the
future triad. He observed her breathing; the rapid, shallow breathing
of the second stage and thirty-third page of the parentcraft
manual. He suggested sighing, but she wouldn't listen. She was
panting and pushing, then regurgitating while he held the tray.
He examined the curdled contents, but failed to grasp the
form of reality to which it pertained. What had he done? His
divine experiment, miraculous semen, unique production.
Her voluminous repletion. Would it be a proper
specimen? The head emerged, a crumpled tulip,
eyes not yet opened and already gone to seed,
an old man facing her right thigh. Next,
the shoulders, followed by the little body
and the loud announcement: It's a boy.
A sudden trepidation overwhelmed
him: He will kill me. Fallible
experiment, forged production.
Quirky thought soon
banished by the tender
exigencies of the
moment.

opposite, **Gloria Patri** (detail)
1992
Etched and polished aluminium
1 of the 5 shields,
73.5 × 61 × 6 cm each

right, **Gloria Patri**
1992
31 units
Dimensions variable
Installation, Herbert F. Johnson
Museum, Cornell University,
Ithaca, New York, 1992

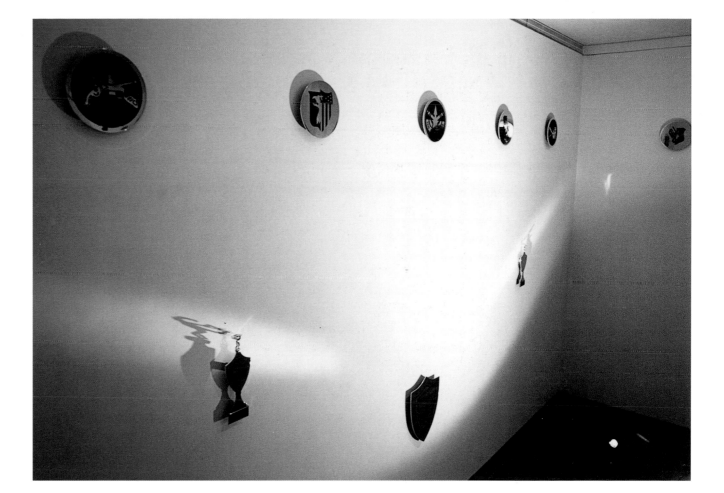

spectator. Even so, it maintains a pictorial stance, something that's like a facade, but there's no position from which you can actually see everything at once. It sets up an expectation of spectacle, a fetishistic pleasure, but as you enter into it you're sort of out of control. To see the trophies or the logos you have to look up or over; the view is always partial. I was interested in peripheral vision and how it fragments the viewing space. You could say for installations in general that texture and surface don't immediately appear to be tied to a specific field, but are the effects of dispersal or repetition – the fanatical repetition and horrific shininess of polished aluminium in *Gloria Patri*, for example, is a kind of framing device.

Crimp I know that for you, what gets left out in the development of one work often suggests material for the next. But I'm curious about what happens in between. What sort of research takes place in the period between the completion of one work and the beginning of another? Perhaps you can say, for example, what your plans are now that *Gloria Patri* is completed.

Kelly **From the very beginning of *Gloria Patri* there was what I thought of as the other side or 'beside', as Homi Bhabha has suggested, of the shield, something about death and victimization, which was not about parody and masculinity but what I call the anamorphic image, the thing you didn't see on the TV screen, or if you did it was just a flash, the charred body, the screaming witness. I felt the only spaces of identification that were allowed were either hysterical over-identification with the victim or projection of the Other into the realm of the abject. So, in between those I wanted to reconsider another**

position. I think of this visually in terms of the way the spectator will negotiate his or her position in the installation. I was also interested in the notion of hysterical blindness, particularly during wars – not necessarily the Gulf War. In Cambodia there are many reports of women who were declared hysterically blind after witnessing atrocities. And then there's the question of Bosnia and the Bosnian War Crimes trial, which I have followed.

If you look at the *Interim* notebooks, you'll find in all of the sections themes developing at the same time. Also, a project that has to do with our very old age, with death and abjection, and has been running parallel to my current works is *Mea Culpa*. They're brought together by a photograph taken of me that looks like a shroud, the dead body of the woman – need I say any more? I was fascinated not just with the question of death and ageing but the link it had to the other questions I was raising about war trauma and victimization and identification: vicarious identification with a traumatic event which you did not witness except as filtered through the media. I think that has as much impact as the so-called 'real' event. If we consider Freud's theory of seduction – that the problem is not whether the trauma was real or fantasized, but its implications in the formation of the symptom – then we need to think more about not just those who were victims, but those for which the subjective moment of the trauma is the inscription of this *history of victimization*. I would say the gestures of the mother perhaps more than words are implicated in that founding moment. I'm thinking about certain things like a Jewish child saying 'There were these books that we weren't allowed to read, but we knew what was in them even before they were opened'.

Crimp After I published the AIDS issue of *October* in 1997, I was accused of privileging AIDS activist art over any other aesthetic response to the epidemic. The assumption was that I was claiming that only work directly connected to movement politics had any real political force or meaning and was therefore the only work that should be supported. In fact, at that time, my argument was, rather, that activist work, agit prop, was being overlooked by art world institutions because they tenaciously held onto idealist notions of the work of art. This forced me to clarify my position, to demonstrate my commitments to other work on AIDS and to argue for other work also to be understood in political terms. Because you always stress your relation to the feminist movement, especially at the beginning of your work as an artist, I would be curious to know how you negotiate the charge that difficult, theoretically informed art practices are somehow not political. For example, I think it's easy enough for most people to accept a slogan like 'the personal is political', but when you translate that in a particular way, as paying attention to the 'subjective moment', and paying that attention by taking a detour through psychoanalytic theory, it is often read entirely differently, as theoretical *instead of* political. I think much of the current work informed by queer theory confronts these same charges.

Kelly **My work is not about positive images or local issues. It is, as I said, about continuing the legacy of institutional critique by expanding the notion of site to discourse, and discourses continually problematize themselves. So, my only aim is to keep pace with them. As far as feminism is concerned, that process is both theoretical *and* political. As far as 'detours' are concerned, they're *always* more interesting than the main road.**

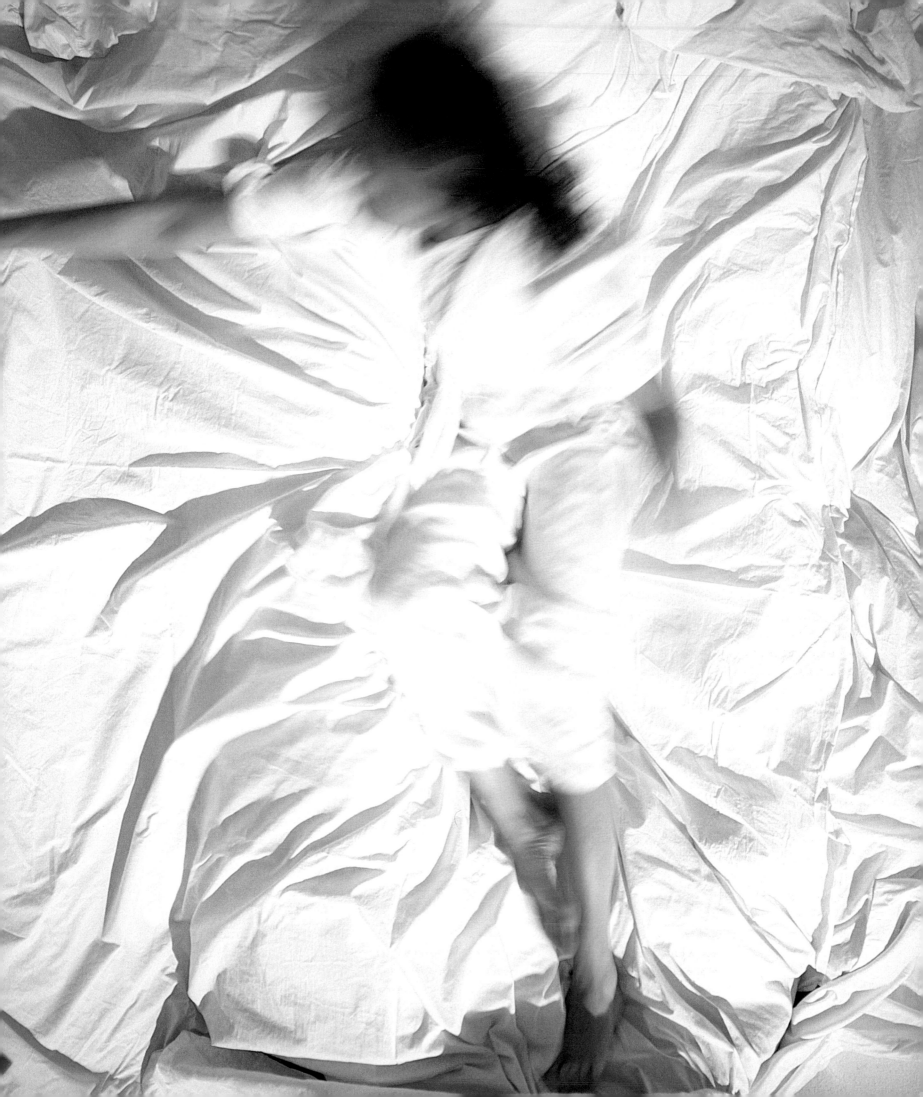

Kelly Brrie
Kelly
Barrie

(age 4,5) B IS FOR BALLOON. This is the
first letter he has constructed with the
express purpose of writing a specific word-
his surname. He draws P and carefully
adds ɔ. Learning to write 'Barrie' has also
sorted out his backwards 'b' and the up-
side down 'a'. B IS FOR ALLIGATORS
BURSTING BALLOONS. B IS FOR BEARS PLAY-
ING BAGPIPES IN A BAND. GOOD NIGHT LIT-
TLE B. BERTRAM BULLFINCH BASSET HOUND

April 19, 1978: Now Kelly is at school all day. Ray
insisted that he was ready to stay for school dinners.
He said Kelly was quite happy and I had to admit it
did seem to be true so far. When he comes home I try
to ask him what he does at school, what he has for
lunch, but he's usually not very informative he's in
such a hurry to change his clothes and go out to play
with Ronnie. They've become very good friends. Once he
said he didn't think he needed a mummy and daddy
because he and Ronnie could live together and look
after themselves. He brought home some flash cards
which seem to take the place of our 'a.b.c.' sessions
and he keeps a little notebook at school which I can
go and look at from time to time. Things have definitely
changed, and so quickly. When I told Rosalind that
he'd started infant's school she said "well, your're a
real mother now"

Contents

Mary Kelly's entrance into the international art scene of the mid 1970s was nothing short of audacious. The first three sections of *Post-Partum Document* were exhibited at London's Institute of Contemporary Arts in 1976 and were given a noisy reception by the tabloid press: 'Dirty Nappies!', they shrieked. In fact, *Documentation I* of the *Document*, which is concerned with the mother's anxieties over the months of weaning her baby from the breast, consists of faecal stains on gossamer nappy liners and are exhibited with pristine elegance. The liners are fixed flat within recessed frames like precious prints on some rare, handmade paper, and the stains themselves form shadowy images reminiscent of the Shroud of Turin. An obsessively careful daily diary of the infant's solid food intake printed on a sheet of paper and placed under the liner, shows through at the bottom of each composition.

The tabloid press represents one extreme reaction to the work, which it deemed scatological. But Kelly's work met with another negative reaction which judged it to be too cerebral and obscure. This split response is eloquent testimony to a charged ambivalence which inhabits all her work. Her 'style' evokes the precision and formal restraint of Minimalism and her use of language and diagrams which record and analyse the results of extended research projects links her to the strategies of Conceptualism. But what Conceptualist would have thought of inserting a mother and baby into that art discourse? Even some feminists were a bit surprised since they were busy asserting their right to be free from the demands of reproduction which was thought to hamper women's creative production. The mother artist was an oxymoron both within Patriarchy and within the movements which sought to challenge it.

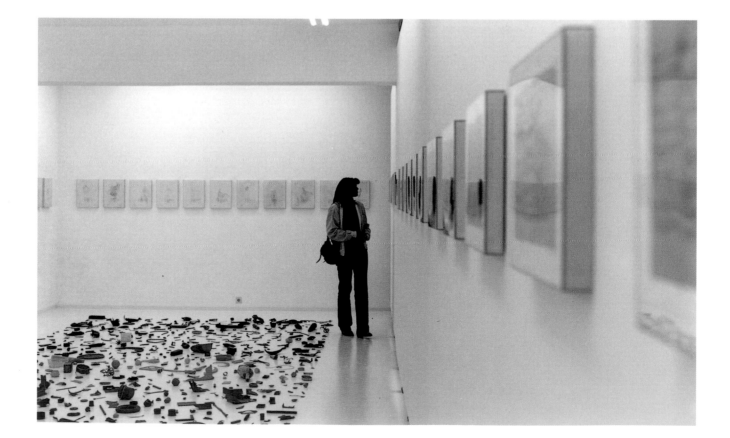

**Post-Partum Document
Documentation I, II, III**
(*foreground*, Tony Cragg)
1973-79
Installation in six parts
Overall dimensions variable
Installation, 'Europa '79',
Stuttgart, 1979

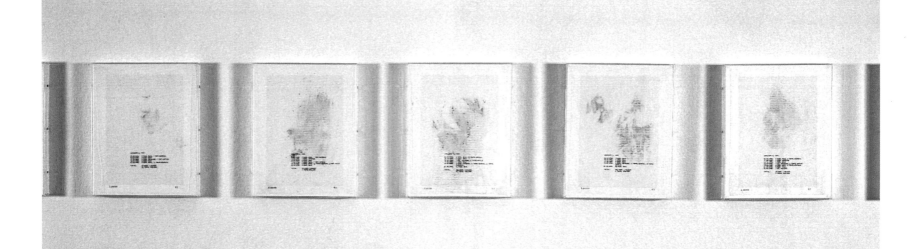

**Post-Partum Document:
Documentation I, Analysed
faecal stains and feeding charts
(prototype)**
1974
Perspex units, white card, diaper
lining, plastic sheeting, paper, ink
5 of the 7 units, 28 × 35.5 cm

Kelly's work shares with Conceptualism a political commitment to distanced reflection on cultural discourses, but she exchanges the tools of linguistic analysis for those of psychoanalysis. Her 'content' or raw material is subjectivity: the body, fears and desires, and the institutional and cultural forms which impinge on them. The systematic rigour of Kelly's art is set against powerful emotion and is itself infused with a sense of anxiety. *Post-Partum Document* marks a highly significant turn towards the subject and psychoanalysis in art practice and theory prompted mainly by feminists. Kelly was well placed to take the lead. Although born in the USA and now returned there, she spent formative years in the 1960s and 1970s in London in close contact with Juliet Mitchell, who wrote *Psychoanalysis and Feminism* (1974), and Laura Mulvey, who wrote 'Visual Pleasure and Narrative Cinema' (1975).[1] She has maintained this incisive

cutting-edge. In the following discussion of her three great installation works to date, *Post-Partum Document, Interim* and *Gloria Patri*, the three terms – contemporary art practice, feminism and psychoanalysis – must be kept in play if we are to get the full measure of Mary Kelly's astuteness, inventiveness and audacity.

Kelly's work will now inevitably be seen in the context of other contemporary neo-conceptualist art made by women which addresses the issue of gender difference: Cindy Sherman prominent among them. But Kelly started her work earlier and in a different milieu, that is, in London in the early 1970s, when a Marxist-feminist inquiry into the sexual division of labour was beginning to be complemented by a study of psychoanalytic theories of gender differentiation. This specific introduction meant that she would never have

DOCUMENTATION II
ANALYSED UTTERANCES,
RELATED SPEECH EVENTS

REF.1-23 R

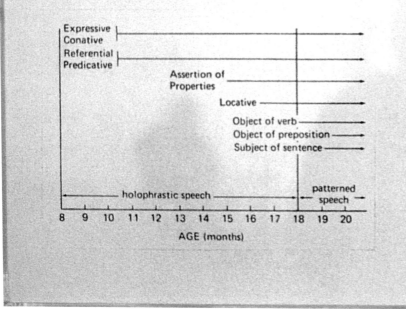

Expressive
Conative

Referential
Predicative

Assertion of
Properties

Locative

Object of verb
Object of preposition
Subject of sentence

holophrastic speech | patterned speech

8 9 10 11 12 13 14 15 16 17 18 19 20

AGE (months)

UTTERANCE /MA-MA/
GLOSS HELP ME. SEE THIS. BE THERE
FUNCTION EXISTENCE
AGE 17.0 JAN 26 1976

Tl 26.1.75

CONTEXT: M(mother) getting K(son) ready for bed, 21:20 HRS.
SPEECH EVENT(S) /ma-ma/Rl
1.1 M. Is that Kelly the baby? (looking in mirror together)
 K. /ma-ma/ ma-ma/
 M. What, who's the baby? (pointing to K)
 K. da/ da/ da-da/ da-da/ (father not there at the time)
 M. No, it's Kelly.
1.2 K. /ma-ma/ (looking at object on M's desk)
 M. What is it?
1.3 K. /ma/ ma-ma/ ma/ (crying and reaching for desk)
 MOST FREQUENT UTTERANCES; /ma-ma/ da-da/ eh/ no/ dere/
 MEAN LENGTH OF UTTERANCE: 1.42 17 months

Post-Partum Document:
Documentation II, Analysed
Utterances and Related Speech
Events
1975
Perspex units, white card, wood,
paper, ink, rubber
4 of the 23 units, 20.5 × 25.5 cm
each
Collection, Art Gallery of Ontario

Left panel

UTTERANCE /GAH/
GLOSS KITTY IS 'GONE'
FUNCTION NON-EXISTENCE
AGE 17.11 FEB 6 1975

T2 6.2.75

```
        CONTEXT: M(mother) putting K(son) to bed.      13.00 HRS.
        SPEECH EVENT(S)                                /gah/R5
  5.1 K. /dit-dy/ dit-dy/ e dit-dy/ (seeing kitty out the window)
        /gah/ dit-dy gah/ (kitty disappears under a car)
        M. Oh! (seeing it come out again)
        K. /dere/ dere/ e dere/ e dere/ (excitedly)
        MOST FREQUENT UTTERANCES:/dere/ e dere/ gah/ dit-dy/ ah-gah/
        MEAN LENGTH OF UTTERANCE: 1.78        17 months, 11 days
```

Right panel

UTTERANCE /E WEH BOH/
GLOSS WHERE IS THE 'P BALL'
FUNCTION RECURRENCE
AGE 18.8 MAR 6 1975

T5 6.3.75

```
        CONTEXT: S(mother substitute), A (her daughter) and K (M's
        son, having tea.                               16.30 HRS.
        SPEECH EVENT(S)                                /e weh boh/17R
 17.1 S. Don't spill it. (K playing with tea cups)
        K. /e weh boh/ e weh boh/
        S. Go fetch it for me.(no ball in sight)
 17.2 A. Where are you? (coming into the room)
        Kelly come on let's go outside.
        K. /e weh boh/
        A. This red ball? (bringing a ball)
        MOST FREQUENT UTTERANCES:        /e weh boh/ weh ka/ weh gah/
        MEAN LENGTH OF UTTERANCE: 1.65        18 months, 8 days
```

Joseph Kosuth
One and Three Chairs
1965
Photograph, wooden chair, text
Dimensions variable

The problem of addressing the complexity of women's desire revolved, for Kelly, around the aesthetic strategies not only of Minimal and Conceptual Art but also of avant-garde film. In fact, from 1970 she collaborated on an unconventionally filmed documentary called *Nightcleaners*. The scale, complexity, attention to detail and involvement in the real-time experience of the subjects possible in film were transposed by Kelly into a project-based art practice. Her subject matter demanded, she has said, 'a rupture of the single, rather seamless, artefact'. Another attractive feature of both film and Conceptual Art for Kelly, is their use of multiple registers of signification. Joseph Kosuth's *One and Three Chairs* (1965) seems in retrospect like a prescription for such a practice. But he doesn't use the heterogeneity of the sign (found object, photograph, text) to expound anything beyond the art-idea itself. Kelly brought the potential of these various registers and their affective differences for the spectator to bear on the presentation of extra-artistic subject matter.

Of course some conceptual artists, Dan Graham or Hans Haacke, for example, did turn their attention to extra-artistic issues. But Kelly has criticized the way these artists and others assume an authoritative position outside of the field of their investigations: they 'stopped dramatically short of synthesizing the subjective moment into their inquiry'.[2] Kelly brought to Conceptual Art the question of the subject and gender difference, including her own subjective experience of that difference. In this regard, Vito Acconci and Yvonne Rainer provoke comparison.

recourse to notions of an essential femininity outside of the constitutive social institutions of family, language and the law, and had certain consequences for her art practice. Her distinctive avoidance of iconic representations of women set a precedent for the 'constructivist' feminist position. She would argue that the kind of feminist art practice which offers 'empowering' iconic representations of the woman's body risks delivering up the female spectator to identifications with an ideal mother, an illusory mirror image of herself as whole, self-sufficient and autonomous – in short, a female version of the bourgeois subject.

Kelly's concern with the reflexive experience of the spectator is perhaps what led her to integrate the formal character of minimal sculpture in her installations. She is also undoubtedly drawn to the sheer austere beauty of installations by Judd, Andre or Hesse. But she makes use of these effects for her own purposes. Kelly lists some of the formal features of her work that attest to this borrowing: 'the fragmentation of the visual field, the imposition of a temporal sequence, the intrusion of peripheral vision, the ephemeral effect of light, and above all the physical presence of the viewer in the installation.'[3] The last of these considerations is, of course, necessary for the kind of reception of art which includes an awareness of how the spectator's own presence inflects the work.

Conceptual and Minimal Art practices are obvious proximate influences on Kelly's work, but again, her subject matter dictates recourse to a more remote artistic language. All of Kelly's art attempts the representation of psychic representations as these are ciphered through social formations. In short, her installations are visualizations of the unconscious. Perhaps, then, one way of looking at Kelly's work is as Surrealism revisited by a contemporary artist whose work is informed by a feminist reading of sexuality. The combination in Surrealism and in Kelly's work of psychoanalysis, politics, word-image art practice, found objects, chance as well as 'ethnographic research' and documentation, makes the comparison compelling. Of course, the differences in approach are equally telling. The surrealist idea of the unconscious as the site of transgressive desire personified by the hysterical woman could not be uncritically appropriated by Kelly. Yet Surrealism remains the richest source of visual experimentation inspired by psychoanalysis. Indeed, Jacques Lacan, whose psychoanalytic theory is important for Kelly, acknowledged the movement's importance to his intellectual development and he contributed to their magazines. Because the formal or aesthetic character of Kelly's work is often neglected in favour of its intellectual or political content, I refer to a range of surrealist imagery for comparison which will serve to foreground Kelly's innovative strategies for visualizing the unconscious. To give my survey of the three installations a distinctive focus, I will view each through the lens of an appropriate psychoanalytic concept: fetishism, hysteria and paranoia, respectively.

Fetishism and *Post-Partum Document* (1973–78)

The tension or ambivalence at the heart of this work is summed up succinctly by Kelly's statement that it concerns 'my lived experience as a mother and my analysis of that experience'.[4] In it she explores, with the aid of psychoanalysis, the way biological sex difference is made to conform to patriarchal social norms of gender difference which are 'sealed', so to speak, in the woman's experience of maternity. Her status within patriarchy as the gender that lacks a penis is momentarily absolved by the birth of a baby, unconsciously equated with the Phallus. At the same time the mother can enjoy an active libidinal relation to her baby which is not socially proscribed and re-experience the closeness she

Mary Kelly and son, recording
session
1975

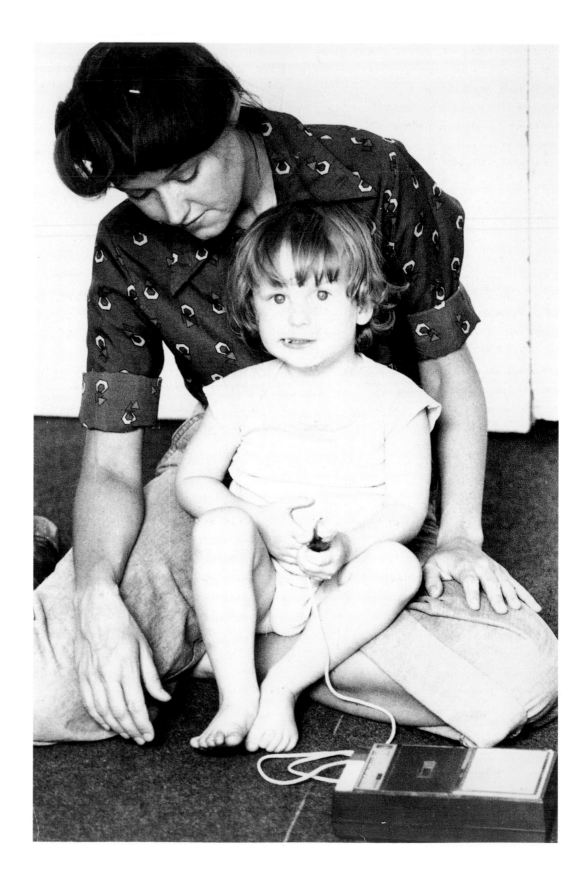

once felt to her own mother's body. Yet separation, anxiety and loss mark even the early months of motherhood. The love affair is doomed. Gradually, she re-experiences the symbolic castration she underwent as a little girl. Understanding these psychic processes through which women internalize their oppression was thought to be a crucial first step towards liberation. Yet Kelly's use of psychoanalysis is critical. The story of this moment is usually told from the child's point of view with the mother's fantasies, fears and desires neglected. *Post-Partum Document (PPD)* is about a reciprocal relationship, but the child's development is always seen through the loving, anxious eyes of the mother. It is a picture of *her* psychic life.[5]

How is this picture to be represented? Actual pictures of mother and child, an icon of love and tenderness in the history of art, could now only be sentimental and kitsch, and in any case lack explanatory power. The modernist eschewal of figurative representation obliterated this motif and Kelly does not want to revive it in its original form. Instead, one finds a division in the work between gestural marks, found objects, imprints traces, moulds (what C.S. Peirce called indexical signs) and writing, diagrams or symbols. The index to some extent resists verbalization and is related to the sense of touch, so these signs invoke the sensuous, emotive quality of the mother's lived experience. The mute immediacy of this experience together with the mother's first-person musings are relieved through the other register of Lacanian theory and diagrams and scientific discourses in which these experiences are situated and put into

'perspective'.

These antagonistic registers of signification are used very effectively in the *Introduction* series which consists of four tiny vests lined up in Perspex boxes, each one adding a line to complete a Lacanian diagram. The piece suggests that the mother's intense attachment to these objects is now mediated by an explanatory theory. The mother's fetishistic attachment to the object, itself a displacement from the baby's body, is sublimated in the pleasure of understanding psychoanalytic theory as well as, in Kelly's case, the mastery of her artistic materials. There is an implication here that the losses incurred through this process (the baby-phallus and maternal femininity itself) open a space for sublimated pleasures. It is interesting in this regard that the found objects of the early *Documents* give way to intricately fabricated ones later on. The idea of the diagrams and pseudo-scientific discourse as sublimated fetishism helps to dispel the false presumption that these registers are meant to be authoritative and objective. Lacan's ludicrously complicated Schema R, repeated on panels throughout the six sections (and the key to it provided in the footnotes), bear too close a resemblance to Duchamp's playful physics accompanying *The Large Glass* to be purely coincidental. Kelly takes Lacanian psychoanalysis seriously and yet also parodies it as a rather perverse hyper-trophy of the symbolic order. She has herself noted the deeply ambivalent affective charge of the diagrams. They are 'representations of the difficulty of the symbolic order for women', as well as 'blazons of a love-hate relationship with the Father (Phallic Mother?) cathected as much,

Giovanni Bellini
Madonna and Child
1485-90
Oil on canvas
72 × 54 cm

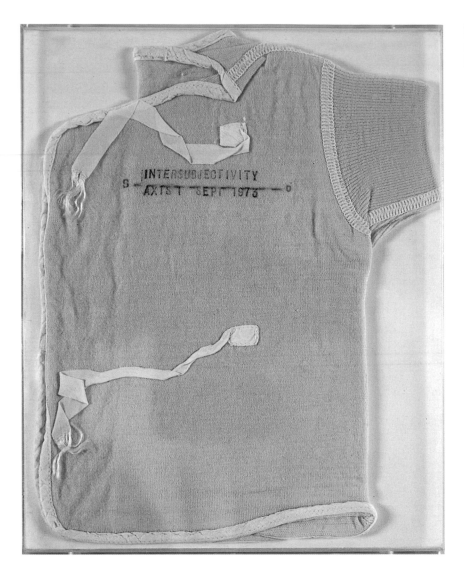
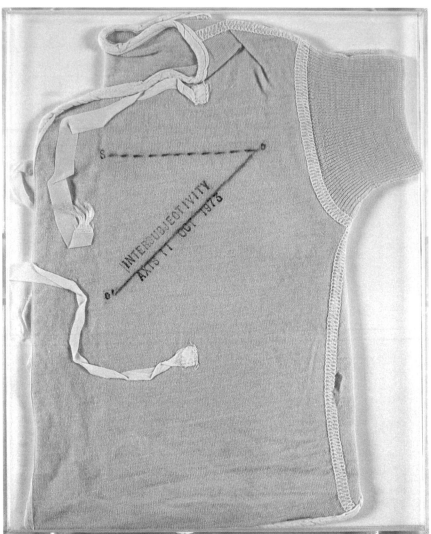

Post-Partum Document
Introduction
1973
Perspex units, white card, wool
vests, pencil, ink
4 units, 20 × 25.5 cm each

perhaps more, than the memorabilia'.[6] This ambivalence means that female spectators may respond to them in quite different ways, some clinging to the security offered by the conceptual apparatus, others balking at its alienating remoteness from lived experience and turning to the objects for comfort. One's emotional response is part of the installation. The point is to reflect on these transferential responses and to consider what they mean in terms of one's own psychic economy.

More needs to be said about the concept of maternal fetishism, because this is another point where Kelly departs from psychoanalytic orthodoxy for which fetishism is an exclusively male perversion. Kelly suggests, on the contrary, that if a baby fulfils in fantasy the lack carved out in the woman by a phallocentric society, then the loss of the maturing child must represent a castration threat. As a consequence, the mother preserves little fetishes – shoes, photographs, locks of hair, school reports – which both memorialize the loss and defend against it. *Documentation IV* is the most romantic representation of the reciprocal

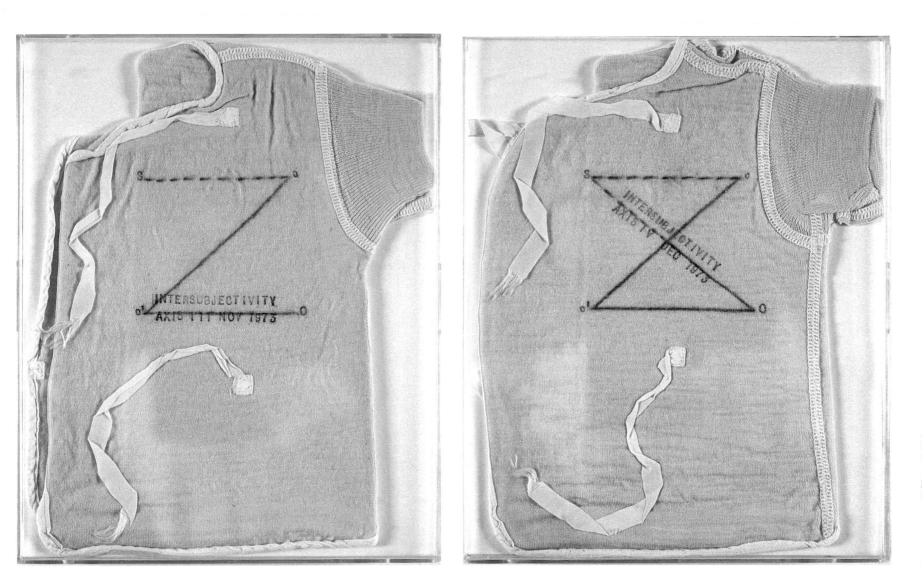

love, loss and memorialization. Separation anxiety is a feeling shared by mother and baby and they each have their 'transitional objects', a fragment of a blanket for the baby, a plaster cast of a small curled-up hand reminiscent of the newborn's as yet unfurled body. As the hand mould grows shallower, the representation of the Lacanian diagram that may explain the relationship is completed on its surface. Kelly does not want to generalize the fetish beyond its clinical definition – specifically, an object which defends against castration anxiety and so gives the subject pleasure – she just wants to extend that form of defence to women and, at the same time, provide the woman with a ground for sublimated pleasure in art.

The small-scale, box-like dimensions of the individually framed units allude to this fetishization. They can be read as a rhythmic alternation of presence/absence, panel/space, which mimes the mother's version of the 'fort-da' game (*My little baby/My big boy*).[7] Yet they also combine to form 'cinematic' frames recording the passage of time and the changes occurring in the

Laura Mulvey and Peter Wollen
Riddles of the Sphinx
1977
95 mins., colour
Filmstill

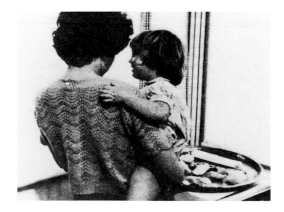

Marcel Duchamp
The Bride Stripped Bare by Her
Bachelors, Even (The Large Glass)
1915–23
Oil, lead wire on glass
277 × 175 cm

mother's relationship with her child. Kelly calls this latter strategy 'the narrativization of space' and it is crucial to her ongoing explorations of desire and anxiety and the complex social realities which inflect them.[8] The work must not only visualize the unconscious but also evoke the temporality of the subject. I am reminded of Octavio Paz's remark about Duchamp's monumental work, *The Bride Stripped Bare* … : 'What we see are only moments and states of an invisible object, stages in the process of manifestation and concealment of a phenomenon'.[9] I have already alluded to the resemblance between the 'mechanistic scientific discourse '[10] in *PPD* and the 'playful physics' in the accompanying Green Box of notes to *The Large Glass*, and it is tempting to explore the analogy further. Certainly, the three 'draft pistons' at the top of the glass – irregularly shaped rectangles formed by hanging a fine veil in a draft and photographing them – is a visual source for the nappy liners (and the stains are equally 'a manipulation of chance'). But Duchamp left his Bride suspended in her moment of erotic ecstasy and, needless to say, did not anticipate that she might get pregnant, give birth and reflect on her situation in the form of a monumental work of art.

Neither Conceptual nor Minimalist Art practices aim at the visualization of unconscious desire and anxiety. Duchamp was the key artist for conceptual artists, and for the most part they inherited his ironic detachment. Minimalist sculptural forms engage the spectator in an aesthetic rather than emotional way. From this point of view, Kelly's sensibility seems closer to

André Breton's deeply passionate art. For example, in the book of his affair with an enigmatic woman, *Nadja*, he includes numerous photographs and some of her drawings; but he disdains to reproduce a literal representation of her because his object, like Kelly's, is invisible.[11] Breton's artistic strategy of automatic writing and drawing is ironically mimed by Kelly with the child's 'automatic drawing' in *Documentation III*, and surely, Breton's *poème-objet* of 1935 is one visual source for *Documentation V*. Both allude to nineteenth-century museum displays of natural history. The Document connects the three year-old's curiosity about nature to his infantile investigation of the mother's body. The objects exhibited are the product of 'objective chance'; that is, the child's spontaneously presented 'gifts', which accompanied his queries about sexuality. Flowers (botanical sex organs), insects and a snail are classified and named in a way which stands for the naming and distancing of the mother's body. The objects of his displaced curiosity become her fetishistically collected treasures.

The child's infantile sexual researches are repressed, but sexuality intrudes in his attempts to master the alphabet. It is 'sublimated in the body of the letter'. *Documentation VI* marks the final stage of the Oedipus complex and the beginning of latency when the child learns to write, assuming the name-of-the-father as he spells out his own surname. The form of the units refers to black writing slates, the Rosetta Stone with its triple register and, what has not been noted, tomb stones, monuments to a loved one who is absent, that is, gone to infant school. These are memorials

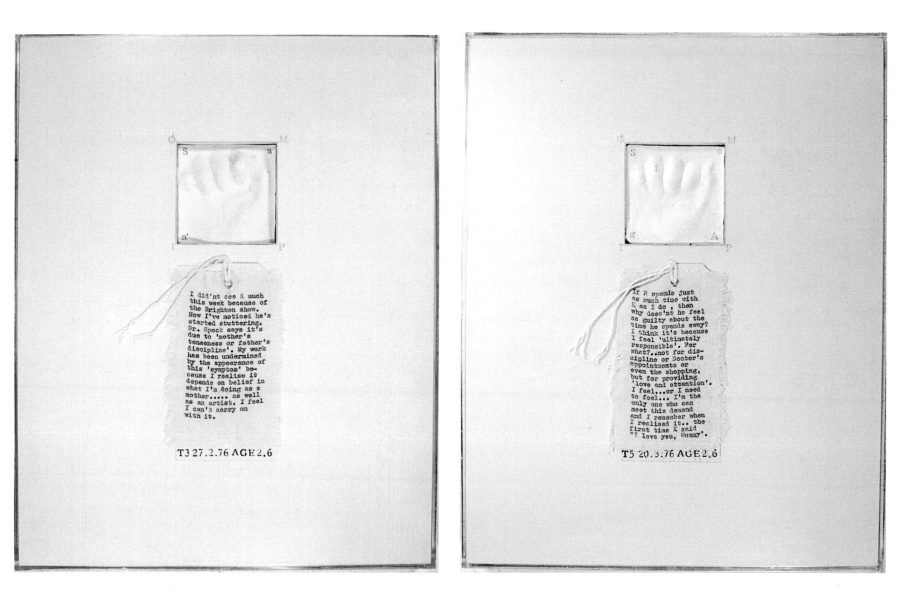

I did'nt see K much
this week because of
the Brighton show.
Now I've noticed he's
started stuttering.
Dr. Spock says it's
due to 'mother's
tenseness or father's
discipline'. My work
has been undermined
by the appearance of
this 'symptom' be-
cause I realise it
depends on belief in
what I'm doing as a
mother..... as well
as an artist. I feel
I can't carry on
with it.

T3 27.2.76 AGE 2.6

If R spends just
as much time with
K as I do , then
why does'nt he feel
as guilty about the
time he spends away?
I think it's because
I feel 'ultimately
responsible'. For
what?..not for dis-
cipline or Doctor's
appointments or
even the shopping,
but for providing
'love and attention'.
I feel...or I need
to feel... I'm the
only one who can
meet this demand
and I remember when
I realised it.. the
first time K said
"I love you, Mummy".

T5 20.3.76 AGE 2.6

Post-Partum Document:
Documentation IV, Transitional
Objects, Diary and Diagram
1976
Perspex units, white card,
body/hand imprint in clay, plaster
of Paris, cotton fabric, string
2 of the 8 units, 28 × 35.5 cm
each
Collection, Zurich Museum

Post-Partum Document:
Documentation III, Analysed
Markings and Diary-perspective
Schema
1975
Perspex units, white card, sugar
paper, crayon
8 of the 10 units, 35.5 × 28 cm
each
Collection, Tate Gallery, London

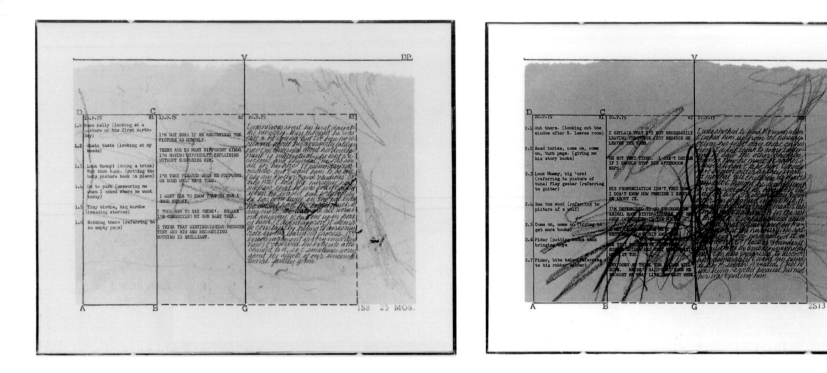

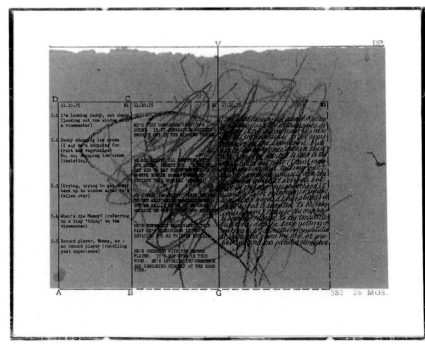

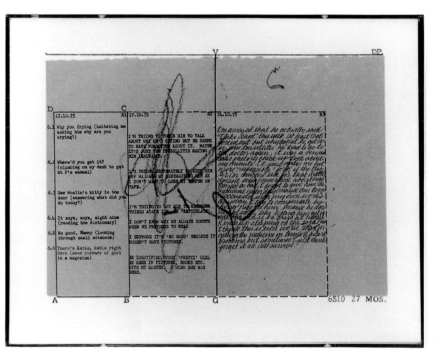

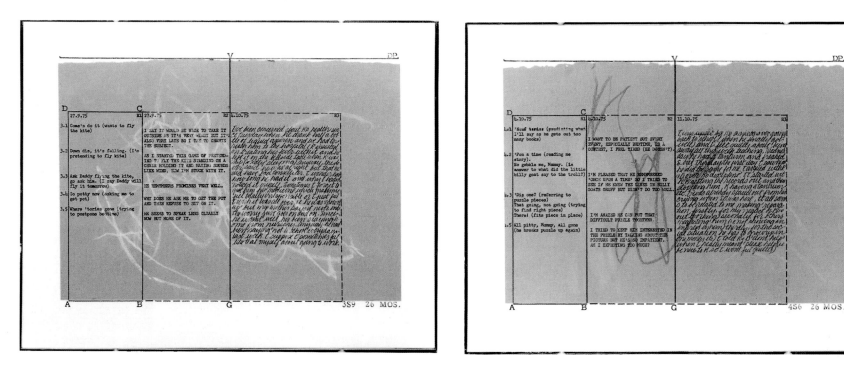

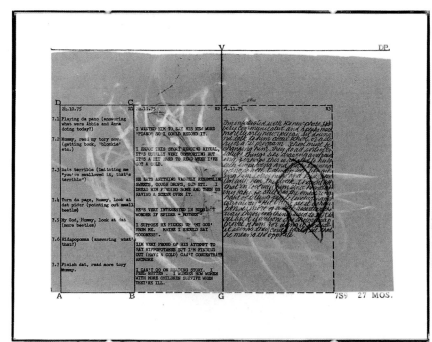

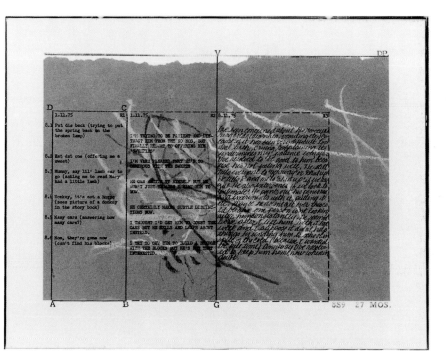

to the trauma of castration or separation. In this *Document*, Kelly makes a critique of the sort of linguistics that drains language of its graphic medium – the mark as signifier and its unconscious, pictographic, associations (the little person 'i', the snake 's'). This critique might equally apply to receptions of Kelly's work which read the texts as transparent signifieds, draining them of their visual form and affective charge. Her installations are through and through *poèmes-objets*.

Each section of *PPD* ends with a modified version of Lacan's diagram of the subject: S over little s, divided by the bar of repression, meaning that the subject is the subject of a (phallic) signifier of lack. Kelly uses that formulation to represent maternal anxiety. Questions ('What have I done wrong?') become the unconscious representation of her lack. What Kelly wants to suggest here is that separation or castration opens up a gap, ruining the picture of herself as essentially or naturally maternal, and creating 'a chasm which resounds with questions'.[12] And as Kelly says, 'it is precisely at such moments that it is possible to desire to speak and to dare to change'.[13] This vista of possible future change is where the *Document* ends; the next project sets out to answer the last echoing question: ('What will I do?')

Hysteria and *Interim* (1984-89)

With *Post-Partum Document*, Kelly broke the taboo surrounding maternity in contemporary, critical art practice. She followed this up with an equally impertinent topic: women and middle age. *Interim*

explores the crisis of identity experienced by the older, post-maternal woman. What are the social roles, the self-images, the expectations in circulation for her? The work is truly monumental in scale; it filled the New Museum of Contemporary Art in New York when it was exhibited there in 1990. But it might also be considered monumental in other senses since it is so reflexive about the past and concerned with memory, both personal and collective. It has been suggested that 'middle age' is also metaphorically the position of the women's movement itself; which is in the process of redefining itself.[14]

The work consists of four parts which focus on recurrent themes of feminist discourse – the Body, Money, History and Power. In the same way that the earlier work proposed maternal fetishism as a specifically feminine 'aesthetic' or ground of sublimated pleasure, *Interim* turns on the issue of identification and dis-identification in relation to representation. The fraught issue of feminine identity for the older woman is brought into relation with the psychoanalytic category of hysteria and with recent feminist re-evaluations of the image of the hysteric. *Interim* is addressed to a female spectator as the subject of desire. How does it propose to do this? By representing the maternal body as lost and therefore as an object of desire. At that moment when the anxiety-laden closeness of identification with the mother's body in maternity gives way to the shifting instability of the signifier, it can be experienced as pleasurable loss. Perhaps this is why the garments in *Corpus* have a ghostly presence.

Kelly began her project by sifting through

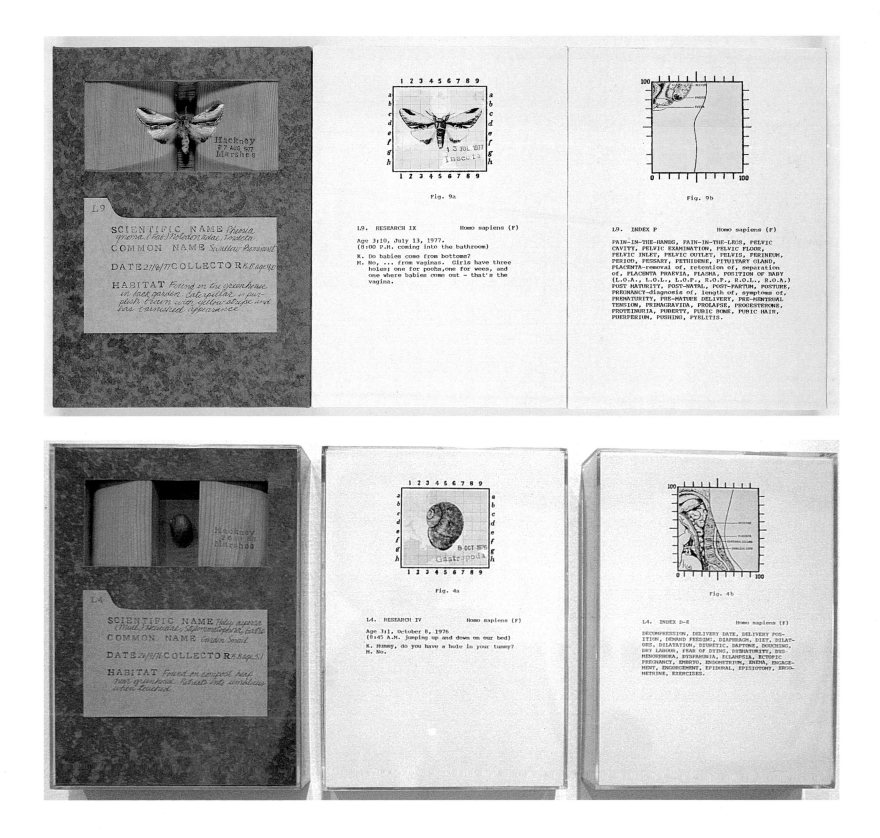

SCIENTIFIC NAME *Pheosia*
gnoma (Fab.) Notodontidae, Insecta
COMMON NAME *Swallow Prominent*

DATE 27/8/77 COLLECTOR *R.K.B.age40*

HABITAT *Found in the greenhouse*
in back garden. Caterpillar is pur-
plish brown with yellow stripe and
has varnished appearance

Fig. 9a

L9. RESEARCH IX Homo sapiens (F)

Age 3;10, July 13, 1977.
(8:00 P.M. coming into the bathroom)

K. Do babies come from bottoms?
M. No, ... from vaginas. Girls have three
 holes; one for poohs, one for wees, and
 one where babies come out - that's the
 vagina.

Fig. 9b

L9. INDEX P Homo sapiens (F)

PAIN-IN-THE-HANDS, PAIN-IN-THE-LEGS, PELVIC
CAVITY, PELVIC EXAMINATION, PELVIC FLOOR,
PELVIC INLET, PELVIC OUTLET, PELVIS, PERINEUM,
PERIOD, PESSARY, PETHIDENE, PITUITARY GLAND,
PLACENTA-removal of, retention of, separation
of, PLACENTA PRAEVIA, PLASMA, POSITION OF BABY
(L.O.A., L.O.L., L.O.P., R.O.P., R.O.L., R.O.A.)
POST MATURITY, POST-NATAL, POST-PARTUM, POSTURE,
PREGNANCY-diagnosis of, length of, symptoms of,
PREMATURITY, PRE-MATURE DELIVERY, PRE-MENTRUAL
TENSION, PRIMAGRAVIDA, PROLAPSE, PROGESTERONE,
PROTEINURIA, PUBERTY, PUBIC BONE, PUBIC HAIR,
PUERPERIUM, PUSHING, PYELITIS.

SCIENTIFIC NAME *Helix aspersa*
(Mull.) Helicidae, Stylommatophora, Gastro
COMMON NAME *Garden Snail*

DATE 26/9/76 COLLECTOR *R.B.age31*

HABITAT *Found on compost heap*
near greenhouse. Retreats into umbilicus
when touched

Fig. 4a

L4. RESEARCH IV Homo sapiens (F)

Age 3;1, October 8, 1976
(8:45 A.M. jumping up and down on our bed)
K. Mummy, do you have a hole in your tummy?
M. No.

Fig. 4b

L4. INDEX D-E Homo sapiens (F)

DECOMPRESSION, DELIVERY DATE, DELIVERY POS-
ITION, DEMAND FEEDING, DIAPHRAGM, DIET, DILAT-
ORS, DILATATION, DIURETIC, DAPTONE, DOUCHING,
DRY LABOUR, FEAR OF DYING, DYSMATURITY, DYS-
MENORRHOEA, DYSPARUNIA, ECLAMPSIA, ECTOPIC
PREGNANCY, EMBRYO, ENDOMETRIUM, ENEMA, ENGAGE-
MENT, ENGORGEMENT, EPIDURAL, EPISIOTOMY, ERGO-
METRINE, EXERCISES.

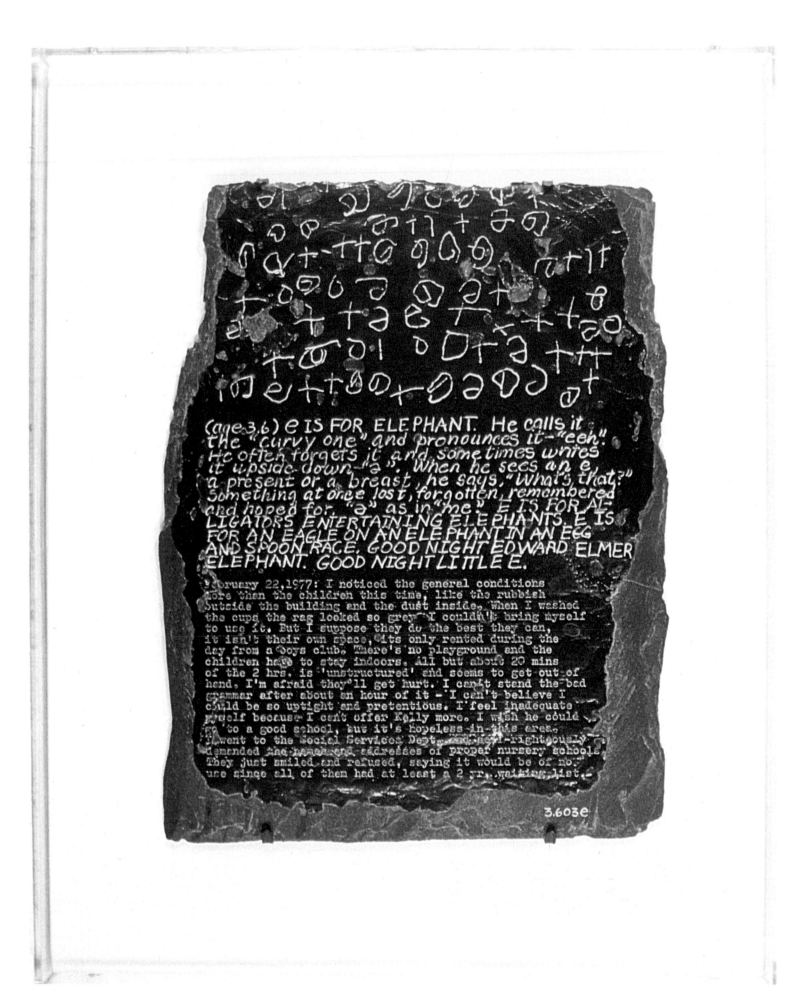

(age 3,6) e IS FOR ELEPHANT. He calls it the "curvy one" and pronounces it "een". He often forgets it and sometimes writes it upside down "ə". When he sees an e, a present or a breast, he says, "What's that?" Something at once lost, forgotten, remembered and hoped for. "ə" as in "me". E IS FOR ALLIGATORS ENTERTAINING ELEPHANTS. E IS FOR AN EAGLE ON AN ELEPHANT IN AN EGG AND SPOON RACE. GOOD NIGHT EDWARD ELMER ELEPHANT. GOOD NIGHT LITTLE E.

February 22,1977: I noticed the general conditions more than the children this time, like the rubbish outside the building and the dust inside. When I washed the cups the rag looked so grey I couldn't bring myself to use it. But I suppose they do the best they can, it isn't their own space, its only rented during the day from a Boys club. There's no playground and the children have to stay indoors. All but about 20 mins of the 2 hrs. is 'unstructured' and seems to get out of hand, I'm afraid they'll get hurt. I can't stend the bad grammar after about an hour of it - I can't believe I could be so uptight and pretentious. I feel inadequate myself because I can't offer Kelly more. I wish he could go to a good school, but it's hopeless in this area. I went to the Social Services Dept. and self-righteously demanded the names and addresses of proper nursery schools. They just smiled and refused, saying it would be of no use since all of them had at least a 2 yr. waiting list.

3.603e

**Post-Partum Document:
Documentation VI, Pre-writing
Alphabet, Exergue and Diary**
(details)
1978
Perspex units, white card, resin,
slate
15 units, 20 × 25.5 cm each
left, Installation, 'Issue', left,
Institute of Contemporary Arts,
London, 1980
Collection, Arts Council of Great
Britain

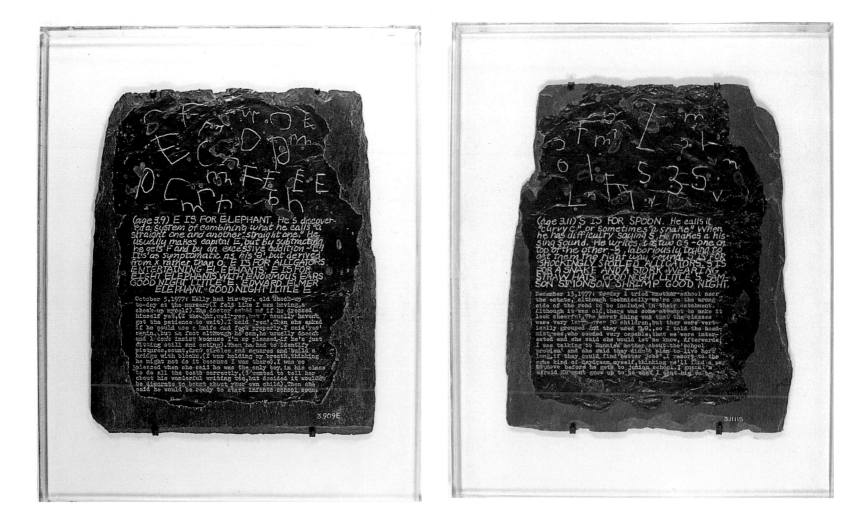

pop-cultural artefacts (like women's magazines and advertising), and by recording (in her notebooks) conversations with many women in order to find out what positions we habitually take up or what ones are fantasized. In our culture, the female body is supposed to pass from a state of virginal girlhood to one of mature, maternal femininity. These clearly articulated positions are followed by one that has no name and apparently no use. While an excess of discourse surrounds the young woman and the mother, the 'middle-aged' woman is excluded from discourse – unspoken, invisible, uneasy. Consequently, she makes muffled protests with her body analogous to the symptoms of hysteria. Kelly uses the concept of the

hysterical female body in a metaphorical way and it is a metaphor loaded with cultural meanings ranging from the Ancients' conception of a specifically female malady caused by a 'wandering womb', to the nineteenth-century notion of a non-organic disorder whose symptoms may be exaggerated or simulated. These extreme views correlate nicely with two opposing misogynist disparagements of woman as either at the mercy of her disorderly physiognomy or cunningly deceitful. Why then has the hysteric been taken up by some feminists as a heroine? According to these writers, the hysteric is a woman who refuses to conform to the repressive regime of patriarchal culture and so falls ill, satisfying her desire unconsciously in the

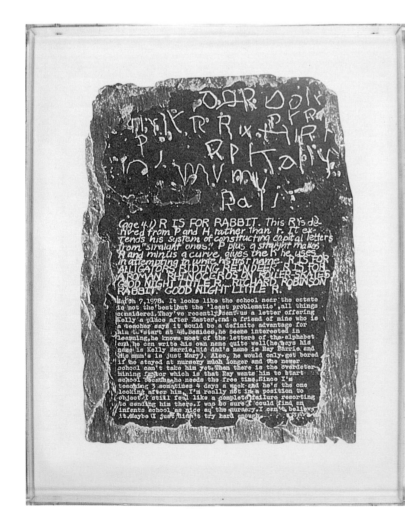

opposite, **Post-Partum
Document: Documentation VI,
Pre-writing Alphabet, Exergue
and Diary** (details)
1978
Perspex units, white card, resin,
slate
2 of the 15 units, 20 × 25.5 cm
each
Collection, Arts Council of Great
Britain

below, **Post-Partum Document:
Documentation VI, Pre-writing
Alphabet, Exergue and Diary**
(detail, diagrams)
1978
2 of the 3 units, 20 × 25.5 cm
each
Collection, Arts Council of Great
Britain

form of bodily symptoms. If Freud did once
foolishly say 'anatomy is destiny', he also said,
'hysteria behaves as though anatomy did not
exist'.[15] This refusal of destiny is why Juliet
Mitchell describes it as a 'pre-political
manifestation of feminism'. Kelly is in fact rather
wary of this recent feminist celebration of
hysteria. The 'hysteric' is for her a symptom within
theory which *Interim* sets out to investigate.

Corpus

The discourse of hysteria is explicitly indexed in
Corpus, the first section of *Interim*, which concerns
the body. The work is made up of five sections,
each consisting of three pairs of panels (image and
text) making a total of thirty large panels. Each of
the five sections represents an article of clothing;
the panels are labeled with the terms given by the
nineteenth-century French neurologist J.-M.
Charcot to the so-called 'passionate attitudes'
which accompanied hysterical attacks – *Menacé,
Appel, Supplication, Erotisme, Extase*. Photographs
of articles of clothing are arranged in postures
resembling those assumed by the women patients
at the hospital for nervous diseases, the
Salpêtrière, and recorded photographically. The
sartorial versions of the attitudes are paired with
anecdotal text panels, spoken in the first person.

One immediate effect of the diversity of
garments and postures is the disruption of any

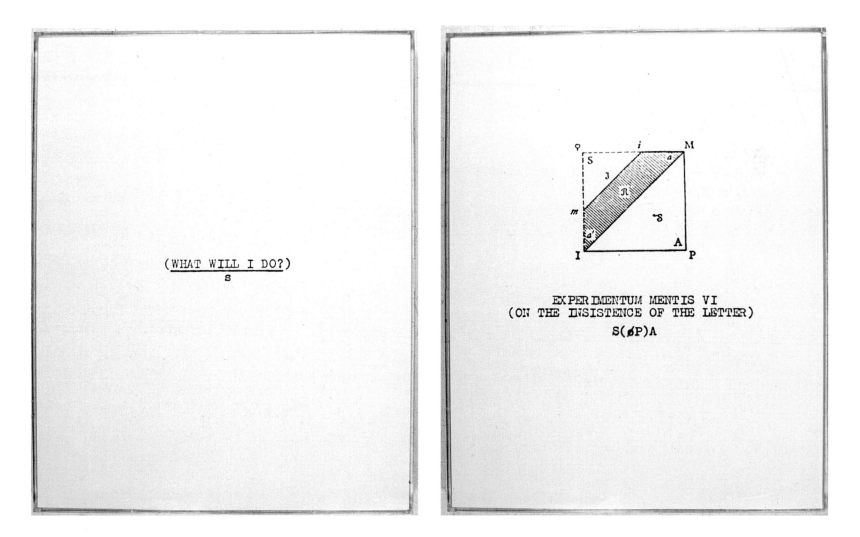

unifying and universalizing conception of 'the woman'. In an interview with Hal Foster, Kelly remarked that '*Interim* proposes not one body but many bodies, shaped within a lot of different discourses. It doesn't refer to an anatomical fact or to a perceptual entity, but to the dispersed body of desire'.[16] This also accounts for the absence of iconic images of the woman's body in Kelly's work. Yet this absence is equally a response to the special requirements of the female spectator: it prevents her 'hysterical' identification with the male voyeur. The use of writing helps, she says, to open up a gap, 'to distance the spectator from the anxious proximity of her body'.[17] But the special character of the photographic images might also be crucial in this regard.

Kelly's iconography in *Corpus* is not without artistic precedent. The Surrealists were inspired by the hysterical woman. They revered and identified with her. She was for them the figure of difference, an enigmatic Other, primitive and closer to the unconscious. They made heroines of particular hysterics and other deranged women like the assassin Germaine Berton, or Violette Nozière, who

poisoned her parents, or the psychotic Papin sisters. Breton's visionary Nadja ends up in an asylum. His book, *Nadja* (1928), concludes with the ringing pronouncement, 'Beauty will be CONVULSIVE or will not be.' The word 'Convulsive' refers to the attacks of the *grandes hystériques* of the Salpêtrière. One of the illustrations in the book important for my argument is that of a bronze woman's glove: 'the wrist folded over, the fingers flat'. This isolated article of clothing suggesting a metonymy of part for whole (the glove standing in for the whole woman) and having a definite expressive character might serve as a model of the image panels for *Corpus*.

Also in 1928, Breton and Aragon published a hymn of praise to hysteria in a two-page spread for the periodical *La Revolution Surrealiste* to mark the 50th anniversary of hysteria.[18] Reproduced there are selected photographs of the pretty young hysteric, Augustine, assuming the *attitudes passionelles* from the *Iconographie Photographique de la Salpêtrière*.[19] The text by Breton and Aragon declares, for example, that hysteria is a 'poetic discovery' and that it 'is by no means a pathological symptom and can in every way be considered a supreme form of expression'. However, the surrealist images that formally relate most closely to the *Corpus* panels do not invoke hysteria; they are Brassaï's strange close-up photographs of *Sculptures Involuntaires*, miniature 'sculptures' formed involuntarily from ticket stubs, bread dough and other debris. They were published in the surrealist magazine *Minotaure* in 1933,[20] with captions undoubtedly by Dalí who is also responsible for the cochlea-shaped photo-montage called

The Phenomenon of Ecstasy consisting of ecstatic women, Gaudí sculpture and ears. While the glove in *Nadja* is photographed flat, the involuntary sculptures are subjected to a raking light and seem to hover just above the ground so that a shadow is cast behind the object. Kelly produces this atmospheric effect using different means. I will return shortly to the question of the significance of the form of these photographs for Kelly.

The Surrealists elevated the hysteric to the status of a romantic heroine who rebels against a repressive Patriarchal order. They emphasized the marvellous character of her hallucinations and conversion symptoms, substitutes for a repressed sexual, pathogenic thought and its attendant affect. This is the classical Freudian account of hysteria – or at least it is one of them. Parveen Adams has persuasively argued that there are two accounts of hysteria in Freud and only one is identified by the characteristic features of repression and bodily conversion. According to the other (incompatible) theory, hysteria is a matter of patterns of identification, often bi-sexual identifications. There may be somatic symptoms in this case too; Dora's hysterical cough derives from her father's and is a case of object choice regressing to identification. Adams concludes: 'The symptom now expresses hostile and loving impulses towards others'.[21] This phenomenon may be called 'hysterical identification', yet it is not especially pathological but rather a common, everyday occurrence. Nor does it throw much light on the vexed question of hysteria's special affinity with femininity (a pendent to the close relationship between obsessional neurosis and

masculinity), except perhaps in so far as it turns on the issue of bisexuality; Lacan suggests that the hysteric's question is: 'Am I a man or a woman?' This is the key question posed by the 'hysterical spectator' assumed by Mary Kelly's *Corpus*. Unlike the Surrealists' glorification of the famous *grandes hystériques* of the Salpêtrière, *Corpus* explores the everyday identification of everywoman with the idealized image of the Other, both male and female. And in this respect the work is an implicit critique of those new French feminist re-valuations of hysteria as a protest against the phallocentric Oedipal moment in the form of a privileged pre-Oedipal relation to the mother's body, expressed in a rhythmic and colourful bodily language. For example, Michèle Montrelay declares that 'the word is understood only as an extension of the body which is there in the process of speaking ... to the extent that it does not know repression, femininity is the downfall of interpretation'.[22] Hélène Cixous invokes Freud's patient Dora who walked out on him: 'You, Dora, you the

below, left, **Brassaï**
Sculptures Involuntaires,
from *Minotaure*
1933
Magazine illustration, text and images
31.5 × 23.5 cm

below, right, **Salvador Dalí**
The Phenomenon of Ecstasy
1933
Magazine illustration collage
31.5 × 23.5 cm

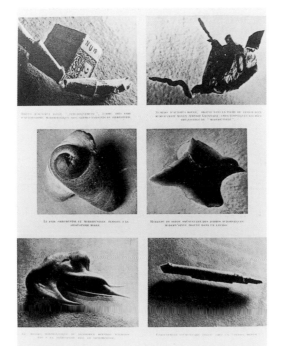

SCULPTURES INVOLONTAIRES

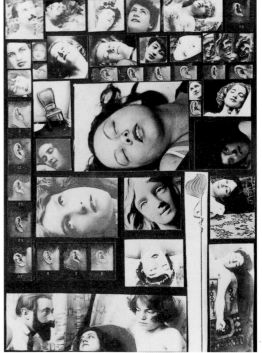

Bruce Weber
Obsession
1985
Artist's archival material for
Corpus, Calvin Klein
advertisement

indomitable, the poetic body, you are the true mistress of the Signifier'.[23] As Jacqueline Rose, amongst many others, has pointed out, this feminist strategy seems to tie femininity so closely to the body that, like the hysteric, it cannot speak articulately. 'Hysteria is assimilated to a body as site of the feminine, outside discourse, silent finally, or, at best, "dancing".'[24] Or, to put it more pointedly, it simply repeats the surrealist gesture.

This theorization of femininity is based on psychoanalytic theory and plenty of justification for it can be found in Freud's texts: in the essay 'Female Sexuality', for example, he writes that this (pre-Oedipal) 'phase of attachment to the mother is especially intimately related to the aetiology of hysteria, which is not surprising when we reflect that both the phase and the neurosis are characteristically feminine'.[25] However, the often exaggerated emphasis on the body seems pre-Freudian. It was the pre-Freudian Charcot who presented the visible spectacle of the hysteric's body to his colleagues at the Salpêtrière, and who organized the photographic record of their attacks, paralyses, contractures and hallucinated fantasy scenarios. Freud, on the contrary, initiated psychoanalysis by listening to his patients. In a discussion of *Corpus*, Kelly stresses Freud's crucial shift from looking to listening: 'With this he introduced the linguistic moment into the analysis of psychic disorder. In effect, the body was dispersed, made invisible, with the invention of the "talking cure".'[26] The question posed by psychoanalysis for an art informed by feminism then, is 'how is one to represent this dispersed body'?

One way might be simply to avoid all representations of the female body. Kelly's strategy in *Corpus* is to represent the body indirectly and to pair each image panel with a text panel. The image panels allude to and interrogate the history of representations of women (including those of the Surrealists) as well as contemporary projection of her image in advertising – 'the new theatre where the hysterical postures of woman proliferate'.[27] *Corpus* invokes a moment in the woman's life when identification with the maternal body is ruled out (the second text panel involves an older woman's decision not to have another baby). At this moment, the woman's imagined closeness with the mother's body must wane. What is represented is an absence: the lost body of the mother. We are dealing then with what Kelly calls 'a realm of lost objects'. Kelly repeatedly stresses that 'it is the representation of moments of separation and loss which captivate us more than the promise of plenitude'.[28] By visualizing that lost object, Kelly hopes to open up a space for women's pleasurable relation to the image. Visualizing the object or viewing an image is not, then, necessarily a matter of suffocating closeness to it, that is, of becoming the image through identification with it. A body 'too close to see' is put at a distance. This insight derives from feminist film theory concerned with the masquerade or with the possibility of a kind of cinematic representation of woman that is liberating for her because femininity is given so obviously as a mask. A pleasurable and disturbing 'sense of separation is effected through the visualization of exactly that which was assumed to be outside seeing'.[29] By posing 'ghostly' articles of

clothing rather than the body of the woman, Kelly makes possible for the female spectator a desiring relation to the image which depends upon separation and loss.

We are now in a position to look more closely at some of the image and text panels of *Corpus*. Kelly distilled from women's magazines and conversations three repeated themes which she understands as indicative of women's fantasies and anxieties. They are fashion, popular medicine and romantic fiction. Each of the five passionate attitudes and its associated article of clothing is refracted through these three modalities of feminine desire and fear in relation to the body. The garment motifs thus have a triptych structure. The motifs themselves have, as I've indicated, a curious presence (absence). They are semi-transparent photographic images, laminated photo positives, applied to Perspex panels. The panels are raised against a pale ground and lit so that the motifs cast a shadow, emphasizing the space or gap behind. I have already suggested one explanation for the curious formal character of the images. The articles of clothing that stand in for the body are, so to speak, all surface. The spectator can thus enjoy the masquerade without the anxiety of identification with the literal bodily figure of the woman. It's only a picture, a mimicry. Two forms of 'hysterical' identification to which women are vulnerable are thus elided; she is released from the tendency to identify too closely with the image (Am I like that?), as well as from her identification with the male voyeur of images of woman. While the garment motifs cast a shadow, the text panels are devised so that the

reflection of the viewer appears in the text. The handwritten texts are silkscreened on Perspex and raised against a dark ground so that the reflection of the spectator merges with the words, inviting pleasurable identification with the characters. In the case of textual representation, Kelly implies, the dangers of hysterical identification recede. Each text panel narrates a story in the first person evoked by the article of clothing, its 'attitude' and its place in the triple register of modalities – fashion, medicine, fiction.

The way the formal character of the garment motifs relate to the masquerade is clear, but what of the resonances from their art-historical references in Breton's scripto-visual text *Nadja*, or Brassaï's *Sculptures Involuntaires*, or Duchamp's works on glass? From the point of view of technical execution, the nearest model for the motifs is Duchamp's *Glider Containing a Watermill* (1913-15), which sits on a hinge attached to the wall and throws a shadow on the wall. Kelly gives us a clue to what she found valuable in this work and the photographs when she contrasts the function of perspective construction, in which the surface of the picture is tied to a geometric point and conceived as the intersection of a pyramidal path of light, with another kind of picture found in 'the realm of lost objects', a realm where 'vanishing points are determined not by geometry, but by what is real for the subject, points linked, not to a surface, but to a place – the unconscious – and not by means of light, but by the laws of primary process'.[30] Kelly has turned to surrealist art for a tradition rich in the representation of this peculiar space. Orthodox perspective construction was

Marcel Duchamp
Glider Containing a Watermill
1913-15
Oil, lead wire on glass
147 × 79 cm

André Breton
Gant de Femme
c. 1926
Bronze
3 × 22 × 11 cm

either entirely disposed of, or skewed and exaggerated, as in painting by de Chirico or Dalí. But for the representation of lost objects, traces of experiences or traumas cut off from consciousness, the object is perhaps best represented as isolated, floating in an uncharted space. In *Studies in Hysteria*, Freud and Breuer propose that the symptom, say the paralysis of a limb, is connected with a group of ideas isolated by 'associative inaccessibility'.[31] The hovering garments of *Corpus* draw on the surrealist visual realization of this inaccessibility to conscious thought.

Of course, the articles of women's clothing photographed by the Surrealists are susceptible to another interpretation. Briony Fer has suggested, with special reference to Man Ray's photographs of hats, that the high camera angle, the isolation of a specific part and undue attention on the genital-shaped forms, imply a male spectator for whom they serve as fetishes.[32] The glove photograph in *Nadja* fits Fer's account even better with its Medusa-like multiplication of fingers and the text's indication that it is, in fact, not flaccid but a bronze cast. In her reference to Surrealism, Kelly has to rescue the object from this fetishizing masculine gaze and return it to the woman's gaze as subject of desire.

The garment motifs as they appear on the panels representing the fashion modality, are presented like clothes in an expensive shop. For example, the captivatingly glossy black leather jacket motif is neatly folded. Each fashion motif is accented in red, rather like displaced lipstick – metaphorically the site of an erogenous or hysterogenic zone. All the text panels are marked

in this way, indicating that language too has cathected zones and over-determined nodal points where disparate thoughts converge. The padded shoulder of the leather jacket is marked in this way indicating a masculinization of the fantasized body. With the loss of identification with the maternal body, Kelly notes, 'a different order of fear emerges, one which reveals the importance of repressed pre-Oedipal identification with the father – the desire to be "like him", but the fear of being the *same*, that is, of being "like a man".'[33] The jacket is an emblem of this desire and dread. Many of the text panels intervene in debates about the feminine position as object of the gaze and women's desire to achieve the perfect to-be-looked-at ideal. Particularly for the older woman, the masquerade does not often come off very well. Perhaps in response to this, Kelly develops a notion of the masquerade which is not for the man, but is rather a symptom of identification with another woman whom we admire, ultimately the mother. I am particularly touched by the story associated with the motif of a pair of boots, about the reunion of two women who have swapped images in emulation of each other's appearance at their last meeting – one a dancer of androgynous beauty and soulful boots, the other in an overstated feminine masquerade reminiscent of the style of classical Hollywood cinema.

The second set of panels in each triptych is the underside of the first. The perfect image may mask a fear of ageing, death or, worse, flabby thighs. This accords with Lacan's sense of the mirror image as a 'salutary fiction' for the infant who is racked by fragmenting drives and hampered

Man Ray
Untitled
1933
Black and white photograph

by lack of coordination. The mirror stage is replayed for the older woman. If the fashion panels allude to an illusory, imaginary wholeness, then the popular medicine series uncover the real of the body. As Laura Mulvey says, 'the second image tears off the mask to reveal a hidden disorder, the body and its actual uncontrollable symptoms'.[34] One of the images of Augustine reproduced in *La Révolution surréaliste* is not taken from the series of *ullitudes passionelles*, but rather shows a convulsive attack and seems closely related to these panels. Looking at this image, one can see clearly why Kelly chose to represent

emblematic garments, rather than repeat the sensational and voyeuristic image of the woman herself. The garment motifs are manipulated in such a way that they recall anatomical drawings with the skin peeled away to expose the flesh beneath or, more hideously, the seventeenth-century anatomical wax models of female figures with lids that open to reveal internal organs. Instead of lipstick accents, areas of the garments are outlined in red like malignancies marked on X-ray photographs of the body. The jacket emblem is now unzipped to reveal the intestinal convolutions of its lining. The smart leather handbag of the

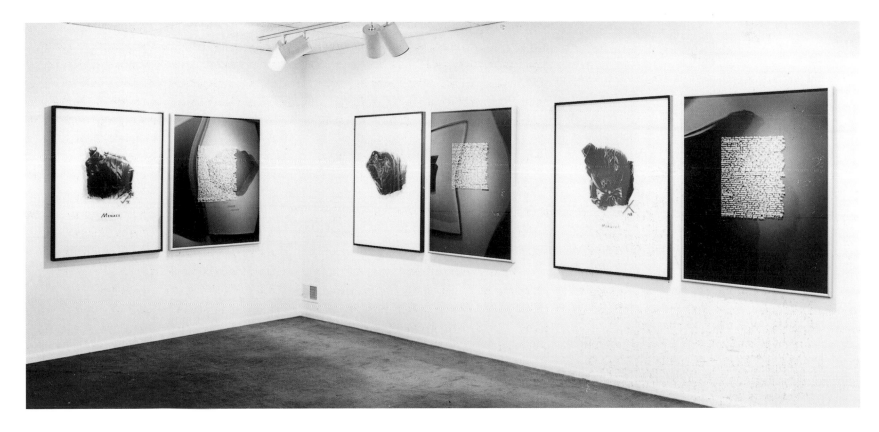

Interim, Part I: Corpus
1984–85
Laminated photo positive, silkscreen, acrylic on Plexiglas
6 of the 30 panels,
90 × 122.5 cm each
Installation, Henry McNeil Gallery, Philadelphia, 1988

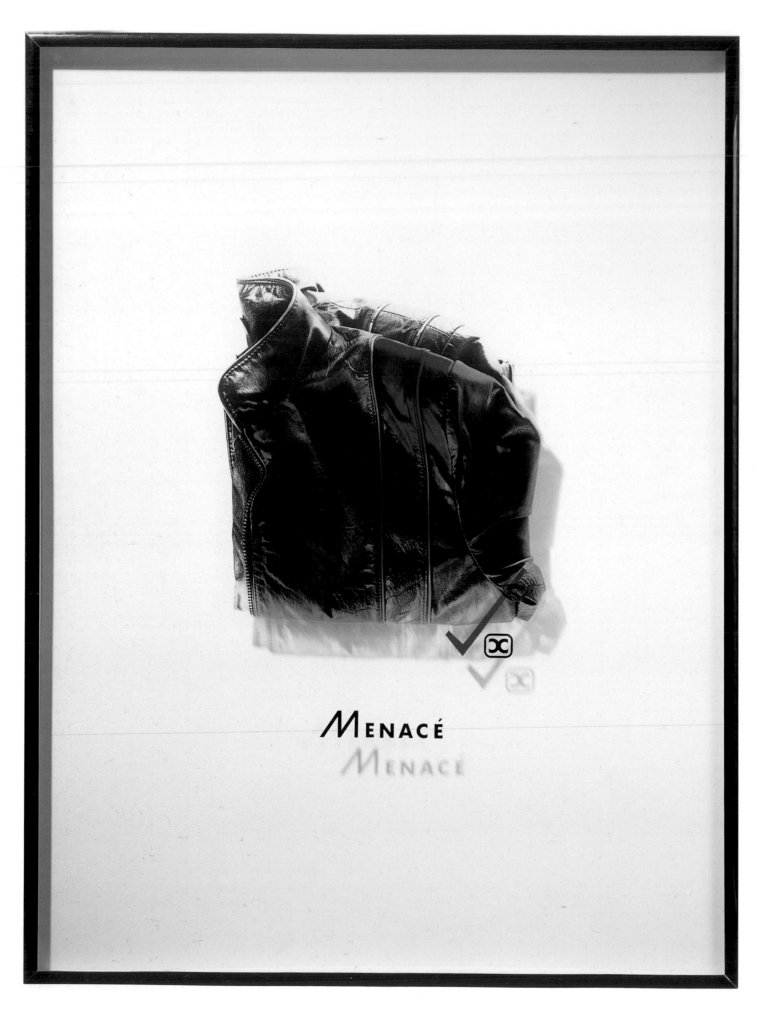

Interim, Part I: Corpus
(details, **Menacé**)
1984–85
Laminated photo positive,
silkscreen, acrylic on Plexiglas
2 of the 30 panels,
90 × 122.5 cm each

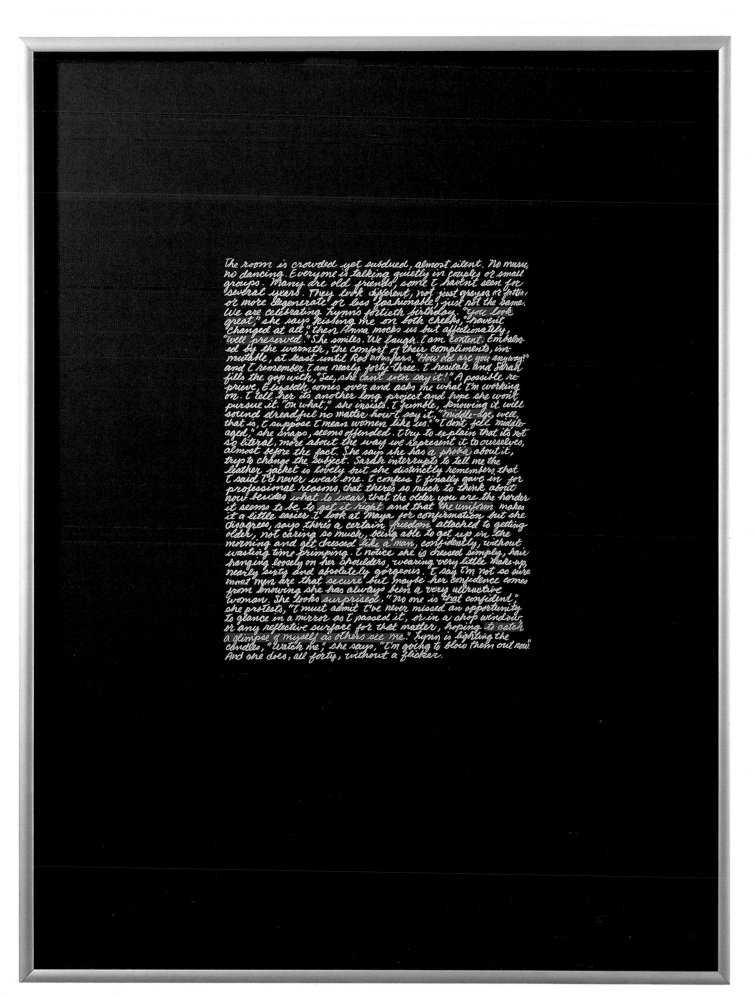

The room is crowded yet subdued, almost silent. No music, no dancing. Everyone is talking quietly in couples or small groups. Many are old friends, some I haven't seen for several years. They look different, not just greyer or fatter, or more degenerate or less fashionable, just not the same. We are celebrating Lynn's fortieth birthday. "You look great," she says, kissing me on both cheeks, "haven't changed at all," then Anna mocks us but affectionately, "well preserved." She smiles. We laugh. I am content. Embalmed by the warmth, the comfort of their compliments, immutable, at least until Rod whispers, "How old are you anyway?" and I remember I am nearly forty-three. I hesitate and Sarah fills the gap with, "See, she can't even say it!" A possible reprieve, Elizabeth, comes over and asks me what I'm working on. I tell her it's another long project and hope she won't pursue it. "On what," she insists. I fumble, knowing it will sound dreadful no matter how I say it. "Middle-age, well, that is, I suppose I mean women like us." "I don't feel middle-aged," she snaps, seems offended. I try to explain that it's not so literal, more about the way we represent it to ourselves, almost before the fact. She says she has a phobia about it, tries to change the subject. Sarah interrupts to tell me the leather jacket is lovely but she distinctly remembers that I said I'd never wear one. I confess I finally gave in for professional reasons, that there's so much to think about how besides what to wear, that the older you are the harder it seems to be to get it right and that the uniform makes it a little easier. I look at Maya for confirmation but she disagrees, says there's a certain freedom attached to getting older, not caring so much, being able to get up in the morning and get dressed like a man, confidently, without wasting time primping. I notice she is dressed simply, hair hanging loosely on her shoulders, wearing very little make-up, nearly sixty and absolutely gorgeous. I say I'm not so sure most men are that secure but maybe her confidence comes from knowing she has always been a very attractive woman. She looks surprised. "No one is that confident," she protests, "I must admit I've never missed an opportunity to glance in a mirror as I passed it, or in a shop window, or any reflective surface for that matter, hoping to catch a glimpse of myself as others see me." Lynn is lighting the candles, "Watch me," she says, "I'm going to blow them out now." And she does, all forty, without a flicker.

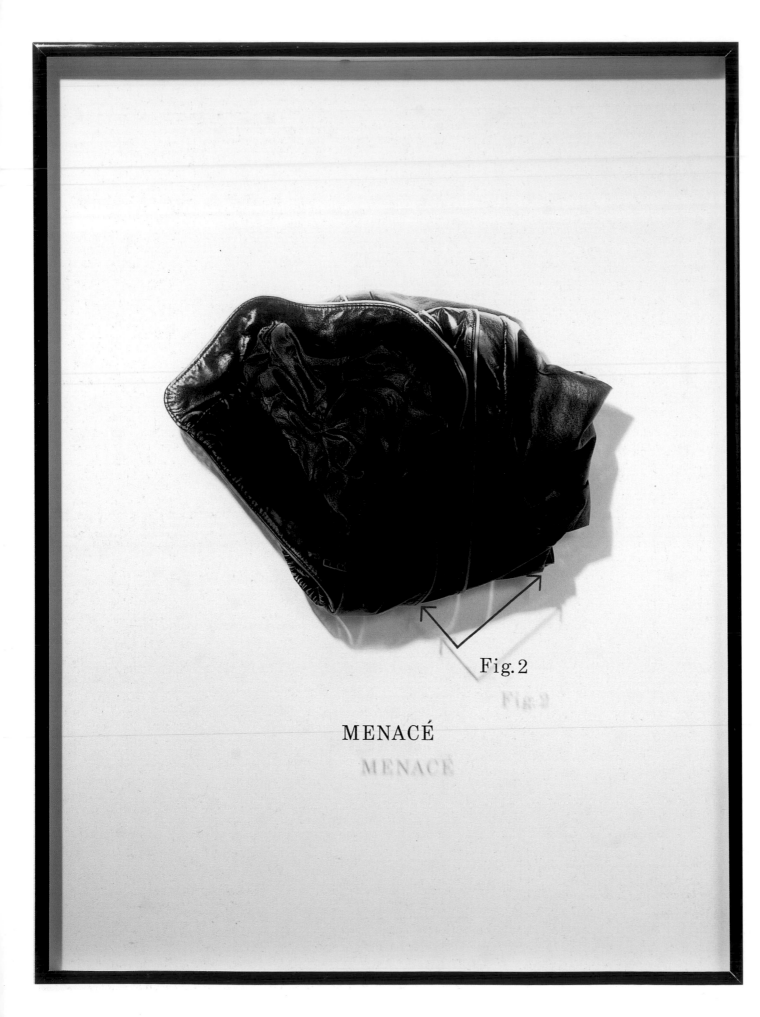

Interim, Part I: Corpus
(details, **Menacé**)
1984–85
Laminated photo positive,
silkscreen, acrylic on Plexiglas
2 of the 30 panels,
90 × 122.5 cm each

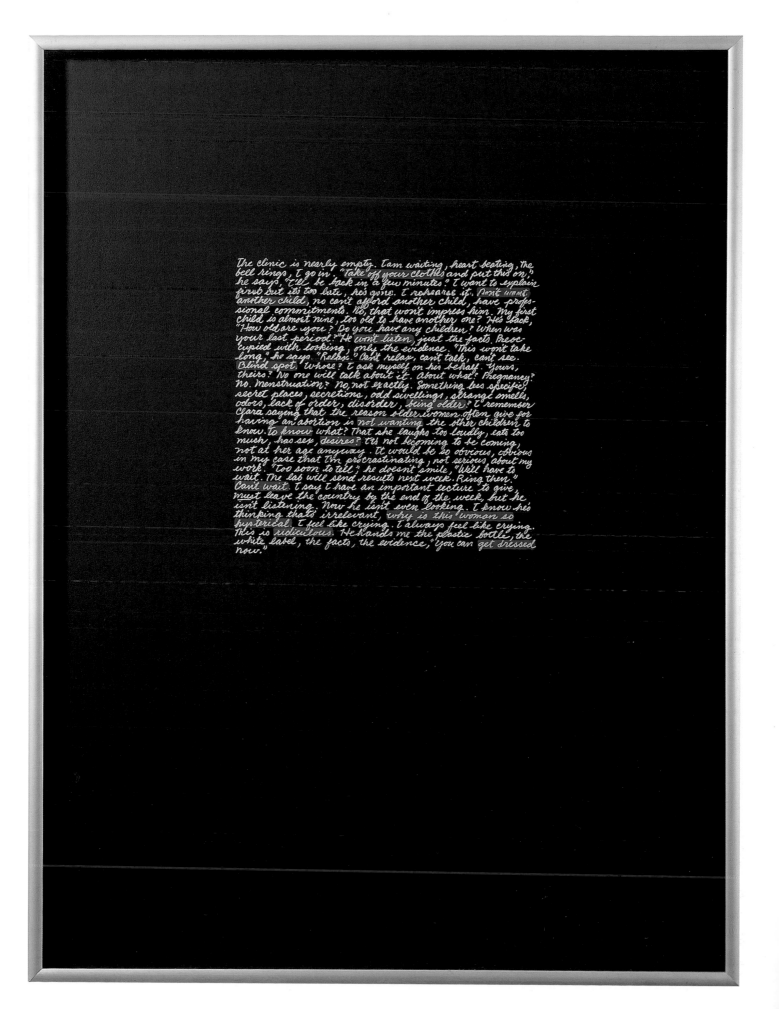

The clinic is nearly empty. I am waiting, heart beating, the bell rings, I go in. "Take off your clothes and put this on," he says, "I'll be back in a few minutes." I want to explain first but it's too late, he's gone. I rehearse it. Don't want another child, no can't afford another child, have professional commitments. No, that won't impress him. My first child is almost nine, too old to have another one? He's back, "How old are you? Do you have any children? When was your last period?" He won't listen, just the facts. Preoccupied with looking, only the evidence. "This won't take long," he says. "Relax." Can't relax, can't talk, can't see. Blind spot. Whose? I ask myself on his behalf. Yours, theirs? No one will talk about it. About what? Pregnancy? No. Menstruation? No, not exactly. Something less specific; secret places, secretions, odd swellings, strange smells, odors, lack of order, disorder, being older? I remember Clara saying that the reason older women often give for having an abortion is not wanting the other children to know. To know what? That she laughs too loudly, eats too much, has sex, desires? It's not becoming to be coming, not at her age anyway. It would be so obvious, obvious in my case that I'm procrastinating, not serious about my work. "Too soon to tell," he doesn't smile, "We'll have to wait. The lab will send results next week. Ring then." Can't wait. I say I have an important lecture to give, must leave the country by the end of the week, but he isn't listening. Now he isn't even looking. I know he's thinking that's irrelevant, why is this woman so hysterical. I feel like crying. I always feel like crying. This is ridiculous. He hands me the plastic bottle, the white label, the facts, the evidence, "you can get dressed now."

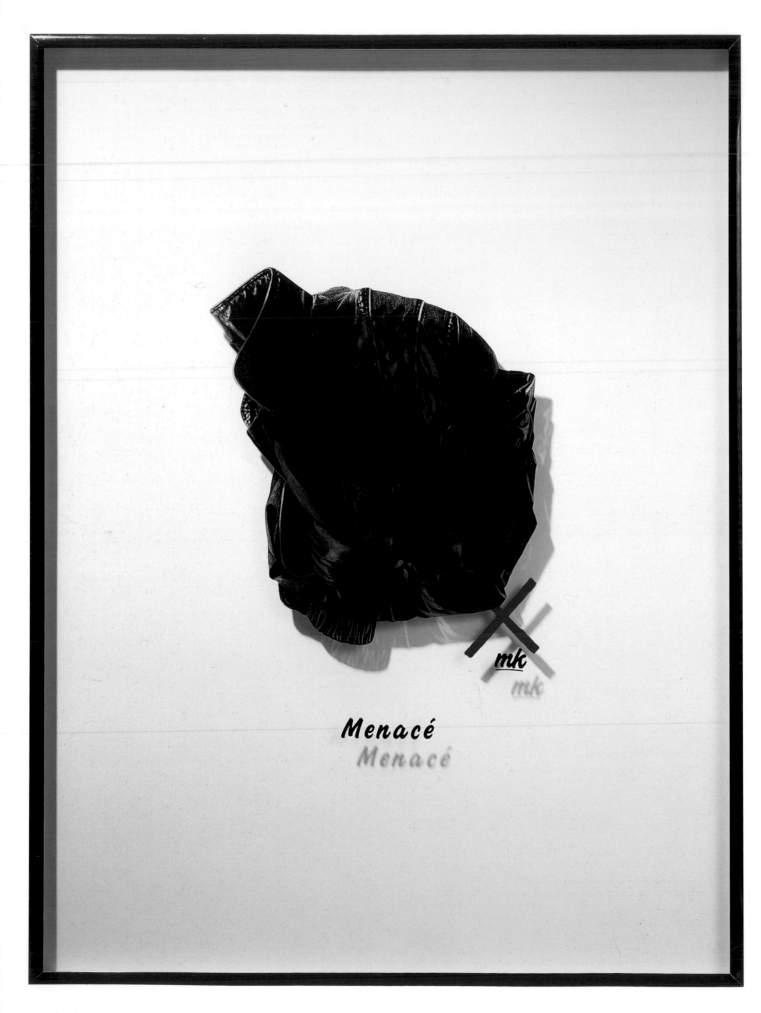

Interim, Part I: Corpus
(details, **Menacé**)
1984-85
Laminated photo positive,
silkscreen, acrylic on Plexiglas
2 of the 30 panels,
90 × 122.5 cm each

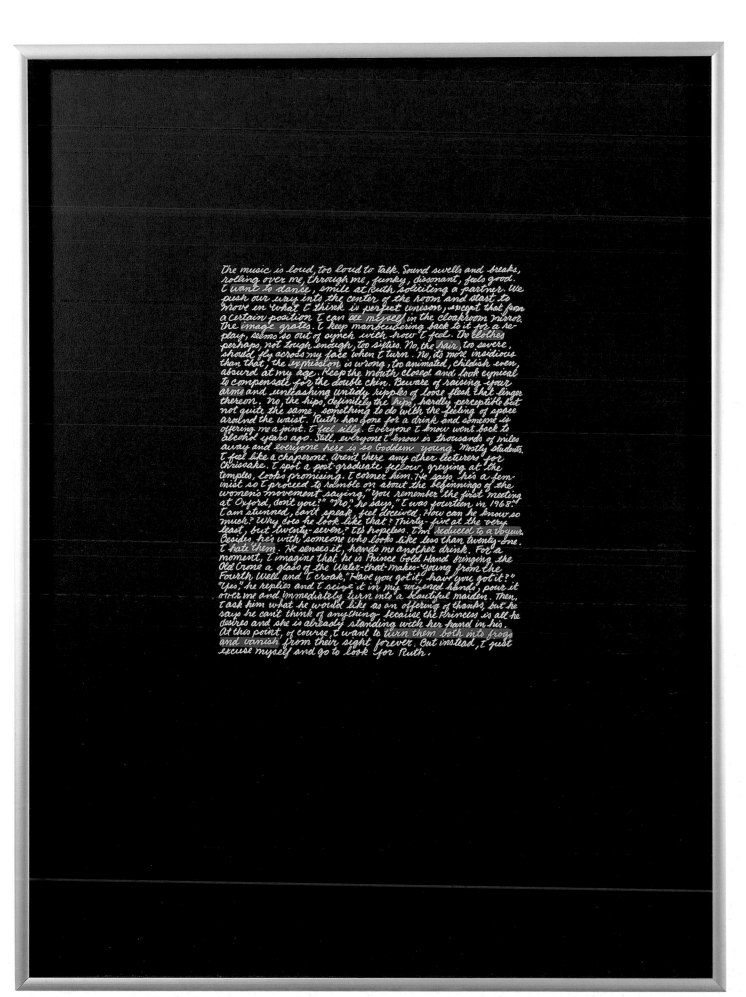

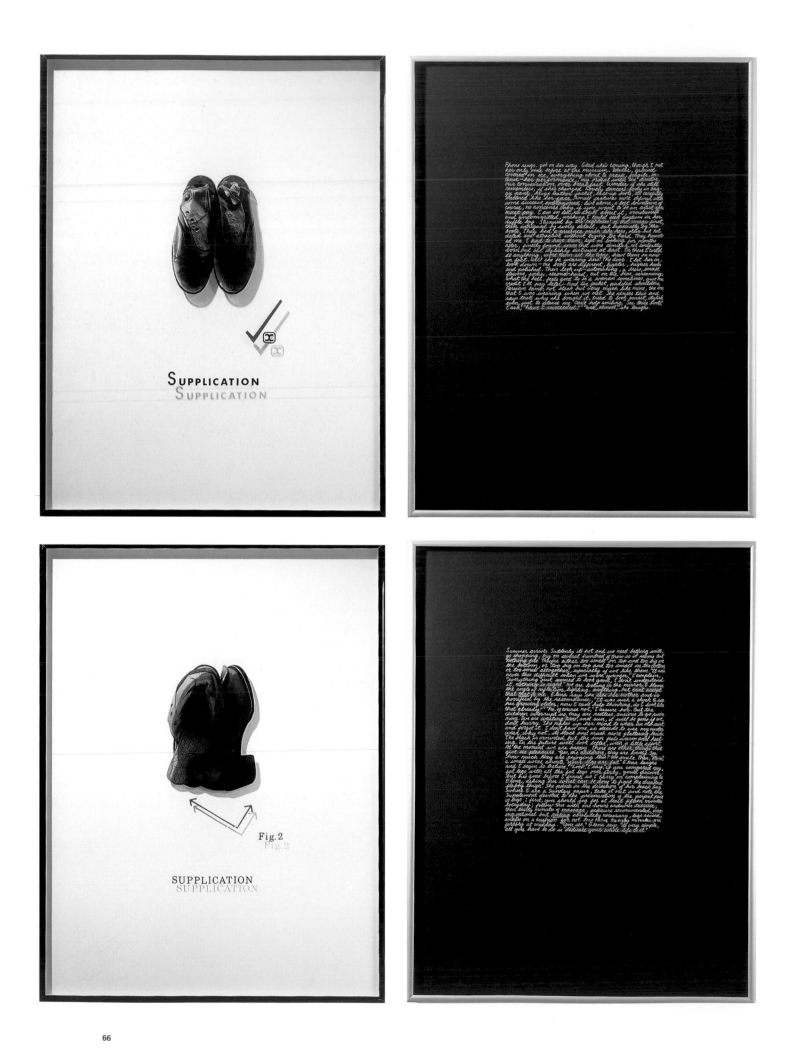

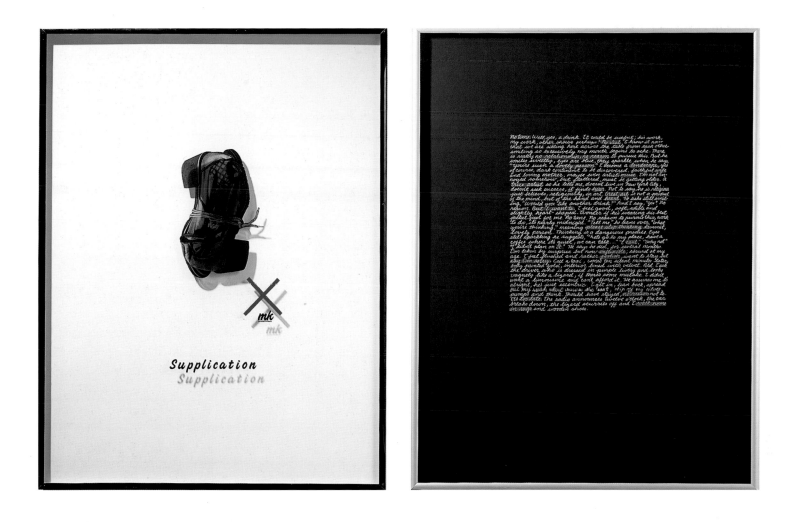

fashion series, emblazoned all over with the logo of its designer, is here collapsed (prolapsed?) forward and opened wide so that it resembles a uterus under examination. The text panel paired with the bag motif describes the horror and fascination of graphic illustrations of the ageing process on a woman's self-help manual. Yet the Real of the body, at this stage, is not all ageing and death. One of the text panels in this series describes a visit to a luxurious 'women only' health spa where clothes, separate identities and dignity are checked in the locker room for a sensuous oceanic experience of oneness with others mixed with water and steam. This is a utopian vision of a pleasurable, feminine bodily experience, perhaps reminiscent of the repressed maternal body. This

and other stories of pleasurable meetings with women friends may relate to a statement made by the analyst Michèle Montrelay, and endorsed by Kelly: 'The adult woman is one who reconstructs her sexuality in a field that goes beyond sex.'[35] Or, as Kelly puts it elsewhere, a woman must acknowledge that 'being a woman is only a brief moment in her life'.[36]

If classical perfection has given way to warts-and-all realism in the first two modalities of the triptych, then the third in the set, governed by 'romantic fiction', can only be described as baroque. It is the most hysterically convulsive and hallucinogenic. The garment motifs are knotted and twisted in bizarre configurations that recall the exaggerated folds Bernini gave to the gown of

Interim, Part I: Corpus
(details, **Supplication**)
1984-85
Laminated photo positive,
silkscreen, acrylic on Plexiglas
6 of the 30 panels,
90 × 122.5 cm each

Clemente Susini and Giuseppe Ferroni
La Donna delle Specola di Firenze
1782
Wax
Lifesize

Saint Theresa. They suggest acute anxiety, perhaps a touch of sado-masochism, and certainly a flight from normative strictures. It is possible to imagine in them fantastic anatomies like the wasp waists and swan necks of romantic fiction. The beautiful image of a summer dress tied at the waist was apparently inspired by shop window displays which frequently show impossibly cinched waists. The pair of boots bound together with its laces suddenly recalls a famous surrealist sculptural icon: Meret Oppenheim's pair of high heels upside-down and trussed like a chicken ready for roasting; *Ma Gouvernante, My Nurse, Mein Kindermächen* (1936). The 'cathected zones' of these motifs are areas crosshatched, a conventional graphic means

of rendering shadow. Here the reference might be to moody chiaroscuro or to the very artifice of fine art. Certainly the texts paired with these panels push anti-realism to an extreme; they deal with love, sex, sensuous pleasure and have ludicrous fairy-tale endings. In one, the narrator imagines, after declining a flattering proposition, that she is Cinderella rushing from the ball in a chauffeur-driven limousine. 'The radio announces twelve o'clock, the car breaks down, the lizard scurries off and I walk home in rags and wooden shoes'.

This summary of the three modalities suggests that they are not only themes distilled from women's magazines, but a catalogue of the ways the invisible, dispersed body of desire might be represented. Feminine desire beyond or outside maternal femininity is refracted by Kelly through the three registers of Lacan's model of the unconscious. The body is the raw material for the creation of an imaginary perfection addressed to another. Yet this mask conceals an anxious underside, the real of the body and the fragmenting drives. This real might also be more positively figured as the faint residue of our undifferentiated pre-Oedipal attachment to the maternal body. The Lacanian symbolic is figured here not as patriarchal language and social law but as a kind of 'hysterical' literary protest against that regime. Romantic fiction is a pop-cultural version, for Kelly, of *écriture feminine* (and, of course, a distancing parody of it) with its eruptions of a repressed maternal voice and reverberations of an excessive feminine pleasure or *jouissance*. The 'romantic fiction' panels speculate on the possibility on a kind of writing or visual art which

Gianlorenzo Bernini
Ecstasy of Saint Theresa
1646-52
Marble
h. 350 cm
Santa Maria della Vittoria, Rome

Meret Oppenheim
Ma Gouvernante, My Nurse, Mein
Kindermächen
1936
Mixed media
14 × 21 × 33 cm

evades normative strictures and imagines another self, another future responsive to woman's desire.

Pecunia

I have given disproportionate attention to Part I of *Interim*, mainly because it is the largest and most complex of the four parts, partly because it raises acutely the issues surrounding hysteria and partly because it illustrates best my particular interest in Kelly's surrealist inheritance. Although Part II of *Interim* is called *Pecunia* (Money), it is less about money than the way the older woman's problematic sense of her identity hinges on the objects she desires. It offers a highly original contribution to the debates surrounding woman's position as both object of exchange and subject of consumption. We see these two positions refracted through four social positions mapped out for her: mother, daughter, sister and wife. These are spelt out in Latin on the five units of the four sections. The series is made up of cleverly folded, 'pop-up' pieces of galvanized steel, treated in such a way that they have the glitzy iridescence of greeting cards. The texts silkscreened inside the 'cards' are scenes from the everyday life of everywoman, punchy suggestions on how to make a million dollars, and classified ads. Some of the narratives are horribly familiar: there is the self-sacrificing mother who has 'postponed her life' and the housewife whose idea of happiness is a perfectly clean toilet bowl, emblem of her independent identity – 'Now everything would be her way'. Or, there is the woman who, finding herself in the position of having to be the family breadwinner, feels deeply ambivalent about it.

Like *Corpus*, this section is about the question of identity for women, but here it is elaborated not in terms of hysteria, but rather in terms of 'coprophilia'. This section does not concern identity as it relates to her self-image, but as it hinges on the objects she desires. Once again, the troubling proximity of the mother's body is behind the symptom. For Kelly, this proximity and 'its affective force constitutes a certain block or failure in the process of repression, and coprophilia is the symptomatic consequence'.[37] Kelly argues that at different stages in a woman's life, different fantasies predominate. The young woman's fantasy is narcissistic – she wants to present herself as the flawless, phallic object for the Other. The maternal fantasy is of completion through the baby's body which is the phallus for her. What then of the older woman? Kelly suggests that she may turn to certain child substitutes (pets) or possessions or pride in the arrangement of her household objects. And this indicates a regression along the series of Freud's unconscious equivalences baby = phallus = faeces. Faeces is the object of pleasurable retention (possession), par excellence. The sublimation of that pleasure is the fantasy of completion through collecting things. Yet the coprophilic regression may also incite fresh repression and reaction-formations – that is, coprophobia. The sublimation of coprophobia is excessive cleanliness or orderliness. A key theoretical source for this section is an essay by the analyst and close associate of Freud, Sandor Ferenczi, called 'The Ontogenesis of the Interest in Money' which argues that any explanation of capitalist behaviour must take account of the

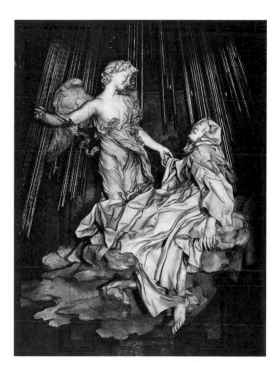

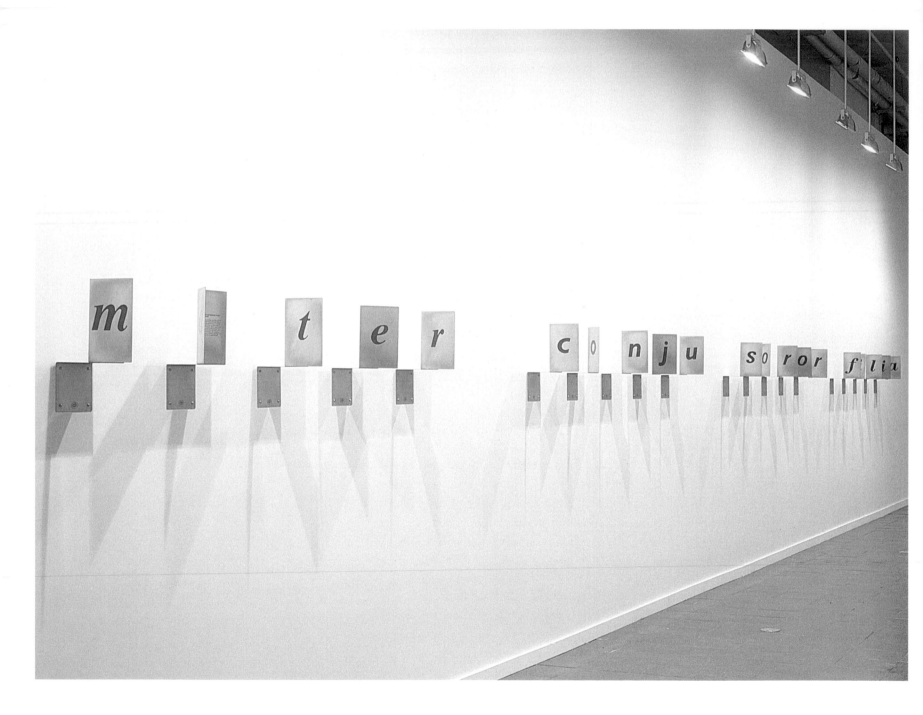

Interim Part II: Pecunia
1989
Silkscreen on galvanized steel
20 units, 40 × 16 × 29 cm each
Installation, New Museum of
Contemporary Art, New York, 1990
Collection, Vancouver Art Gallery

irrational element of anal-eroticism.[38]

In *Pecunia* the coprophilic or phobic psychic economy is geared into a cultural form in which women have difficulty stepping into the world of money-making, taxation, savings, pension schemes and so on – some because they are poor, others because they are brought up to be dependent. The other social matrix which organizes the section is familial. Kelly's source for this is Michel Foucault's *History of Sexuality, Vol. I*. For Foucault, the family in the modern period, far from being an institution which represses sexuality, is actually one that 'deploys' and channels it. Doctors, educationalists and finally psychoanalysts support this process: 'Then these new personages made their appearance: the nervous woman, the frigid wife, the indifferent mother … the impotent, sadistic, perverse husband, the hysterical or neurasthenic girl … '[39] For Foucault, familial relations are the erogenous zones of society.

This sketch of the theoretical armature of *Pecunia* enables us to understand better how the ideas, stories and visual form of the work fit together. Kelly has stated that the piece is based on greeting cards which are sent on those occasions – birthdays, weddings and holidays – when the familial erogenous zones become inflamed and their iridescent surface is meant to evoke 'the look of sentiment'. But that shiny surface is also an allusion to money and its close tie with coprophilia. Ferenczi observed that the sublimation of infantile coprophilia involves a progressive negation of all the qualities of excrement – odour, stickiness, dark dullness. He

concludes that money is 'nothing other than odourless, dehydrated filth that has been made shiny' and appends the Latin tag *Pecunia non olet* (Money doesn't smell).[40] Kelly uses the tag as a logo for her cards but makes the ambivalence of the saying more obvious by crossing out 'non'.

The wife's section of *Pecunia* provides us with thumbnail sketches of one coprophilic and one coprophobic character. The former is a woman who is surveying a prospective home that does not quite match her fantasied ideal. She imagines costly improvements that would make it 'perfect'. A small, dank kitchen is instantly transformed: 'she'd add a skylight, then a granite counter, a porcelain sink, refrigerator, freezer, Aga range'. These clean and shiny metallic surfaces are the woman's sublimation of anal eroticism. The insistence on aesthetic perfection provides an idealizing aura around what is fundamentally a perverse pleasure.

This regressive eroticism can provoke a 'reaction-formation' and the other wife's story in *Conju* exemplifies this condition. Ernest Jones, in his 'Anal-Erotic Character Traits', refers to 'housewife psychosis' in terms of the characteristic rhythm of retention and sudden pleasurable release, but more pertinent in this context is Freud's own 'Character and Anal Eroticism' and his account of the counter-forces or dams of shame and disgust which block excitement from zones or objects 'unserviceable for sexual aims'.[41] These dams are, of course, the agencies of repression, and so we are returned to the problematic of feminine identity and her unresolved relation to pre-genitality and the mother's body. Disgust is

Interim Part II: Pecunia (details, **Conju**)
1989
Silkscreen on galvanized steel
5 units, 40 × 16 × 29 cm each
Collection, Vancouver Art Gallery

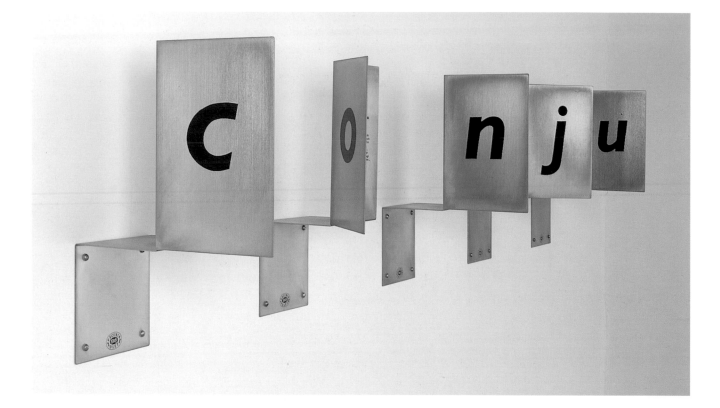

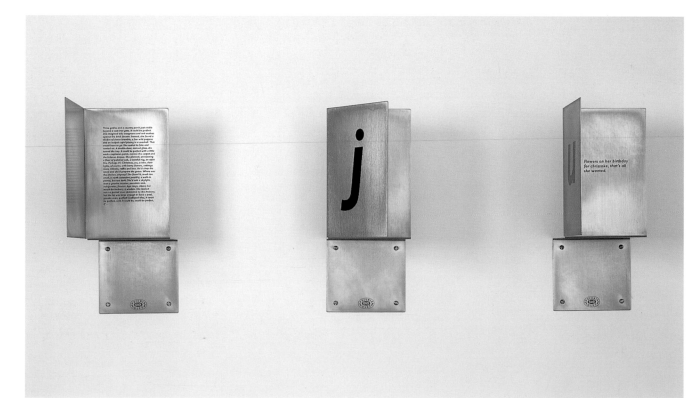

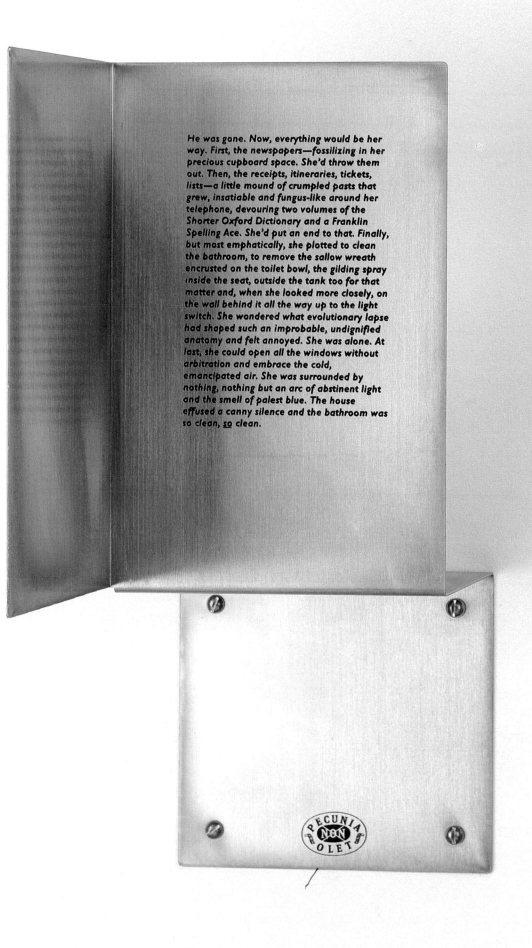

He was gone. Now, everything would be her way. First, the newspapers—fossilizing in her precious cupboard space. She'd throw them out. Then, the receipts, itineraries, tickets, lists—a little mound of crumpled pasts that grew, insatiable and fungus-like around her telephone, devouring two volumes of the Shorter Oxford Dictionary and a Franklin Spelling Ace. She'd put an end to that. Finally, but most emphatically, she plotted to clean the bathroom, to remove the sallow wreath encrusted on the toilet bowl, the gilding spray inside the seat, outside the tank too for that matter and, when she looked more closely, on the wall behind it all the way up to the light switch. She wondered what evolutionary lapse had shaped such an improbable, undignified anatomy and felt annoyed. She was alone. At last, she could open all the windows without arbitration and embrace the cold, emancipated air. She was surrounded by nothing, nothing but an arc of abstinent light and the smell of palest blue. The house effused a canny silence and the bathroom was so clean, _so_ clean.

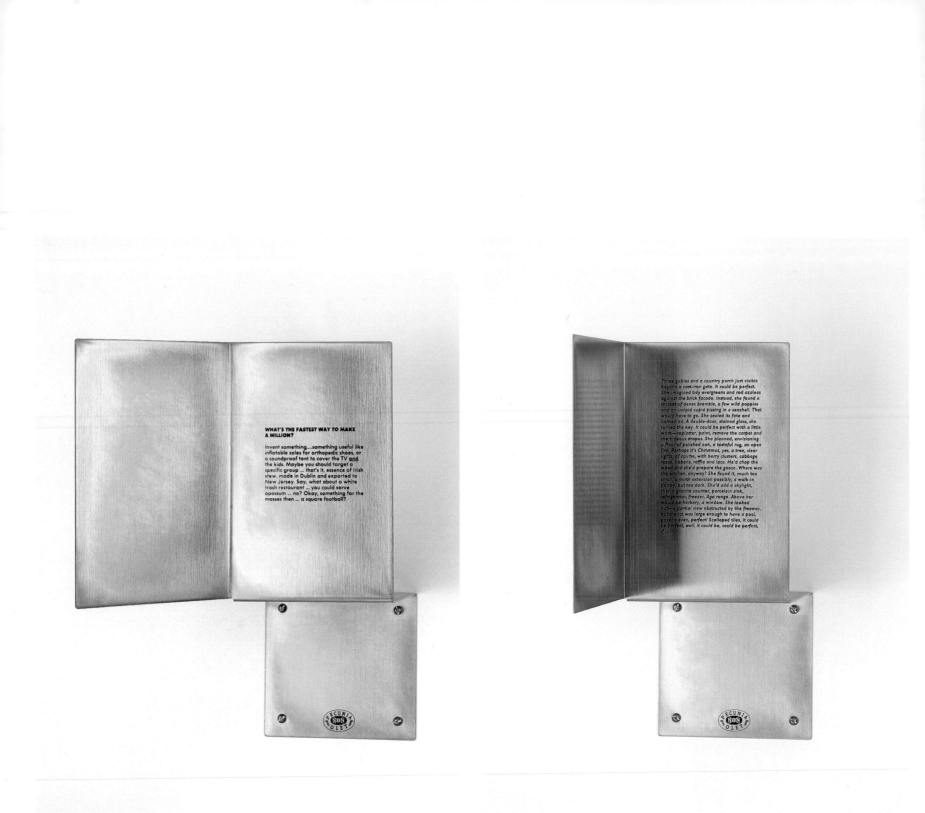

Interim Part II: Pecunia (details,
Conju)
1989
Silkscreen on galvanized steel
5 units, 40 × 16 × 29 cm each
Collection, Vancouver Art Gallery

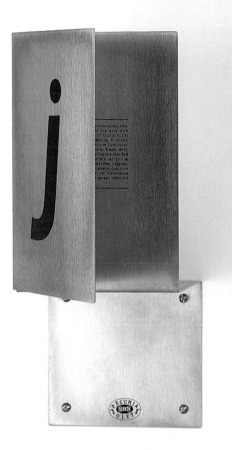

above, left, **Richard Serra**
Floor Pole Prop
1969/78
Antimonium leaden sheet propped
against the wall by rolled up
antimonium leaden sheet
Sheet, 241.5 × 254.5 × 1.5 cm
Roll, 250 × ø 15 cm

above, right, **David Smith**
Cubi XIX
1964
Stainless steel
287× 156 × 105 cm

the motive that drives the behaviour of the other wife in *Conju* who, in the absence of her husband, cleans the Augean stables of their house, particularly the toilet bowl and surrounds. Finally revelling in its antiseptic brightness, she stands in 'an arc of abstinent light and smell of palest blue' and fantasizes a transfigured, clean, whole, perfect self. The visual form of the work evokes bright, shiny commodities and make artistic reference to 'clean' minimalist sculpture. But the inscription on these objects of stories which evoke archaic coprophilic eroticism means that the psychic use-value of the woman's things is thrown into relief. Her desire is set at a distance. As Kelly observes, 'by taking herself out of circulation she, the spectator, is no longer the object of exchange, but the subject or author of the transaction'.[42] We learn a great deal more about the psychic economy underlying desublimatory gestures both in and outside art practice from *Pecunia's* intricate account of excremental sublimation than from the mere transgressive gesture offered as art.

Historia and *Potestas*

The fictional narratives of *Corpus* and *Pecunia* contrast with the 'true stories' of Part III, *Historia*. Identification here is about the assumption of a political identity in the women's movement and again, Kelly presents not a monolith of the collectivity of women, but four consecutive and parallel personal histories told by four generations of feminists since 1968. The texts in this section offer a Utopian vision of political, ethnic and age differences subsumed within a jubilant common gender identity, and they also question this

aspiration. Formally, the *Historia* series looks like either open books or newspaper galleys, recording what might otherwise have been hidden from history, and also like tomb stones, monuments to the courage of those who have gone before. A fragmented silkscreened photograph of a suffragette from 1905 opens each section. The last part, *Potestas* (power), presents a graph showing the worldwide relative position of men and women with respect to wealth and power. The relief-like structure on the wall is made up of contrasting metal bars which evoke, for men, the work of abstract expressionist sculptor David Smith, and for women, the rusted surfaces of Richard Serra's much-maligned minimalist prop pieces. Although the work as a whole is deeply informed by psychoanalytic and Foucauldian theory, it does not rest content with representing the circumstances of women's oppression. Self-transcendence is presented as a possibility within the history of the women's movement.

The same year as she began work on *Interim*, Mary Kelly published a beautiful, subtle essay called, 'Desiring Images/Imaging Desire'. It ends with a paragraph in which she positions herself theoretically in relation to those feminists who want to excavate an essential femininity behind the patriarchal facade, and those that conceive of femininity as a mask one can wear and cast off at will. These views have different conceptions of the relation of the female spectator to representation: 'Until now the woman as spectator has been pinned to the surface of the picture, trapped in a path of light that leads her back to the features of a veiled face. It is important to acknowledge the

masquerade that has always been internalized, linked to a particular organization of the drives, represented through a diversity of aims and objects; but at the same time, to avoid being lured into looking for a psychic truth beneath the veil. To see this picture critically, the viewer should be neither too close nor too far away.'[43]

The stories and images of *Interim* point back to the maternal body, yet stop short of finding at the vanishing point of desire the basis for a unitary, fixed feminine identity. That would be standing too close. On the other hand, she cautions, the masquerade is not a fashion parade, not the quick change artistry of a famous female pop star. Rather, its many manifestations have deep psychic roots and unless we recognize this element of unconscious determination, we are too far away.

Paranoia and *Gloria Patri* (1992)

One of the most striking images of *Corpus* is of the glossy, smoothed-down black leather jacket, the artist's equivalent of the businesswoman's tailored suit, which mimes male attire and points to the importance of identification with the father. One of the paths through the Oedipal complex in girls as described by Freud is the 'masculinity complex', in which she identifies with the paternal ideal and stubbornly resists the imputation that she has not got the Phallus. In fantasy, she does, and so presumably do men, whose penis inevitably falls far short of the Phallus. In *Gloria Patri*, Kelly analyses the masculinity complex in men and women against the background of the Gulf War.[44] We can now see that the series of Kelly's

installations follows a strict logic – from maternal femininity, to the troubled but potentially liberating ambivalence of the post-maternal woman's sense of identity (Am I a man or a woman?), and finally to the assumption of masculine identity by both men and women.

Kelly's own glosses on the work centre on the narcissistic dimension of masculinity, that is, how it is set up through the internalization of a masculine ego ideal. Key texts for her are Lacan's 'Mirror Stage' and 'Reflections on the Ego', although, once again, Kelly assumes a critical rather than merely illustrative stance vis-à-vis this material. What Lacan offers as an account of ego-formation in general, Kelly takes to be a certain masculine pathology of the ego. The masculinity of the Lacanian ego is particularly clear in the 1953 article 'Some Reflections on the Ego', in which he writes about the close relation between *Homo Psychologicus* and his machines, particularly his motor car. 'We get the impression that his relationship to this machine is so very intimate that it is almost as if the two were actually conjoined: its medical defects and breakdowns often parallel his neurotic symptoms. Its emotional significance for him comes from the fact that it exteriorized the protective shell of his ego, as well as the failure of his virility.'[45] The latter, I presume, when the car won't start.

Gloria Patri explores this pathology of the masculine ego in a context exacerbated by a state of war. Kelly attended to the media coverage of the Gulf War and the quite sinister spectacle of violent aggression set against a confused national position following the end of the Cold War. The

Arthur Elgort
My Uniform
1992
Artist's archival material for
Gloria Patri, Anne Klein
advertisement

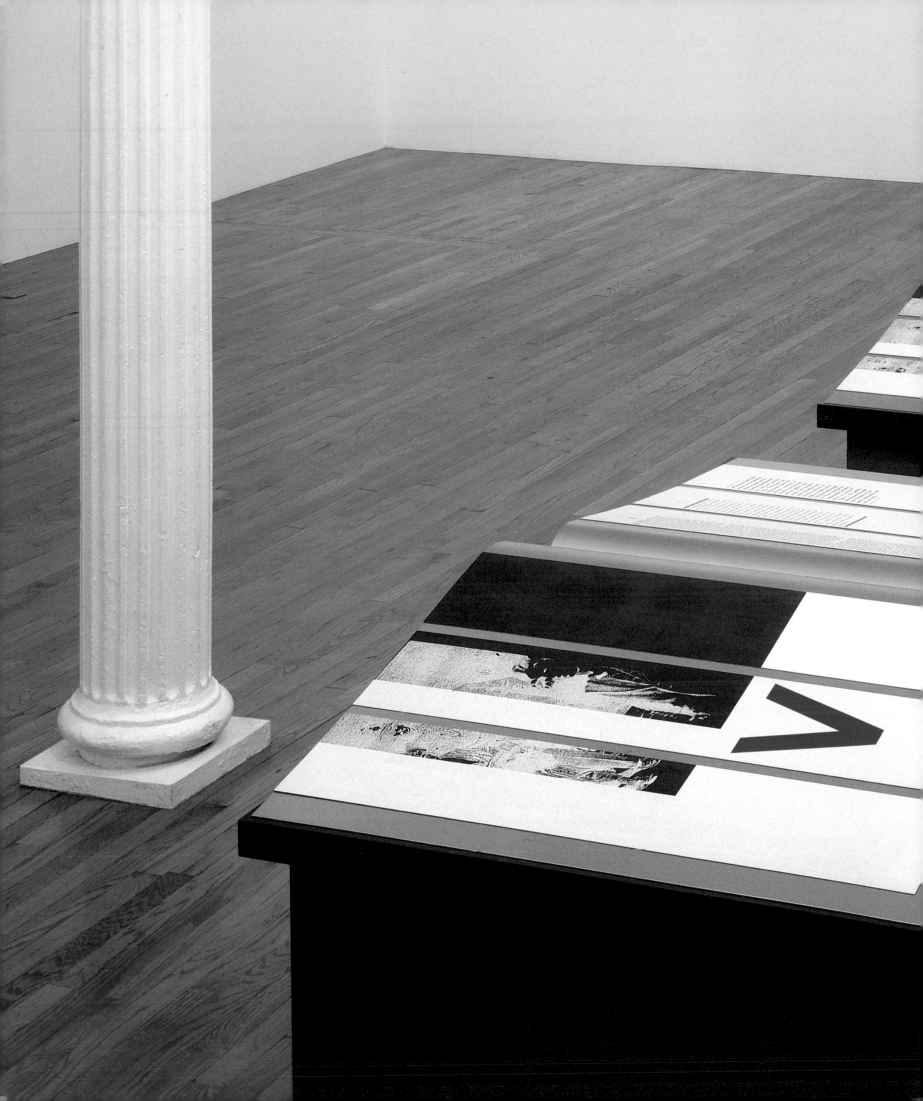

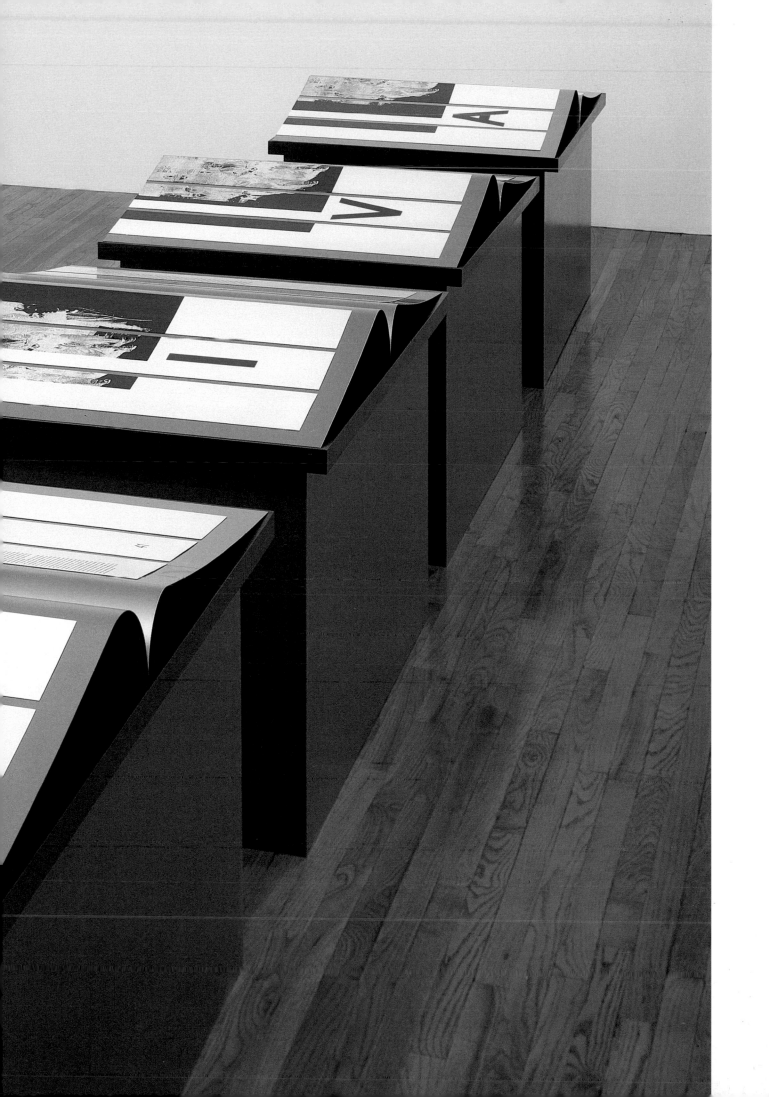

Interim Part III: Historia
1989
Oxidized steel, silkscreen,
stainless steel on wood base
4 units, 152.5 × 90 × 72.5 cm
each
Installation, Postmasters Gallery,
New York
Collection, Mackenzie Art Gallery,
Regina Saskatchewan

large, polished aluminium shields which make up part of the installation are meant, first, to evoke a pathological, armoured, masculine ideal and, second, to show this up as a facade. The narratives printed on the shields do the same; they are scenarios of failed masculinity taken not from war, but from everyday life. The other elements of the installation, all in polished aluminium, are twenty discs silkscreened with re-configured military logos and two-dimensional trophies, topped by male figurines in an archaic 1950s style. Its forbidding visual quality is heightened by 'search-beam' up-lighting. The whole visual effect is extremely intimidating, but this is counterpointed by the narratives themselves, which are sympathetic.

In theorizing the work, Kelly borrows a Lacanian concept, 'display', which is the masculine counterpart of the feminine masquerade, yet she emphasizes the lack of symmetry between the two. In the context of sexual relations, for instance, the feminine masquerade pretends to be lacking, while display pretends to repletion (having the Phallus). Furthermore, *display* according to Lacan has quite other functions beyond the sexual aim of luring the other. These are camouflage and intimidation, both of which have militaristic connotations. Camouflage means becoming invisible, like putting on a uniform. But the sacrifice of visibility is compensated by authority and rank within a total hierarchy. Klaus Theweleit has studied this phenomenon in the context of the proto-fascist *Freicorps* of the 1930s. The soldier gives up his individuality like a component and embraces the

Interim Part III: Historia (detail)
1989
Oxidized steel, silkscreen,
stainless steel on wood base
1 of the 4 units, 152.5 × 90 × 72.5
cm each
Collection, Mackenzie Art Gallery,
Regina Saskatchewan

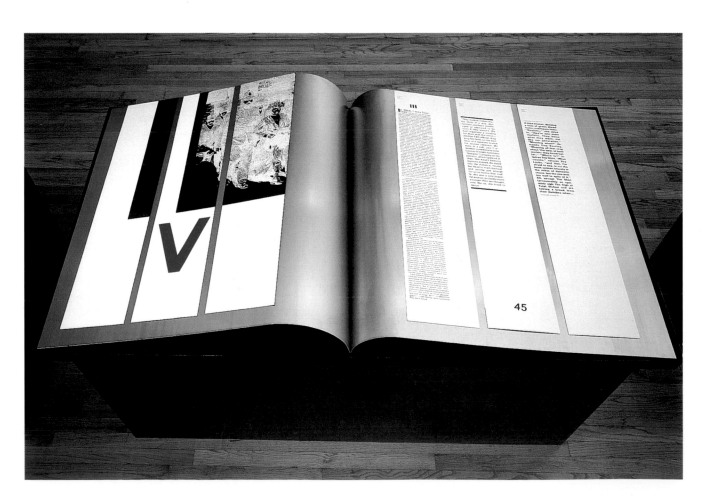

Interim Part III: Historia (detail)
1989
Oxidized steel, silkscreen,
stainless steel on wood base
4 units, 152.5 × 90 × 72.5 cm
each
Collection, Mackenzie Art Gallery,
Regina Saskatchewan

III

In 1968, I was four-**teen** and the anti-war movement was gaining momentum in Canada as a response to the government's complicity with the U.S. on Vietnam. Fourteen was an important year for me, because I was going through a personal change (adapting my physical presence to suit the so-called "youth culture" at that time) becoming part of a whole new social and political scene. We focused on a critical discussion of the family (of course, because of our age), but feminism didn't really happen for me until later. Although I remember vowing that I would never get married, and see, I stuck to it!

Anyway, the next step; I helped found a free school called Seeds, together with a group of friends from the hippie street-scene. It brought together a *really* interesting combination of people—some middle-class kids, some from working-class families, others that were more lumpen and a lot of runaways. Most of them were bright but disillusioned with the school system and authority structures. So, we started to ask controversial cultural figures to teach us (after school or on weekends) and, we would *learn*.

Then, at 16, I dropped out of school myself and left home. I had this rather idealized notion of what it would be like to be on my own, I guess. Somewhere in that year, I began to feel very unhappy about the way women were treated, both in my peer group and in leftist circles generally. I mean, I was promiscuous, but I wasn't experiencing that much pleasure. I didn't like the kind of constructs that were possible with these men, and I didn't like the kind of relationships I saw in my family. So, I think all that had a determinizing effect on me as far as feminism was concerned.

I remember the first time I went to the Toronto Women's Center. It was wonderful. That was around 1970. There had been the Abortion Caravan earlier, but I wasn't part of it. That was a whole other generation of feminists. For me, feminist ideas just disseminated, sort of "naturally." I never went through conscious-ness-raising. (I was a very pretentious little brat, I suppose.) Instead, I leapt right into theory. At that time there were a number of debates between Socialist feminists and other women—radical feminists, lesbian separatists and so on. I was really fascinated by their articulation of class and gender oppression. That seemed right on to me. Also, since I left home, I had to support myself. I'd worked in a number of horrendous clerical jobs and, over a two-year period, I'd become very interested in union organization.

One of the first actions I took part in was the Artistic Woodwork Strike, in 1972 I think. It was a very long strike by immigrant women working for a South African firm, and it was extremely violent. The police were very active in picket-line invervention. I was beaten up, thrown under a truck. I remember seeing myself on television (my coat was being ripped off), and I saw my friends and other workers on the picket-line sent to hospital with fractured limbs. *That* was really radicalizing.

At that time, I lived in one of the hippie epicenters of the city (we all slept together and debated politics incessantly). I even went to live on a farm at one point, but the utopian dream just wasn't working for me. So, one night I got in the pickup truck and drove away. I lived for two years in Latin America and eventually moved to Vancouver where a friend of mine was involved in organizing a feminist union. In 1974, we started the Association of University and College Employees, and by 1979 we were powerful enough to negotiate a merger with a larger union. Then we led a really disastrous strike action that resulted in a zero pay raise. Slowly, contracts were lost, and the union fragmented.

I was still part of the organized left, but I thought they had a huge problem. They were weak on feminism and had no position on sexuality. Finally I went to university, studied history and dabbled in psychoanalysis. but it wasn't until 1983, when the debates around pornography came out, that I started reading seriously (*Screen*, the article on visual pleasure, that sort of thing). All those behaviorist theories about looking, well, I just knew they were wrong.

"They looked indescribably tired; in a way, anonymous, perhaps middle-aged or appeared to be even if they weren't. We had organized a meeting for them with the union—another T&G official, dragging his heels on the business of a separate branch for women .cleaners. We were in a pub, yes, I remember something by John Lennon (it might have been "Imagine"), playing on the jukebox, when I glanced at Jean. She wasn't listening anymore. Instead, she stared into the distance, moving her head to mark the beat and smiling just enough for us to notice that, really, she was a very beautiful woman, probably much younger than we thought, and, like us, she loved to dance."

(continued from page 43)

A third woman, donning a halo of green dread-locks, overhears them. "Realistic," she joins in, "they're just more realistic. They know what they want, not like our generation." "Meaning what?" demands One Earring. "Meaning all that crap about 'the best of both worlds;' they know better," "Which is?" inquires The Shirt. "What counts," retorts The Locks, "and that, I'm afraid to say, is not the book written bravely in the midst of domestic chaos, but the one written well in spite of it." All, except The Shirt (presumably an optimist) sigh The Sigh of Total Defeat and are taking a break from their diatribes when...

(continued on page 47)

45

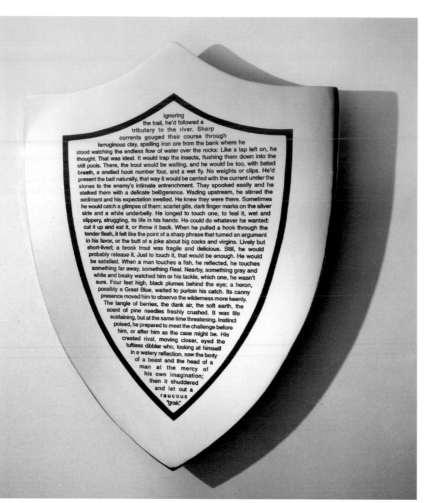

Gloria Patri (detail)
1992
Etched and polished aluminium
1 of the 5 shields,
73.5 × 61 × 6 cm each

wholeness he finds in the totality of the machine.[46] Display as intimidation is found in the natural world where, Lacan observes, the male animal swells up and gives himself 'something like a mask, a double, an envelope, a thrown-off skin, thrown off in order to cover the frame of a shield'.[47] Again, display as shield obscures the vulnerable body.

Clearly, display has largely to do with setting up a defensive structure of the ego. But Lacan's account of that process in the 'Mirror Stage' article has to do with the founding of the ego in a mirror double and the inevitable love/hate relationship with that ideal Other who is apparently more coordinated and spatially coherent. One's own chaotic infantile distress,

then, lines any coherent self-image and may be unleashed in fraternal rivalry, aggression and 'imagoes of the fragmented body'.[48] One can clearly see here how jubilant (mis)recognition in the mirror can flip over into hostile rivalry. This is partly because identification involves taking the other's place, that is, killing him. Just beneath the shock-proof shield of the ego, then, lies fear of the fragmented body and sheer aggression. It is a recipe for paranoia.

Although Kelly does not herself explicitly invoke paranoia, the issues raised by *Gloria Patri* – ego formation, homosexual love, rivalry and aggression – clearly relate to it. Kelly does refer to Jacqueline Rose's essay 'Why War?' on the Gulf War, where Rose considers the role of paranoiac projection in US President Bush's relation to Saddam Hussein. It may be an undecidable question whether the attack was motivated more by reality or fantasy – that, is by a projection, a newly desired enemy. Certainly, she notes, 'in more than one analysis, the problem for Bush was that, having called up the image of Hussein as utter monstrosity, he *had* to go to war'.[49] This sort of projection of a monster rival is a major mechanism of clinical paranoia, but Lacan extended the sense of this mechanism to the projection of what he calls, after Melanie Klein, 'bad internal objects' which may be imagoes of the fragmented body or the image of a severe or predatory parent.

Paranoia, rather than hysteria, was the pet mental illness of one of the Surrealists. Salvador Dalí read with interest Lacan's PhD thesis on the subject and Lacan acknowledged the acuity of

Dalí's reading. Dalí was prone to perceptive paranoiac projections; he saw the image of a severe father in Michelangelo's *Moses* and a predatory mother in Leonardo's *Mona Lisa*. More prosaic, and closer to the everyday pathologies of masculinity invoked by the texts of *Gloria Patri*, is his opening gesture in *The Secret Life of Salvador Dalí*. There he declares that when he smiles he never exposes 'horrible and degrading spinach' clinging to his teeth for the simple reason that he does not eat spinach. He goes on: 'I detest spinach because of its utterly amorphous character ... The very opposite of spinach is armour. That is why I like to eat armour so much ... , namely shellfish'.[50] This relates closely to Kelly's story on one of the shield panels of the young boy who refuses to eat his greens. The abject, formless greens on the plate represent within this paranoiac projection the mother's femininity and his own *informe*, vulnerable flesh. The boy does not demand lobster, but he is trying to construct a defensive exo-skeleton with his heavy metal techno music and identification with Arnold Schwarzenegger. In the end, his effort to abject the feminine in himself fails and he relents.

The imago of the body as abject, feminine, squishy green stuff, is one image of the underside of the masculine ego-shield. Theweleit's analysis of masculine pathology also involves a flight from the fleshy body coded as feminine: 'The most urgent task of the man of steel is to pursue, to dam in, to subdue any force that threatens to transform him back into the horribly disorganized bundle of flesh, hair, skin, bones, intestines and feelings that calls itself human.'[51] On the last of the series

of panels, Kelly invokes another sort of monstrous feminine imago, but one seen, as it were, from the inside. A woman straps herself in to a high tech exercise machine and readies herself to attack the enemy – her own flabby body and her rivals at work. One reads her story with horror and sympathy. She has internalized the paternal ideal and set up a severely self-punishing super ego. Kelly implicitly asks with this story if today's women have unconsciously incorporated a masculine ego ideal. If so, what price glory? If the classical symptoms of hysteria have all but disappeared in the West (the great exception being anorexia nervosa), has women's distress disguised itself as health? Has the theatre of the hysteric become the health club?[52] For the body-builder, as for the male characters, the poor fit of the exoskeleton causes considerable pain. In each of the stories an initially strong, masterful stance comes unstuck (except the woman's story, perhaps because the failure of her self-flagellation would have been too pathetic). The design of the installation also produces a double take. The icy cold polished aluminium components, more steely than steel, turn out to be raised from the wall emphasizing their facade-like thinness and hollowness. If the spectator is at first inclined to recognize him or herself in the position of mastery, the work will show this up for the misrecognition that it is. If, on the other hand, one is at first inclined to shrink from the intimidating spectacle, it will reveal the spectacle as a fraud. Kelly's critique of masculine mechanisms of defence links her work once more to the strategies of the Surrealists and their parodic play with

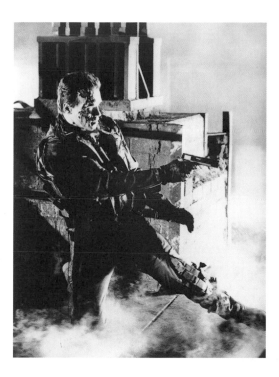

Arnold Schwarzenegger, in
James Cameron
Terminator II: Judgement Day
1991
136 mins., colour
Film still

Bad Girls
1994
Film poster
Dimensions variable

automatons, mannequins and robots.

In his 'Aggressivity in Psychoanalysis', Lacan suggests that the process of psychoanalysis involves breaking down the defences of the ego by inducing a 'controlled paranoia' in which fantasies of persecution, imagoes of the fragmented body and disguised acts of aggression against the analyst are unleashed, checked and held up within the analytic situation. Lacan cites Hieronymus Bosch's paintings as a catalogue of these imagoes.[53] *Gloria Patri* is also full of them. For example, snatches of Gulf War rhetoric printed on the trophies echo in the downbeat stories – for example, Schwarzkof's stated strategy for liquidating the Iraqi army, 'Cut it off and kill it', echoes the reflections of a lone fisherman stalking a brook trout, 'He could do whatever he wanted: cut it up and eat it or throw it back'. On another shield a man witnessing his son's birth suddenly projects a future when his son kills him. The body-building woman wants to 'cut off her sequacity and kill it'. Perhaps in the controlled situation of the art installation we may be provoked into unleashing a few imagoes of our own in order to reflect on the degree to which we, both men and women, are driven to forms of display and paranoiac projection in order to defend against our vulnerability.

Most art criticism informed by psychoanalysis has assumed the position of an analyst deciphering the work of art as if it were the artist's dream or symptom. Kelly's work makes it clear that this is the wrong orientation. Spectators come to works of art expecting to be told about themselves, assuming that the artist has the answer. Parveen Adams has argued that this expectation is particularly pronounced in the Kelly's work: 'going to the exhibition (of *Interim*) is like going to analysis', she writes.[54] Yet at the end of analysis one realizes that the analyst doesn't have the answer and this lack in the Other finally frees us from the fruitless quest for an irretrievable object that will satisfy desire. Similarly, we leave Kelly's installations much more reflexive about the identities we try on, the things we think might make us whole and the fantasies we entertain about others. This process takes time and, for it to work, the spectator must have space to engage his or her own fantasy. This explains why Kelly's work is formally discreet. The new theatres of fetishism, hysteria and paranoia – advertising and Hollywood cinema – are full-colour, vision-filling spectacles. Around them has developed a sophisticated and insightful theoretical discourse. Mary Kelly's work is positioned between these domains, neither repeating the seductive lures of the media, nor presenting a purely abstract argument, but rather offering us the opportunity to reflect on the objects of our desire.

1 Juliet Mitchell, *Psychoanalysis and Feminism*, Penguin Harmondsworth, 1974 and Laura Mulvey, 'Visual Pleasure and Narrative Cinema', reprinted in *Visual and Other Pleasures*, Macmillan, London, 1989

2 Mary Kelly, *Imaging Desire*, MIT, Cambridge, Massachussetts, and London, 1997, p.xx

3 Ibid., p. xxiv

4 Terence Maloon, Interview with Mary Kelly, *Artscribe*, New York, no. 13, 1978

5 See Mary Kelly, *Post-Partum Document*, Routledge, London, 1983. This is the complete installation translated into book form.

6 Mary Kelly, 1997, op. cit., p.45

7 The fort/da game refers to the game invented by Freud's grandson which involved throwing a cotton reel tied to a bit of string into his curtained cot and then retrieving it. Freud thought the game was a kind of working through of the shock of separation from the mother. See Sigmund Freud, 'Beyond the Pleasure Principle' (1920), Pelican Freud Library, London, vol. 11, *On Metapsychology*, pp. 269–338.

8 Mary Kelly, op.cit., 1997, p.188

9 Octavio Paz, '*Water Writes Always in * Plural', *Marcel Duchamp: Appearance Stripped Bare*, Seaver Books, The Viking Press, New York, 1978, p.94

10 Mary Kelly, op.cit., 1997, p.60

11 André Breton, *Nadja*, (1928), Gallimard, Paris, 1964

12 Mary Kelly, 1997, op.cit., p.75-76

13 Mary Kelly, 1983, op.cit., p.190

14 See Mary Kelly, *Interim*, The New Museum of Contemporary Art, New York, 1990

15 The first phrase is in 'The Dissolution of the Oedipus Complex', *On Sexuality*, Pelican Freud Library, London, vol. 7, p.320. The second is in 'Some Points for a Comparative Study of Organic and Hysterical Motor Paralyses' (1883). *The Standard Edition of the Complete Psychological Works of Sigmund Freud*, vol. I, Hogarth Press, London, p.169

16 Mary Kelly, 1997, op.cit., p.169

17 Ibid., p.170

18 Louis Aragon and André Breton, 'Le Cinquantenaire de l'hystérie', *La Révolution surréaliste*, no. 11, Galimard, 1928

19 D.-M. Bournville and Paul Régnard, *La Grande hystérie: Iconographie photographique de la Salpêtrière*, vol. II, Paris, 1878

20 The photographs were printed in conjunction with an essay by Tristan Tzara, 'D'un certaine automatisme du gout', *Minotaure*, nos. 3–4, Skira, Paris, 1933.

21 Parveen Adams, 'Symptoms and Hysteria', *The Emptiness of the Image: Psychoanalysis and Sexual Differences*, Routledge, London, 1996, p.8. The book also contains her essay 'The Art of Analysis: Mary Kelly's *Interim* and the Discourse of the Analyst'.

22 Michèle Montrelay, 'Inquiry into Femininity', *m/f*, 1, 1978, p.89. Reprinted in Parveen Adams and Elizabeth Cowie, *The Woman in Question*, MIT, Cambridge, Massachusetts and London, 1996

23 Hélène Cixous, 'Utopias', in Elaine Marks and Isabelle de Courtivan, eds., *New French Feminisms: An Anthology*, Harvester, Brighton, 1981, p.257

24 Jacqueline Rose, 'Dora – Fragment of an Analysis', *Sexuality and the Field of Vision*, Verso, London, 1986, p.28

25 Sigmund Freud, 'Female Sexuality' (1931), Pelican Freud Library, London, vol. 7, *On Sexuality*, p. 373

26 Mary Kelly, 1997, op. cit., p.135

27 Ibid., p.169

28 Ibid., p.128

29 Ibid., p.128

30 Ibid., p.122

31 Sigmund Freud and J. Breuer, Pelican Freud Library, London, vol. 3, *Studies on Hysteria*, p.150

32 Briony Fer, 'The Hat, the Hoax and the Body', in K. Adler and M Pointon, eds. *The Body Imaged*, Cambridge University Press, Cambridge, 1993, p.172

33 Mary Kelly, 1997, op.cit., p.137

34 Laura Mulvey, 'Impending Time', catalogue essay in *Mary Kelly: Interim*, The Fruitmarket Gallery, Kettle's Yard and Riverside Studios, 1986, p.7. The catalogue reproduces all the garment and text panels of *Corpus*.

35 Michèle Montrelay, op.cit, p.94

36 Mary Kelly, 1997, op. cit., p.137

37 Ibid., p.149

38 Sándor Ferenczi, 'The Ontogenesis of the Interest in Money', *First Contributions to Psychoanalysis*, trans. E. Jones, Stanley Phillipps, London, 1952, p.331

39 Michel Foucault, *The History of Sexuality, Vol. I*, Vintage, New York, 1980, p.110

40 Sándor Ferenczi, op. cit., p.327

41 Sigmund Freud, 'Character and Anal Eroticism', Pelican Freud Library, London, vol. 7, *On Sexuality*, p.211. And, Ernest Jones, 'Anal-erotic Character Traits', *Paper on Psycho-Analysis*, Ballière and Co., New York, 1918, p.118

42 Mary Kelly, 1997, op.cit., p.156

43 Mary Kelly, 'Desiring Images/Imaging Desire', in Mary Kelly, 1997, op.cit., p.128.

44 Mary Kelly, *Gloria Patri*, Herbert F. Johnson Museum of Art, Cornell University, Ithaca 1992

45 Jacques Lacan, 'Reflections on the Ego', *International Journal of Psychoanalysis*, Institute of Psychoanalysis, London, vol. 11, 1953, p.15

46 Klaus Theweleit, *Male Fantasies: Male Bodies, Psychoanalysis and the White Terror*, vol. II, Polity Press, Cambridge, 1989

47 Jacques Lacan, *Four Fundamental Concepts of Psychoanalysis*, Penguin Harmondsworth, 1977, p.107

48 Jacques Lacan, 'The Mirror Stage as Formative of the Function of the I as Revealed in Psychoanalytic Experience', *Écrits: A Selection*, Tavistock, London, 1977

49 Jacqueline Rose, 'Why War?', *Why War?*, Blackwells, Oxford, 1993, p.29

50 Salvador Dalí, *The Secret Life of Salvador Dalí*, Vision, London, 1948, p.9

51 Klaus Theweleit, op. cit., p.160

52 This is a suggestion made by G. Rousseau in 'A Strange Pathology', Sander Gilman, ed., *Hysteria Beyond Freud*, University of California, Berkeley and London, 1993, p.100

53 Jacques Lacan, 'Aggressivity in Psychoanalysis', *Écrits: A Selection*, Tavistock, London, 1977, pp.10–11

54 Parveen Adams, 'The Art of Analysis: Mary Kelly's *Interim* and the Discourse of the Analyst', *The Emptiness of the Image: Psychoanalysis and Sexual Difference*, Routledge, London, 1996, p.71

Ignoring
the trail, he'd followed a
tributary to the river. Sharp
currents gouged their course through
ferruginous clay, spalling iron ore from the bank where he
stood watching the endless flow of water over the rocks: Like a tap left on, he
thought. That was ideal. It would trap the insects, flushing them down into the
still pools. There, the trout would be waiting, and he would be too, with bated
breath, a snelled hook number four, and a wet fly. No weights or clips. He'd
present the bait naturally, that way it would be carried with the current under the
stones to the enemy's intimate entrenchment. They spooked easily and he
stalked them with a delicate belligerence. Wading upstream, he stirred the
sediment and his expectation swelled. He knew they were there. Sometimes
he would catch a glimpse of them: scarlet gills, dark finger marks on the silver
side and a white underbelly. He longed to touch one, to feel it, wet and
slippery, struggling, its life in his hands. He could do whatever he wanted:
cut it up and eat it, or throw it back. When he pulled a hook through the
tender flesh, it felt like the point of a sharp phrase that turned an argument
in his favor, or the butt of a joke about big cocks and virgins. Lively but
short-lived; a brook trout was fragile and delicious. Still, he would
probably release it. Just to touch it, that would be enough. He would
be satisfied. When a man touches a fish, he reflected, he touches
something far away, something Real. Nearby, something gray and
white and beaky watched him or his tackle, which one, he wasn't
sure. Four feet high, black plumes behind the eye; a heron,
possibly a Great Blue, waited to purloin his catch. Its canny
presence moved him to observe the wilderness more keenly.
The tangle of berries, the dank air, the soft earth, the
scent of pine needles freshly crushed. It was life
sustaining, but at the same time threatening. Instinct
poised, he prepared to meet the challenge before
him, or after him as the case might be. His
crested rival, moving closer, eyed the
tuftless dibbler who, looking at himself
in a watery reflection, saw the body
of a beast and the head of a
man at the mercy of
his own imagination;
then it shuddered
and let out a
raucous
"grak."

Contents

The creator will never participate in anything other than the creation of a small dirty deposit, a succession of small dirty deposits juxtaposed. It is through this dimension that we are in scopic creation – the gesture as displayed movement.

– Jacques Lacan[1]

… (Géricault's Charging Chasseur*) prompted me to think about the way the installation could set up a scene of mastery and undo it blatantly through mimicry. 'Mimicry', according to Lacan, 'reveals something in so far as it is distinct from what might be called "an itself" that is behind it'. I'm not suggesting that there is a hegemonic form of masculinity that can be exposed. Rather, I would say that both masculine and feminine identities are transitive, mediated through a set of masks. But something critical is revealed about the character of masculinity as it is staged by women … What is problematic about this identification lies in its connection to pathological gestures of virility. Such gestures are historically contingent. The Gulf War makes this point explicit.*

– Mary Kelly[2]

Gloria Patri
1992
31 units
Dimensions variable
Installation, Malmö Konstmuseet,
1996

Mary Kelly's *Gloria Patri* is a work of rare intelligence and intrigue. The installation functions in ways that beggar its many critical descriptions, its various theoretical readings. To see *Gloria Patri* incur the debt of interpretation and pay it back with even greater interest has been my task. I have treated the installation as a structure extended and embedded in a range of speculations about what it has come to 'mean'. But what of the work itself? How does one return to a work seen in the past, except as the survival of a memory experienced as a slide-show or a lasting impression? A 'lasting impression' is perhaps the appropriate term to explore: lasting, as a form of persistence or continuance, but also as a mode of shaping and structuring, an armature, a 'last', an infrastructure that makes possible an installation.

What lasts, in both senses of the word, is the light that binds the work: shields and trophies reflecting off each other's surfaces, holding the viewer's gaze and then releasing it, turning the eye from a combative capture of cross-beams to an intricate intervention in the writing – stories, logos – that wipes the lustre off the glance, cutting through the hard, perfect surfaces, deflecting the light; the light which turns the entombed structure – museum, bunker, screen – into a memorial of war's pathology. Light lifting off hulled surfaces that stare back at you, masked light that passes you by and places you, and passes

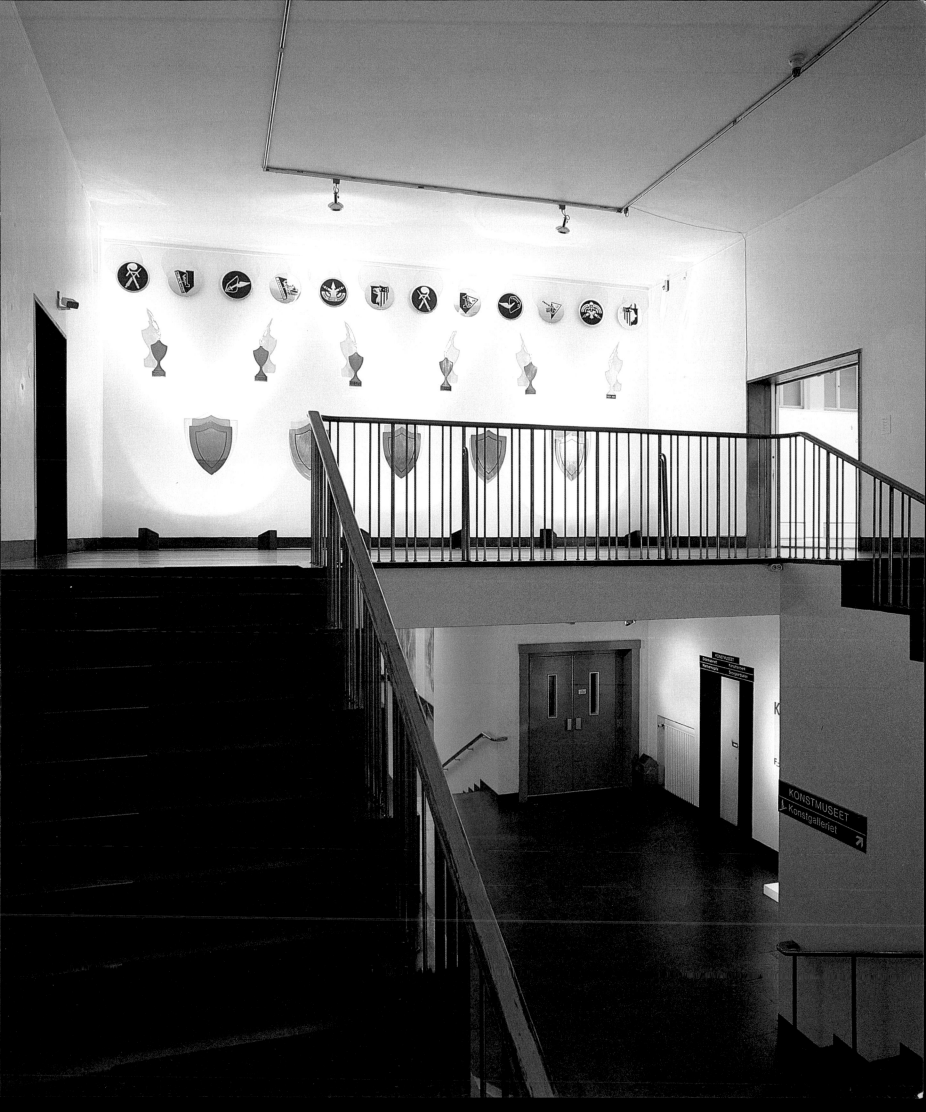

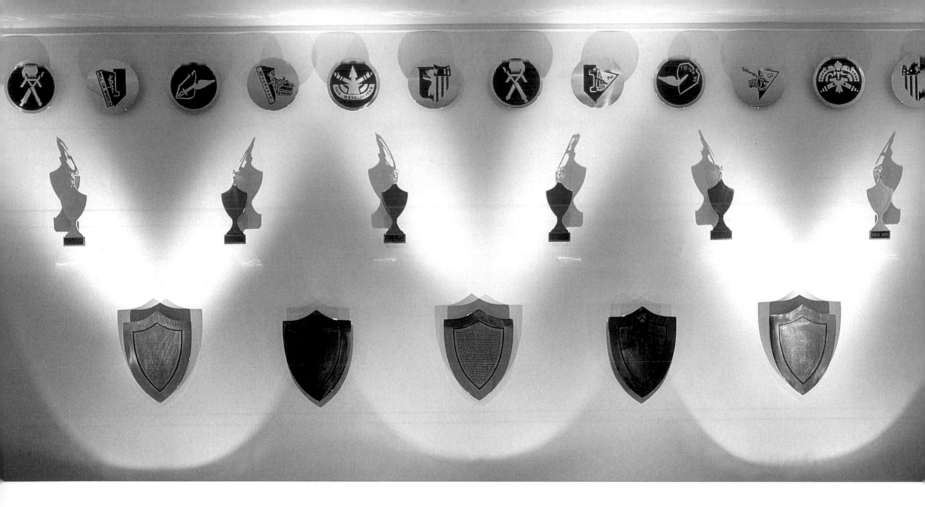

through you, eyeless, but looking at you.

Gloria Patri, structured through the insignia of battle, arrests the viewer in the very process of myth-making. The work stages a battle between its marks of inscription – the iconic, the indexical, the ironic – and the circulation of light that allows one to read, to become part of the narrative, only to be caught up in the glare, to become oneself the blind-spot. The invisibility of history, except when projected on a screen; the intractability of the event except as caught in a lasting impression; in both cases, the installation becomes possible only through alienating, attenuating the signs of war, fixing them in frozen gestures on the wall:

All action represented in a picture appears to us as a battle scene, that is to say, as something theatrical, necessarily created for the gesture ... What can this mean except that the eye carries with it the fatal function of being in itself endowed ... with a power to separate? [3]

Iversen ... you have mentioned a painting by Géricault as being pivotal in your thinking about the precariousness of masculinity.

Kelly Yes, I was thinking specifically of Géricault's Charging Chasseur. *But it takes me back to some more involved thoughts on the Gulf War ... Masculinity as something that becomes*

Théodore Géricault
Charging Chasseur
c. 1812
Oil on canvas
292 × 194 cm

Gloria Patri
1992
31 units
Dimensions variable
Installation, Malmö Konstmuseet,
1996

pathological predominantly in the historical and cultural context of war … Klaus Theweleit, in Male Fantasies, describes the proto-fascist organizations of the 1930s and says there is a certain construction of this totality which he calls the troop machine made up of soldiers, men who lose their individuality in the process of becoming a kind of exoskeleton, poised to confront the other … [This] totality presents itself as straight lines and hardened geometric shapes. As I was thinking about how the work would represent this materiality, well it had to be polished aluminium. When I saw the prototype for the shield, I knew it was right because the surface practically made me sick, it was so severe … And of course the national crisis facing the United States as a military force immediately paralleled for me what Géricault saw in the crisis of the Napoleonic Empire at the time he painted the awkwardly mounted soldier … you had a really ironic situation: where the US was producing war hysteria filtered through the facade of efficacious militarism … So I wanted something that would communicate this facade: everything two inches off the wall – you know, even the trophies had to be 'faux' – they couldn't be 'in the round'.[4]

In this account of *Gloria Patri* there is something too fluent and fortuitous in the formal analogies, or the mimetic metaphors, that describe the turning of influential events and ideas into the manner and materials of artistic display. Despite the concern with masque and camouflage as strategies of displacement, there is an aesthetic approximation and materialization of the tropes of theory. The very spacing of the work – for instance, its installation 'two inches off the wall' to communicate 'facade' – mimics the figurative language

of Lacan's description of the *topos* of the subject's splitting, 'a fracture, bi-partition, a splitting of the being to which the being accommodates itself, even in the natural world'.[5]

Entering into a complex relationship with the ideas it attempts to install, *Gloria Patri* makes common cause with Jacques Lacan's interrogation of the 'philosophical problem of representation',[6] where consciousness knows 'that there is, beyond the thing, the thing itself. Behind the phenomenon, there is the noumenon'. The rhetoric of camouflage and combat staged in the field of the gaze is Lacan's attempt to skewer the subject on the metonymic axis of desire – 'mimicry is camouflage … against a mottled background becoming mottled'[7] – so that the subject's mode of being placed in the world of social

Gloria Patri (details)
1992
Screenprint on polished
aluminium
6 of the 20 discs, ø 43 × 6 cm each

signification is, like camouflage, at once everywhere and nowhere, deterritorializing and terrorizing. All said and (un)done, camouflage is terrifyingly close to *aphanisis* where the emergence of the subject in the alienating dialectic of desire is simultaneously its disappearance in the register of representation; it is the moment when in *dying* to itself, it enters into the mottled condition of mimicry: 'when the subject appears somewhere as meaning, (*being mottled*) he is manifested elsewhere as "fading", as disappearance'.[8] In other words to become mottled against a mottled background is to dis/appear, to become unrecognizable, un(re)marked. What is revealed in-between 'meaning' and 'fading' is the paradoxical positioning of display or mimicry, the *subject beside itself*. This peripherality is part of the performance of mimicry. 'Unlike the animal', wrote Lacan, 'in this imaginary capture ... (he) maps himself. He isolates the function of the screen and plays with it. Man, in effect, knows how to play with the mask as that beyond which is the gaze'.[9] The lateral movement of the side-show agitates the figure of the human being whose 'knowledge of itself' is mapped in the interstitial space between the installation of a screen and the play of the mask. What emerges as agency, then, is the possibility of a form of movement, an action, that is conceived in a temporality of displacement which moves in two directions at once: first, *qua mimicry*, to show that it is distinct from an 'itself' that is *behind* it; secondly, *qua gaze*, to display beyond and beside the mask the gaze that motivates the game of human mapping, of masquerade, by disallowing any alignment of person or thing that is face-to-face, or eyeball-to-eyeball. It is in this field of display and displacement that Kelly's craft attempts

to reveal 'something critical about the character of masculinity as it is staged by women'.

What are the rules of the game, the ruses of the play? Are we placed beyond or behind the screen? How should we play with the mask on its far side? Beyond the gaze, beside the mask, does an 'it/self' begin to emerge?

Kelly's masque of war is caught up in a double or repeat screening where the map of the imaginary is interrogated and isolated until it turns into a screen-play, a masquerade quite beside itself with the anxiety and ambivalence of its own mapping, its mimicry. Behind the work lies the historical background of the Gulf War and its archive of structured remembrances – images, *enonces*, journalistic reports – while somewhere beside the work stand the conceptual sources of its inspiration – Géricault, Lacan, Chomsky. From these grounds the installation performs its camouflage to reveal something quite enigmatic and innovative, – '*something critical that is revealed about the character of masculinity as it is staged by women*'. Where masculinity and femininity meet peripherally in the 'mediation of masks'; when the gaze re-appears, camouflaged, half-hidden; at the point at which the 'display' of sexuality is marginal to both masculinity and femininity; it is there and then that we should look for the promise of Kelly's agency as she inserts, in the *interstices* of this facade – 'everything two inches off the wall … *faux*' – her particular 'idea' about the historical contingent pathology of masculinity-at-war which is symptomatic of a much more generalizable condition of the 'internalized ideal' of male posture, of patriarchal *puissance*, displayed in the symbolic authority of everyday life. In that sense, her work is less about men

"....NOT ENOUGH
GEES AND GOLLIES
TO DESCRIBE IT "

"....LETTING LOOSE
AND HITTING 'EM
WITH ALL WE GOT "

CUT IT OFF
AND KILL IT

Gloria Patri (details)
1992
Etched and polished aluminium
6 trophies, 61 × 21.5 × 6 cm each

and women as the makers of history, and more about a particular relation of the subject to the excessive and prosthetic economy of sexual difference.

What I've ended with is an exploration of what is most visible in terms of, I suppose, a quality of masculine display or a certain form of masculine ideal that this work represents. It's very present, very consuming. But at the same time, it suggests a kind of underside: a repression of the feminine that has been the topic of the work before.[10]

Does this mean that what is 'most visible' about masculine display in *Gloria Patri* – the *excess* of masculinity, its underside, that elides its idealized image – is the critical 'something' that is revealed when the character of masculinity is staged by women? If that 'critical something' is closely related to 'repression of the feminine', then we are in danger of coming close to saying that what undermines masculine display is repressed femininity, the underside, that lies 'behind' it. Of course, we may argue, that the return of the repressed is always uncanny, that each repetition is 'different', distinct from an 'itself' that came 'before' it. But the repressionist narrative is in danger of becoming predictable when it considers itself to be most subversive. The display of masculinity and its repressed femininity may

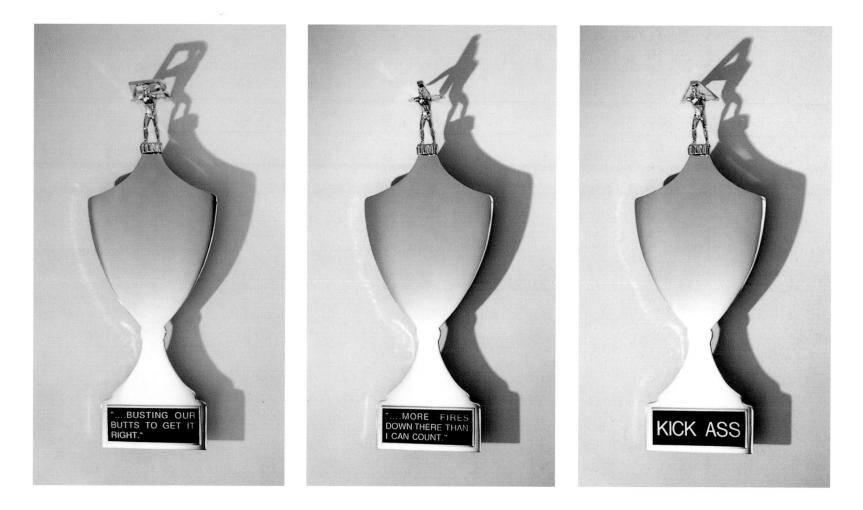

conspire together as a 'dependent' couple; just as the vainglory of war heroes is always accompanied by a sentimental reference to the suffering of the nation's 'people' who are identified as standing behind the martyrs: family, comrades, friends, fallen soldiers, ancestors, all those people in whose silent and unasked name wars are supposedly waged.

In the installation ... the body seems to have been erased with this hard shiny metal surface, but then as you negotiate that space, the body reappears and dramatizes the whole relation of absence and presence ... [The] shield of thrown-off skin that defends us against the vulnerability and visibility of the body.[11]

This theatrical re-entry of the repressed body – at once the feminine underside of the shiny metal surfaces, as well as the vulnerable, spectatorial body – makes visible the 'relation of absence and presence' which is the *sine qua non* of both sexuality and signification. But as both the vulnerable 'body' and the 'feminine underside' re-emerge from behind the full metal jacket, as part of the narrative of the return of the repressed, they expose a 'key' to the work in a way that makes its strategy too visible, its inscription too readable – out of sync with the tenebrous, liminal aesthetic of mimicry and camouflage on which the brilliant

'display' of *Gloria Patri* is staged.

I would like to suggest then, that the peculiar dialectic of camouflage – concealment as display – may not function in the register of 'repression'. The power-play of camouflage or mimicry lies in its ability to infiltrate the imaginary mapping of social and psychic authority by 'working' the effect of mottling, in a lateral direction, *beside itself*. It unmasters the authority of shield and trophy by exposing the propinquity of presence to absence: the proximate 'difference' of masculinity and femininity that can only be realized out of the corner of your eye, opening up an ambivalent territory and temporality, *in-between* the mask and the gaze. When you become mottled against a mottled background the dimension of 'difference' is not obliterated, but radically repeated, over-produced, so that there is no 'end' to mimicry, no spatial boundary that contains or brings closure to the act of imitation; wherein lies the threat of mimicry as much to oneself as to the other. You can lose yourself just as you ruse the other. How can some sense of agency be derived from such a double-edged weapon?

To answer this question, *Gloria Patri* provokes us to return to the problematic of camouflage, approaching it, from the perspective of the temporality that structures the installation. Kelly has articulated the structural memory of the piece in a description of the movement *within* the montage of its materials, making visible the moment when its several visual events are turned through a time-lag, into a 'narrativization of space':

... I am aiming at ... something which is not about style and not about a gestalt of form, but an accumulated sense of those different visual events that really hits you later, a kind of delayed reaction ... what I call the 'narrativization of space'. It's not just that I use narrative in the work, I am also interested in the way that the spectator can be drawn into the experience of real time ... (T)here are a lot of other things happenings in your peripheral vision especially in this installation: trophies, for instance, which are slightly out of your eye line when you're reading the shield; and also, way above you, there are other kinds of slogans that you are taking in at the same time. [12]

The temporality of camouflage consists in just such a strategy of delayed reaction. There is a prior moment of camouflage made possible by the (relatively) pure and unmotivated iterability of a range of signs (mottles, streaks, stars and stripes) that enables the eye to pass across the stillness of the tableau, marking precisely nothing other than what it sees

as the same. However, the agential manoeuvrability of camouflage – mimicry as terroristic manoeuvre – paradoxically demands a synchrony of motion that is staged as an *après-coup*. What seems, at first, quite unexceptional, has to now, belatedly, mark its difference as semblance or similitude that plays the card of masquerade and displacement, so that the tableau of treachery may conceal the 'double-time' by which it works its strategic duplicity. What I have described as the 'deferred' or double action of camouflage resembles Lacan's description of *trompe l'oeil* - neither part of the domain of the visible or invisible, nor of presence or absence. *Trompe l'oeil* is distinguished by a gesture of stillness or arrest that moves 'when by a mere *shift* of our gaze, we are able to realize that the representation does not *move* with the gaze … It *appears at that moment* as something other *than it seemed*, or rather it *now seems* to be that something else' (my emphasis).[13]

Enter, again, the world of *Gloria Patri*: narrated shields, encrypted trophies; the evil eye of a chromed chorus lining the walls, the *trompe l'oeil* of masculinity and militarism. Arrest, caught in the gaze of the shine, fixed in the light, the searchlight searches you out, but what is it looking for - and where from? The eye follows the stories that cover the hard skin of the shield with a skeined glow. The reader follows the many repetitions of vainglory and vulnerability, led by the unfolding, narrative light. Then, at the end of the tale, by a mere shift of the gaze, the story stops and the blind glare of the shield returns: the viewer goes on and on beyond the signs and surfaces, drawing out the space, elongating the excess, the excision, where suddenly the eye stops and the gaze keeps moving … a mere shift of the gaze and in that moment, after that movement, nothing is as it seems.

Through a process of contingency ('a mere shift … '), something – object, subject, strategy, authority, sexuality, power, desire – appears as other than it seemed. In that disjunctive moment, in that temporality of transit, there occurs the potential for an act of revision, a process of reinscription or a performance of translation. What camouflage implies – 'beside', not 'behind', itself – is the need to take responsibility for a history – public or private, social or psychic – that is never part of the past but always working its way through the contingent present. An ethical relation is compelled by a peripheral vision that displays the proximity to the 'other' who stands, unknown, *beside* oneself, as the (un)acknowledged double – 'proximity, beyond intentionality, is the relationship with the neighbour in the moral sense of the term'.[14] Meaningful political action occurs in a vigilant attention to that

Audio
receiver, track
one. He adjusted the
frequency level and pushed away
the tray. A clump of collard greens sat resolutely in the
center of a white plate. Any moment, she would ask him when he was going
to eat it. He could see the look on her face describing a long list of
catastrophes: the inevitable outcome of deficiencies in vitamins A and C.
He fed more bass to speaker B. *Head like a hole, black as your soul*, the
room reverberated. Green as his guilt. It's not that I don't like what you
make, Mom, he would apologize, maybe later. Later he'd be outta there.
Hang with the guys. Throw Arnie on the boob tube and pull some bong.
In anticipation of the bongish bliss, he altered the state of his surround
sound to *Theater* and imagined a stage in his life when he could go out
in the cold without a coat, lose his glasses, pick his nose or his ass or
fart if he felt like it, leave the blinds down and the toilet seat up, and,
above all, eat whatever he damn well chose. He recalled her sitting
next to him, her hand on his; the soft skin, frail and translucent,
loosely draped over her prominent veins, studded with drab
patches and scored with tiny creases. It made him queasy. At
the same time, it made him want to please her, to risk
everything, to order salad even in the presence of his beefy
bros, to announce his queerness with each leafy forkful.
And finally, when the green stuff had gone to his brain,
he would oppose the war. Only girls would be on his
side. All the flesh-eaters would say, "Just bomb the
hell out of 'em." She would pry: What's wrong?
Shut-up bitch, get off my case, he'd want to
say. Instead he'd hit the volume. *Bow
down before the one you serve, you're
going to get what you deserve.*
The song ended and his
resolution waned. You're
going to eat the fucking
greens aren't you,
he sneered.

Gloria Patri (detail)
1992
Etched and polished aluminium
1 of the 5 shields,
73.5 × 61 × 6 cm each

moment when, with the shift of the gaze, we can envision some history being left behind, while something emerges that is transforming, liberating, freedom-yielding; something other than what readily appears as the inevitability of the 'present'.

Gloria Patri is a narrativization of the space of sexuality that goes beyond the revelation of its repressed, pathological underside. It envisages the emergence of a temporality of 'revision' through which a normalized image of masculinity or femininity has to confront repeatedly its 'difference' as *trompe l'oeil*, as having no 'itself' behind it. At that moment the idealized and internalized identification of masculinity drops its shield and its desire for sovereignty, and adopts the mask of survival and the task of the mimic. It is in that *mere* shift that the ethical and aesthetic power of *Gloria Patri* lies; in that sudden moment when the installation moves, and the gaze runs beside, perhaps even behind, itself.

Don't believe me? Read the shields, battling against the glare, out of the corner of your eye. Return to the primal scenes of the masquerade of masculinity to see how display yields to a despondent, yet determined, will to survive: the human mapping of the self in the imaginary recognizes that the deadly game of life can only be played by a masked agent.

What does the son say, what does he do, when faced with his mother's desire? ... *(H)e imagined a state in his life when he could go out in the cold without a coat, lose his glasses, pick his nose ... eat whatever he damn well chose. He recalled her sitting next to him, her hand on his; the soft skin, frail and translucent, loosely draped over her prominent veins ... It made him queasy ... Bow down before the one you serve. The song ended and his resolution waned. You're going to eat the fucking greens aren't you, he sneered.*

1 Jacques Lacan, *The Four Fundamental Concepts of Psychoanalysis*, Jacques-Allain Miller ed., W.W. Norton & Company, New York, 1978, p.117, trans. Alan Sheridan
2 Mary Kelly, 'On Display', *Imaging Desire,* MIT Press, London, 1996, p.185-86
3 Jacques Lacan, op. cit., p.115
4 Mary Kelly, op. cit., p.190-92
5 Jacques Lacan, op. cit., p.106
6 Ibid.
7 Ibid., p.99
8 Ibid., p.218
9 Ibid., p.107
10 Mary Kelly, op. cit., p.189
11 Ibid., p.102
12 Ibid., p.188
13 Jacques Lacan, op. cit., p.112
14 Emmanuel Levinas, *Collected Papers*, Matinus Nijhoff, Dordrecht, 1987, p.119, trans. Alphonso Lingis

IV

Well, I was born in 1965, so I was a toddler in 1968. I went to a public grade school in Massachusetts and then to a prep school for women only. So, there were not a lot of male authority figures, but feminism was more a matter of lifestyle than politics or theory, something taken for granted. There were a few teachers who tried to give a broad range of political points of view, and there were courses for women writers, but we didn't have women's groups. Although I lived in a dorm with at least thirty other women, some of whom were my closest friends, the place still had a very homophobic atmosphere.

I suppose we were the dregs of the hippie generation, which may be why we were so caught up in the anti-nuclear movement. Feminist issues were more repressed. People would say they were for equal rights and all, but insist that they weren't feminist. My confidence in women really comes from my mother—her independence. I would overhear her talking about feminism with her friends. I remember that.

Of course, when I went to college, it was different. I concentrated on Women's Studies. It was a new program—just started when I got there. One of the first courses I took combined Marxism, linguistics, psychoanalysis and film theory—that really got me going. There was a distinction being made between European and American feminism by then. One was described as high theory and the other as practice—direct action, the pornography debate, the nature-culture thing. But, obviously, it's too superficial to say theory exists without practice—I mean, to think is practical. So, I sharpened my teeth on the analytical, but ended up with this—using the media, the problem of representation and all that as a form of direct action.

At Brown, I was involved in setting up the Women's Political Task Force. It was a group of women who tried to organize around local, city and state issues as well as things that were specific to our own campus. For instance, we ran an escort service to protect women from rape, which was a common occurrence. In fact, we held a meeting, a speakout, that lasted five hours—in the rain, too. One woman after another got up and talked about her experience. It was really empowering for everyone involved. That was around 1984. Then, there was the Gay and Lesbian Awareness Week. I was getting more involved with the lesbian community, and that's when I became aware of the AIDS issue. At that time, it was a very big scare. I would go through what a lot of my gay men friends did—every time I'd notice a mark or feel tired, I'd think, oh no, I've got AIDS.

By 1988, ACT UP had started. I had friends in New York who were involved in it, and I decided to work with them. We would try to come up with creative actions to bring attention to AIDS-related issues. We organized a major, I think the largest, protest at City Hall on March 28th and later at the Food and Drug Administration which was in the middle of nowhere. This is when we realized the media couldn't represent us—I mean, their stance is always "us and them." So, the video people from ACT UP have taken this on—trying to find ways of talking to each other.

There's also a really interesting intersection between Lesbianism and the issue of reproductive rights. I think it's fertile ground for coalition-building. On April 9th, when 600,000 women, people I mean, mostly women, went to Washington, more than 100 members of ACT UP were there. I remember when we passed the Center for Justice, some of us spontaneously went up and wrote "the center for injustice." We got so much support from people marching—lots of dancing and chanting—"keep your laws off my body," "U.S. out of my uterus," "women are not incubators," "sex without punishment," and so on. Then on April 26th—the day they were hearing the case of Webster v. Reproductive Rights which was aimed at overthrowing Roe v. Wade—we organized an illegal picket and, of course, got arrested. Twenty lesbians, eight gay men and a few straight women. I mention this because there are so many different sub-groups in the women's movement. I don't think NOW, for example, is fighting the same fight I'm fighting which brings me back to activism: the law affects everyone, doesn't it? Well, the kind of thing we're doing—our achievements, affect everyone too.

"When the last issue of our magazine came out, I remember thinking that it marked the end of an important era. There was a sense of loss; loss of collective voice, of body politic, and in a way, of pleasure—I mean, the pleasure of identity formed in the company of other women. Perhaps, it also signaled fear that things don't change 'for the better;' they simply change."

(continued from page 45)

A younger woman, obviously an outsider, sporting a headband and five badges, shouts, "The problem with your generation is that you still need men!" "Ah ha..." reflects No Lipstick, "but some of us might feel, well...suffocated in a woman-only culture." "On the other hand," says Badges, "why not see it this way: if you're not a mother, then you can't be middle-aged." "Of course, that's it." One Earring launches into her debate. "To be adult is to sell out, I mean, adopt the values and the life-style of the social order we detest; but to continue as the child is so undignified. What's more," she frowns, "we know that this dilemma is naive, so now we have the added burden of...how should I put it?...feeling we're at odds with our emotions." "Umm...I think you're onto something there," winks Badges and departs. "*I* think," The Shirt suggests, "this is a problem of the old new left." "Quite right," concludes The Locks. "Aren't we surprised to be alive and standing here without a life support system?" They laugh—The Laugh of Those Who Laugh the Last, but being over forty not necessarily The Loudest, and begin again. In the meantime...

(continued on page 49)

Contents

Two Generations

In its beginnings, the women's movement, as the struggle of suffragists and of existential feminists, aspired to gain a place in linear time as the time of project and history. In this sense, the movement, while immediately universalist, is also deeply rooted in the sociopolitical life of nations. The political demands of women; the struggles for equal pay for equal work, for taking power in social institutions on an equal footing with men; the rejection, when necessary, of the attributes traditionally considered feminine or maternal in so far as they are deemed incompatible with insertion in that history – all are part of the *logic of identification*[11] with certain values: not with the ideological (these are combated, and rightly so, as reactionary) but, rather, with the logical and ontological values of a rationality dominant in the nation-state. Here it is unnecessary to enumerate the benefits which this logic of identification and the ensuing struggle have achieved and continue to achieve for women (abortion, contraception, equal pay, professional recognition, etc.); these have already had or will soon have effects even more important than those of the Industrial Revolution. Universalist in its approach, this current in feminism *globalizes* the problems of women of different milieux, ages, civilizations, or simply of varying psychic structures, under the label 'Universal Woman'. A consideration of *generations* of women can only be conceived of in this global way as a succession, as a progression in the accomplishment of the initial program mapped out by its founders.

In a second phase, linked, on the one hand, to the younger women who came to feminism after May 1968 and, on the other, to women who had an aesthetic or psychoanalytic experience, linear temporality has been almost totally refused, and as a consequence there has arisen an exacerbated distrust of the entire political dimension. If it is true that this more recent current of feminism refers to its predecessors and that the struggle for sociocultural recognition of women is necessarily its main concern, this current seems to think of itself as belonging to another generation – qualitatively different from the first one – in its conception of its own identity and, consequently, of temporality as such. Essentially interested in the specificity of female psychology and its symbolic realizations, these women seek to give a language to the intrasubjective and corporeal experiences left mute by culture in the past. Either as artists or writers, they have undertaken a veritable exploration of the *dynamic of signs*, an exploration which relates this tendency, at least at the level of its aspirations, to all major projects of aesthetic and religious upheaval. Ascribing this experience to a new generation does not only mean that other, more subtle problems have been added to the demands for sociopolitical identification made in the beginning. It also means that, by demanding recognition of an irreducible identity, without equal in the opposite sex and, as such, exploded, plural, fluid, in a certain way non-identical, this feminism situates itself outside the linear time of identities which communicate through projection and revindication. Such a feminism rejoins, on the one hand, the archaic (mythical) memory and, on the other, the cyclical or monumental temporality of marginal movements. It is certainly not by chance that the European and trans-European problematic has been posited as such at the same time as this new phase of feminism.

Finally, it is the mixture of the two attitudes – *insertion* into history and the radical *refusal* of the subjective limitations imposed by this history's time on an experiment carried out in the name of the irreducible difference – that seems to have broken loose over the past few years in European feminist movements, particularly in France and in Italy.

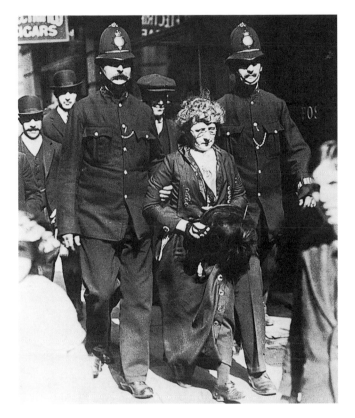

If we accept this meaning of the expression 'a new generation of women', two kinds of questions might then be posed. What sociopolitical processes or events have provoked this mutation? What are its problems: its contributions as well as dangers? [...]

Another Generation Is Another Space

If the preceding can be *said* – the question whether all this is true belongs to a different register – it is undoubtedly because it is now possible to gain some distance on these two preceding generations of women. This implies, of course, that a *third* generation is now forming, at least in Europe. I am not speaking of a new group of young women (though its importance should not be underestimated) or of another 'mass feminist movement' taking the torch passed on from the second generation. My usage of the word 'generation' implies less a chronology than a *signifying space*, a both corporeal and desiring mental space. So it can be argued that as of now a third attitude is possible, thus a third generation, which does not exclude – quite to the contrary – the *parallel* existence of all three in the same historical time, or even that they be interwoven one with the other.

In this third attitude, which I strongly advocate – which I imagine? – the very dichotomy man/woman as an opposition between two rival entities may be understood as belonging to *metaphysics*. What can 'identity', even 'sexual identity', mean in a new theoretical and scientific space where the very notion of identity is challenged?[29] I am not simply suggesting a very hypothetical bisexuality which, even if it existed, would only, in fact, be the aspiration towards the totality of one of the sexes and thus an effacing of difference. What I mean is, first of all, the de-massification of the problematic of *difference*, which would imply, in a first phase, an apparent de-dramatization of the 'fight to the death' between rival groups and thus between the sexes. And this not in the name of some reconciliation – feminism has at least had the merit of showing what is irreducible and even deadly in the social contract – but in order that the struggle, the implacable difference, the violence be conceived in the very place where it operates with the maximum intransigence, in other words, in personal and sexual identity itself, so as to make it disintegrate in its very nucleus.

It necessarily follows that this involves risks not only for what we understand today as 'personal equilibrium' but also for social equilibrium itself, made up as it now is of the counterbalancing of aggressive and murderous forces massed in social, national, religious and political groups. But is it not the insupportable situation of tension and explosive risk that the existing 'equilibrium' presupposes which leads some of those who suffer from it to divest it of its economy, to detach themselves from it, and to seek another means of regulating difference?

To restrict myself here to a personal level, as related to the question of women, I see arising, under the cover of a relative indifference towards the militance of the first and second generations, an attitude of retreat from sexism (male as well as female) and, gradually, from any kind of anthropomorphism. The fact that this might quickly become another form of spiritualism turning its back on social problems, or else a form of repression[30] ready to support all status quos, should not hide the radicalness of the process. This process could be summarized as an *interiorization of the founding separation of the sociosymbolic contract*, as an introduction of its cutting edge into the very interior of every identity whether subjective, sexual, ideological or so forth. This in such a way that the habitual and increasingly explicit attempt to fabricate a scapegoat victim as foundress of a society or a counter-society may be replaced by the analysis of the potentialities of *victim/executioner* which characterize each identity, each subject, each sex.

What discourse, if not that of a religion, would be able to support this adventure which surfaces as a real possibility, after both the achievements and the impasses of the present ideological reworkings, in which feminism has participated? It seems to me that the role of what is usually called 'aesthetic practices' must increase not only to counterbalance the storage and uniformity of information by present-day mass media, data-bank systems, and, in particular, modern communications technology, but also to demystify the identity of the symbolic bond itself, to demystify, therefore, the *community* of language as a universal and unifying tool, one which totalizes and equalizes. In order to bring out – along with the singularity of each person and, even more, along with the multiplicity of every person's possible identifications (with atoms, e.g., stretching from the family to the stars) – the *relativity of his/her symbolic as well as biological existence*, according to the variation in his/her specific symbolic capacities. And in order to emphasize the *responsibility* which all will immediately face of putting this fluidity into play against the threats of death which are unavoidable whenever an inside and an outside, a self and an other, one group and another, are constituted. At this level of interiorization with its social as well as individual stakes, what I have called 'aesthetic practices' are undoubtedly nothing other than the modern reply to the eternal questions of morality. At least, this is how we might understand an ethics which, conscious of the fact that its order is sacrificial, reserves part of the burden for each of its adherents, therefore declaring them

Interim Part III: Historia
(*following pages*, details)
1989
Oxidized steel, silkscreen,
stainless steel on wood base
4 units,
152.5 × 90 × 72.5 cm each
Collection, Mackenzie Art Gallery,
Regina, Saskatchewan

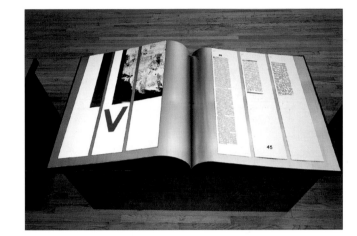
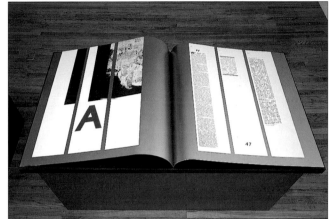

guilty while immediately affording them the possibility for *jouissance*, for various productions, for a life made up of both challenges and differences.

Spinoza's question can be taken up again here: Are women subject to ethics? If not to that ethics defined by classical philosophy – in relationship to which the ups and downs of feminist generations seem dangerously precarious – are women not already participating in the rapid dismantling that our age is experiencing at various levels (from wars to drugs to artificial insemination) and which poses the *demand* for a new ethics? The answer to Spinoza's question can be affirmative only at the cost of considering feminism as but a *moment* in the thought of that anthropomorphic identity which currently blocks the horizon of the discursive and scientific adventure of our species.
Translated by Alice Jardine and Harry Blake

11 The term 'identification' belongs to a wide semantic field ranging from everyday language to philosophy and psychoanalysis. While Kristeva is certainly referring in principle to its elaboration in Freudian and Lacanian psychoanalysis, it can be understood here, as a logic, in its most general sense (see the entry on 'identification' in Jean La Planche and J.B. Pontalis, *Vocabulaire de la psychoanalyse* [The language of psychoanalysis], Presses Universitaires de France, Paris, 1967; rev. ed., 1976). – AJ.

29 See *Seminar on Identity* directed by Lévi-Strauss, Grasset & Fasquelle, Paris, 1977

30 Repression (*le refoulement* or *Verdrangung*) as distinguished from the foreclosure (*la foreclusion* or *Verwerfung*) evoked earlier in the article (see La Planche and Pontalis, op. cit.). – AJ.

From **Signs: Journal of Women in Culture and Society**, vol. 7, no. 1, Chicago, 1981

#08 KELLY/8
A Foto
REVISED 10.18.90
MADE IN CM

#08 KELLY V9
A Foto
10.18.90
MADE IN CM

#08 KELLY/14
A Foto
10.15.90
MADE IN CM

In 1968, I was twenty-seven. I had just moved to London from the Middle East. Some of the universities and almost all of the polytechnics were under siege. The LSE, like the Sorbonne in Paris, had formed a vanguard of student leaders, mostly men, which seemed perfectly natural to me at the time. After all, I was educated, politically speaking, in the "third world," and I had only a very tentative grasp of the concept of women's liberation. It was based on an analogy with progressive nationalism; that is, the developing countries, like women, struggled against their white, male colonial oppressors. Vietnam, Latin America, Northern Ireland, South Africa and occupied Palestine, these were the real issues.

So, I went to my first women's group determined to point out their "deviation," but instead, I was re-educated. This time it was by women, none of whom thought that the women's movement was autonomous from the broader context of Labor and Socialist politics, but all of whom insisted that it was separate. I mean that it was organizationally separate, with separate aims and strategies, as well as theoretically separate, that is, having a specific object, women's oppression. We also started to recognize another dimension to oppression, something very deeply internalized, "the subjective moment," so to speak. I'm sure these discoveries were related to what was going on in our consciousness-raising sessions. It was tense, exhilarating, sometimes dramatic, even disastrous, but anyway, for the kinds of questions we were asking, there simply weren't answers in Marx, however rigorous our reading of the "lacunae" in the German Ideology, and we turned to Freud. Actually, it was Althusser's reference to Lacan that started it and, eventually, some of us did form a Lacan reading group, but that wasn't until a few years later, after Psychoanalysis and Feminism had been published in 1973.

At this time, I mean the early seventies, the women's movement was still organized geographically around local groups. For the most part, these were named after the area where they met. There were only a few like ours, called The History Group, that declared some special interest. All the groups came together, annually, at the National Conference. Other than that, there was no structure except the magazine, Shrew. Each group did its own issue. There was no editorial board or policy as a matter of principle. In, I think 1970, we produced the History Shrew. It included an article on Freud and one on the Miss World demonstration. I remember that because most of us took part in it; several were arrested, my closest friend, in fact. I thought, my God, she has a child and could get done for assault! Anyway, it was a very sobering experience, having to think through and justify our actions during the trial. Although, I must admit, the whole political atmosphere was different then. It was a time of intense trade union activity, led by the miners and aimed at toppling the conservative government. That did happen in 1973. The women's movement was also planning massive demonstrations to pressure Parliament into passing the Equal Pay Bill, and that, finally, became an Act in 1975. Meanwhile, some of us were organizing low-paid, women workers, like office cleaners, particularly those on the nightshift, who weren't unionised. And besides all this, we were involved in the anti-discrimination legislation and the abortion campaign!

This kind of political activism continued, I would say, until the mid seventies. Then things began to shift towards a certain form of specialization. I remember the last National Conference in 1978; some of us conducted a workshop called Women and Representation which focused on things like literature, film and visual art. The first issue of M/F also appeared that year, consolidating the work on psychoanalysis. Soon after, the Marxist-oriented Feminist Review came out. Spare Rib continued to represent the "populist" view. It seemed like the journals became the representatives of different positions that had previously been debated at the conferences. Perhaps, the organization of the movement was too fragile to survive the backlash of the eighties, but, at least, the publications made me feel it still existed in some form.

"I remember the room, it was cold and sparsely furnished. The women spoke to us at length about the history of their country— partition, subjugation, struggle and, of course, the need for our support. We listened. They looked at us, it seemed, without expression, then unexpectedly, began to talk about their own experience of the war; being separated from their husbands for long periods and possibly forever, losing friends, watching their children die or suffer, seeing their parents humiliated and confused. They said, 'Even if the conflict in Vietnam ends tomorrow, these wounds will not heal for centuries.'"

(continued from page 39)

At Someone's party, two women are complaining about younger women. The first, wearing sneakers and one earring says, "They take it all for granted." "But," the second, swathed in Comme des Garcons and no lipstick, intervenes, "we shouldn't keep reminding them, insisting they've no right to an idea unless they have lived through it." "True," One Earring condescends, "but what about our history?" "Umm..." No Lipstick pauses; then they both nod The Nod of Complete Agreement and carry on until...

(continued on page 43)

41

■■

I was twenty in 1968.
I'd gone to university, having read the *Feminine Mystique* because my father picked it up at an airport. Perhaps I also had some sense of a feminist tradition from my mother. I knew that she and her friends had struggled to get some kind of education. At Oxford, the term feminism was in use, but bracketed off...as a term of abuse.

I have a vague recollection of the women's conference at Ruskin in 1970, but I was preoccupied with the student occupation then, which was becoming quite militant. I remember people from Ruskin coming to support us, but I didn't get involved in a women's group until I left university and went to London.

In 1971, maybe it was January 1972, some of us formed The Women's Lobby. Our reference point was the traditional suffrage movement. We wanted to do something that would have an immediate political impact, so we decided to try to get the Equal Opportunities Legislation out of the doldrums...one of the Labor MPs had presented it four or five times to the House of Commons and it had been laughed out. So we mobilized a whole range of women's support groups...to write letters, to speak at meetings, to give the issue a public identity and keep it from continuing as an in-joke in Parliament. Out of this came the *Women's Report*. We thought that unless we could provide women with regular information on current affairs and how this affected them, then we wouldn't be making much progress. Eventually we got into a kind of workshop production of the *Report*. It covered legal, parliamentary and social issues, as well as the arts. Some of us were interested in the question of culture, so we started a section called "Images." We used this wonderful typeface...where women's bodies were shaped into letters and we made these lovely banner headlines. I was involved in that until 1974.

Then came the Women's Art History Collective. The very first meeting took place around that time, and we met regularly for almost three years. We were aware of the women's workshop of the Artist's Union, but we weren't directly involved in it. We wanted to explore new ways of doing historical research about women artists, so we did projects...like self-portraits...exploring the historical and political implications of looking at ourselves. We read Nochlin, Berger and that kind of thing...finally, after we had been meeting for quite awhile, we decided to try teaching *collectively*. We advertised ourselves and were asked by a number of polytechnics to give presentations. The plan was to make sure that everyone had a chance to speak, that no one dominated, and then, to avoid becoming a collective authority as well, so that the audience could feel involved...but, in fact, the whole project was never resolved. I remember it was really amazing going to art schools...you would present your material and you would see the women in the audience gasp, eyes popping at the possibility of someone daring to come out with this, and then back it up with these astounding statistics. It was a horrendous picture...one that you could see there and then, sitting in front of you...here there were these massed ranks of silent women controlled by these, you know, macho, or at least anxious men at the back.

Our efforts to understand those kinds of stereotypes kept bringing up the question of sexuality and, in our group, there was some interest in psychoanalysis. But I remember my first encounter with the Lacanian lot at The Edinburgh Film Festival in 1976; it absolutely enraged me...made me feel so disabled, so ignorant, sort of castrated by my inability to place myself within that discourse. Yet, it really intrigued me...I wanted to translate our material into this other language. But none of the Collective would follow me down that road...everyone went off to develop her own work and it became defunct as a meeting group.

By then, I was committed to writing the history of our projects and some of the other feminist activities of the seventies, because it seemed to me that there was a process of amnesia in the eighties which was so rapid and widespread that the immense revolution initiated earlier was already disappearing. People felt, or were ideologically pressured to feel, they had to erase it. So, I made myself its immediate archivist...feeling that the documents we had collected had to be made available in a certain form, within ▓▓▓▓▓▓▓▓▓▓▓▓▓▓▓▓▓▓▓▓▓▓▓▓, that underlines their significance.

"Each article had to be discussed in detail, then corrected and okayed by the entire group. Most of us had never written anything before. So, one by one, frogs in the throat, knees shaking and all that, we read our contributions. I remember Lorna's. She was hesitant, apologizing first for all the faults we would encounter, and then, finally, after we had coaxed her to continue, she began. The clarity, yes, that's the way it was, we thought. But more, her turn of phrase transported us into a realm of...well, collective ecstasy, I guess, since when she finished no one said a word."

43

(continued from page 41)

They are interrupted by a man, presumably a friend, in a black silk shirt (presumably washable), but no grey hair (probably dyed). "How old are you?" One Earring asks immediately. The Shirt is taken a-back. "Ah...same as you, I guess. What difference does it make?" "No, no, you're younger," she persists. "Never mind," No Lipstick, coming to his rescue, "I think he qualifies. So tell us, what about your students then?" "Mine? ...Well, they're too young to remember or perhaps don't want to... take the concept of repression, Freud's, that is... One of them said to me, 'You mean you want to do something, nobody stops you and you still don't do it? That sucks, sir.'" "Amazing," says No Lipstick. "Tragic," adds One Earring. Then, exchanging The Look of Utter (and Tragic) Amazement, they proceed with their complaints. Meanwhile..

(continued on page 45)

Madame Realism had read that Paul Eluard had written: No one has divined the dramatic origin of teeth. She pictured her dentist, a serious man who insisted gravely that he alone had saved her mouth. The television was on. It had been on for hours. Years. It was smiling. It was there. TV on demand, a great freedom. Hadn't Burroughs said there was more freedom today than ever before? Wasn't that like saying things were more like today than they've ever been? Madame Realism heard the announcer, who didn't know he was on the air, say: 'Hello, victim'. Then ten seconds of nothing, a commercial, the news, and *The Mary Tyler Moore Show*.

She inhaled her cigarette fiercely, blowing the smoke out hard. The television interrupts itself: a man wearing diapers is running around parks, scaring little children. The media call him Diaperman. The smoke and her breath made a whooshing sound that she liked, so she did it again and again. When people phoned she blew right into the receiver, so that she sounded like she was panting. Smokers, she read in a business report, are less productive than nonsmokers, because they spend some of their work time staring into space as they inhale and exhale. She could have been biding her time or protecting it. All ideas are married.

He thought she breathed out so deeply to let people know she was there. Her face reminded him, he said, of a Japanese movie. She didn't feel like talking, the telephone demanded like an infant not yet weaned. Anything can be a transitional object. No one spoke of limits, they spoke of boundaries. And my boundaries shift, she thought, like ones do after a war when countries lose or gain depending upon having won or lost. Power has always determined right. Overheard: a young mother is teaching her son to share his toys. Then he will learn not to share his toys, the toys he really cares about. There are some things you can call your own, he will learn. Boundaries are achieved through battle.

Madame Realism was not interested in display. Men fighting in bars, their nostrils flaring and faces getting red; their noses filling with mucus and it dripping out as they fought over a pack of cigarettes, an insult, a woman. But who could understand men, or more, what they really wanted.

Dalí's conception of sexual freedom, for instance, written in 1930. A man presenting his penis 'erect, complete and magnificent plunged a girl into a tremendous and delicious confusion, but without the slightest protest ... ' 'It is', he writes, 'one of the purest and most disinterested acts a man is capable of performing in our age of corruption and moral degradation.' She wondered if Diaperman felt that way. Just that day a beggar had walked past her. When he got close enough to smell him, she read what was written on his badge. It said BE APPROPRIATE. We are like current events to each other. One doesn't have to know people well to be appropriate.

Madame Realism is at a dinner party surrounded by people, all of whom she knows, slightly. At the head of the table is a silent woman who eats rather slowly. She chooses a piece of silverware as if it were a weapon. But she does not attack her food.

One of the men is depressed; two of his former lovers are also at the dinner. He thinks he's Kierkegaard. One of his former lovers gives him attention, the other looks at him ironically, giving him trouble. A pall hangs over the table thick like stale bread. The silent woman thinks about death, the expected. Ghosts are dining with us. A young man, full of the literature that romanticizes his compulsion, drinks himself into stupid liberation. He has not yet discovered that the source of supposed fictions is the desire never to feel guilty.

The depressed man thinks about himself, and one of the women at the table he hasn't had. This saddens him even more. At the same time it excites him. Something to do – to live for – at the table. Wasn't desire for him at the heart of all his, well, creativity? He becomes lively and sardonic. Madame Realism watches his movements, listens to what he isn't saying, and waits. As he gets the other's attention, he appears to grow larger. His headache vanishes with her interest. He will realize that he hadn't had a headache at all. Indifferent to everyone but his object of the moment, upon whom he thrives from titillation, he blooms. Madame Realism sees him as a plant, a wilting plant that is being watered.

The television glowed, effused at her. Talk shows especially encapsulated America, puritan America. One has to be seen to be doing good. One has to be seen to be good. When he said a Japanese movie, she hadn't responded. Screens upon screens and within them. A face is like a screen when you think about the other, when you think about projection. A mirror is a screen and each time she looked into it, there was another screen test. How did she look today? What did she think today? Isn't it funny how something can have meaning and no meaning at the same time.

Madame Realism read from the *New York Times*: 'The Soviet Ambassador to Portugal had formally apologized for a statement issued by his embassy that called Mario Soares, the Socialist leader, a lunatic in need of prolonged psychiatric treatment. The embassy said the sentence should have read "these kinds of lies can only come from persons with a sick imagination, and these lies need prolonged analysis and adequate treatment".' Clever people plot their lives with strategies not unlike those used by governments. We all do business. And our lies are in need of prolonged analysis and adequate treatment.

When the sun was out, it made patterns on the floor, caused by the bars on her windows. She like the bars. She had designed them. Madame Realism sometimes liked things of her own design. Nature was not important to her; the sun made shadows that could be looked at and about which she could write. After all, doesn't she exist, like a shadow, in the interstices of argument?

Her nose bled for a minute or two. Having needs, being contained in a body, grounded her in the natural. But even her period appeared with regularity much like a statement from the bank. Madame Realism lit another cigarette and breathed in so deeply her nose bled again. I must get this fixed, she thought, as if her nostrils had brakes. There is no way to compare anything. We must analyse our lies. There isn't even an absolute zero. What would be a perfect sentence?

A turn to another channel. The night was cold, but not because the moon wasn't out. The night was cold. She pulled her blanket around her. It's cold but it's not as cold as simple misunderstanding that turns out to run deep. And it's not as cold as certain facts: she didn't love him, or he her; hearts that have been used badly. Experience teaches not to trust experience. We're forced to be empiricists in bars.

She looked into the mirror. Were she to report that it was cracked, one might conjure it, or be depressed by a weak metaphor. The mirror is not cracked. And stories do not occur outside thought. Stories, in fact, are contained within thought. It's only a story really should read, it's a way to think. She turned over and stroked her cat, who refused to be held longer than thirty seconds. That was a record. She turned over and slept on her face. She wondered what it would do to her face but she slept that way anyway, just as she let her body go and didn't exercise, knowing what she was doing was not in her interest. She wasn't interested. It had come to that. She turned off the television.

Excerpted from the story **Madame Realism** which first appeared as an artist's book with drawings by Kiki Smith, 1984. Also in a collection of short fiction entitled **Absence Makes the Heart**, 1990.

if, she's changed. howee
huge leather jacket, li
ike her face, small fe
ess, emblazoned: live a
nonsense baby, if you
I am in debt, no doubt
mmitted, wishing I cou
. Stunned by the 'right
ued by every detail,
had a presence much
attractive without tryi
nad to have them, kept
ely found some that we
but stylishly distressed
ng, wore them all the
ls she be wearing her

Contents

Re-Viewing Modernist Criticism (extract) 1981

Post-Partum Document
1973-79
Installation in six parts
Dimensions variable
Installation, Anna Leonowens
Gallery, Halifax, Nova Scotia,
1981

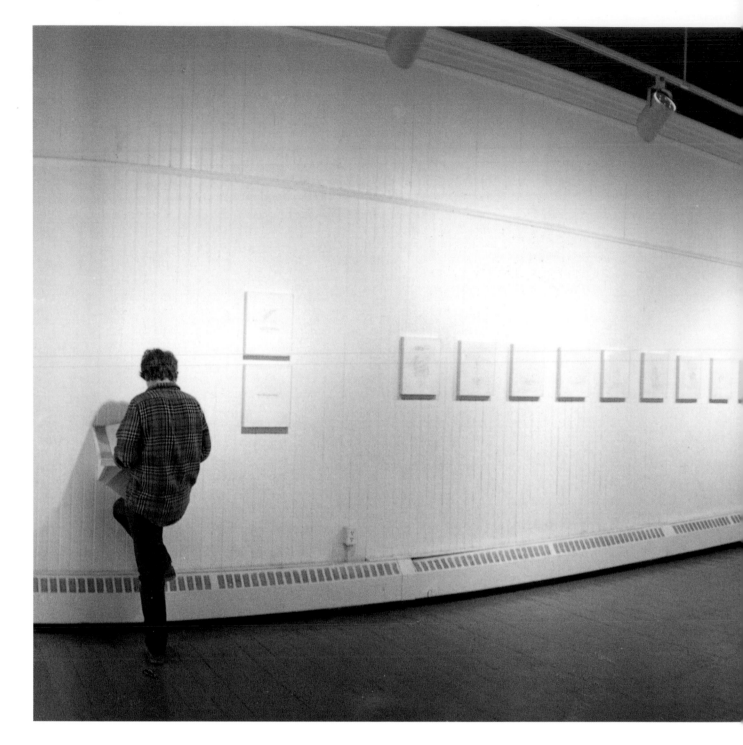

[…] Critical writing on art which places emphasis on the analysis of signifying practice
rather than on the exhortation or description of artistic auteurs, generally
acknowledges that art forms are inscribed within the social context that gives rise to
them. Nevertheless, there is a problematic tendency to constitute the pictorial text as
the paradigmatic insistence of that inscription in a way which forecloses the question of
its institutional placing. The pictorial paradigm constructs the artist's text as both
essentially singular and as centrally concerned with the practice of painting; but, as
Hubert Damisch has pointed out, when painting is considered at the semiotic level, that
is with reference to its internal system, it functions as an epistemological obstacle – an
obstacle never surmounted, only prodded by an endless redefinition of the sign or
averted altogether by taking the semantic route.[29] Perhaps to some extent this accounts
for what appears to be a certain impasse in the area of art criticism when compared, for

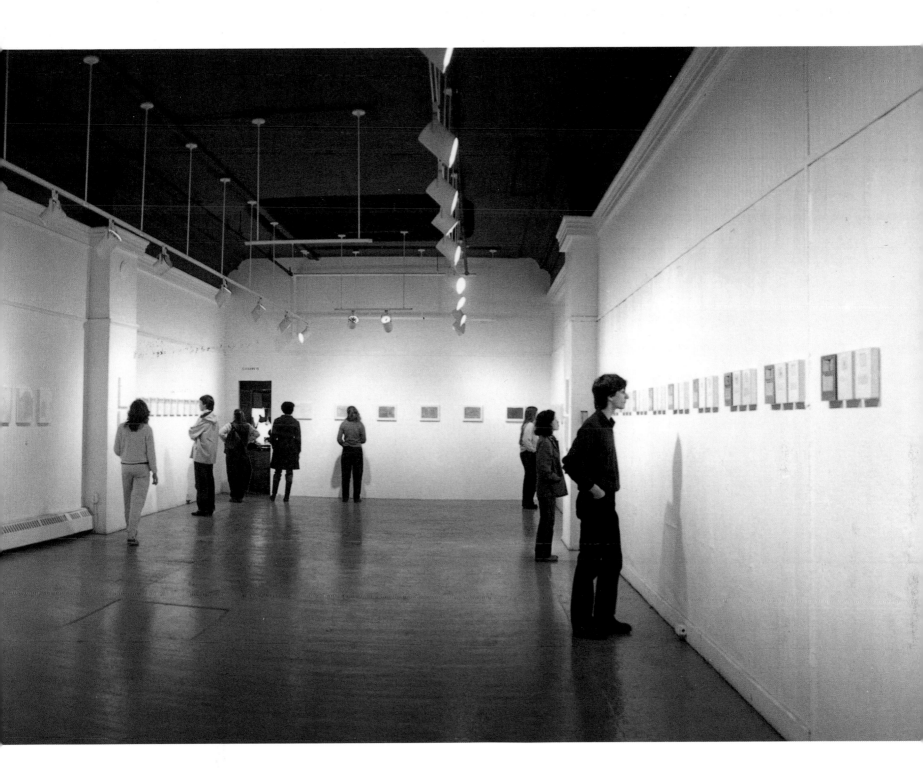

instance, with developments in film theory.

Critical texts have focused either on analysis of the individual tableau (sometimes an individual artist's oeuvre) or on the construction of general cultural categories and typologies of art. This work has been both necessary and important. The arguments outlined here are not so much against such contributions as for a reconsideration of what might constitute appropriate terms for the analysis of current practices in art. This reconsideration is prompted firstly by developments within particular practices. Feminist art, for instance, cannot be posed in terms of cultural categories, typologies or even certain insular forms of textual analysis, precisely because it entails the assessment of political interventions, campaigns, and commitments as well as artistic strategies. In this instance, interpretation is not simply a matter of what can be discovered at the interior of a composition. Secondly, a reconsideration of critical

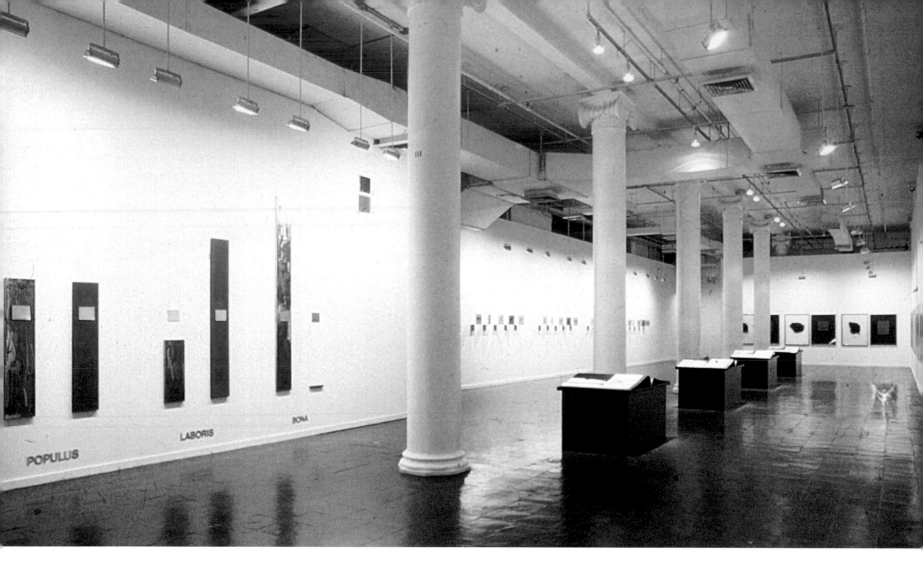

Interim
1984-89
Installation in four parts, *far left,*
Pecunia; *left,* **Potestas**; *centre,*
foreground, **Historia**; *right,*
Corpus
Dimensions variable
Installation, New Museum of
Contemporary Art, New York, 1990

methods is required if one takes account of the specific conditions which determine the organization of artistic texts and their readings at the present time; that is, *the temporary exhibition and its associated field of publications – the catalogue, the art book, and the magazine.* From this point of view, 'art' is never given in the form of individual works but is constructed as a category in relation to a complex configuration of texts.

In terms of analysis, the exhibition system marks a crucial intersection of discourses, practices and sites which define the institutions of art within a definite social formation. Moreover, it is exactly here, within this inter-textual, inter-discursive network, that the work of art is produced as text.

Rather schematically, it can be said that at one level an exhibition is a discursive practice involving the selection, organization and evaluation of artistic texts according to a particular genre (the one-person show, the group show, the theme exhibition, the historical survey, and the Annual, Biennial, etc.), displayed in certain types of institutions (museums, galleries), within specific legal structures (contractual agreements, fees, insurance), and preserved by definite material techniques in a number of ways (catalogues, art books, magazines). At another level, an exhibition is a system of meanings – a discourse – which, taken as a complex unit or enunciative field, can be said to constitute a group of statements; the individual works comprising fragments of imaged discourse or utterances which are anchored by the exhibition's titles, subheadings and commentary, but at the same time unsettled, exceeded or dispersed in the process of their articulation as events.

An exhibition takes place; its spatio-temporal disposition, conventions of display, codes of architecture, construct a certain passage; not the continuous progression of

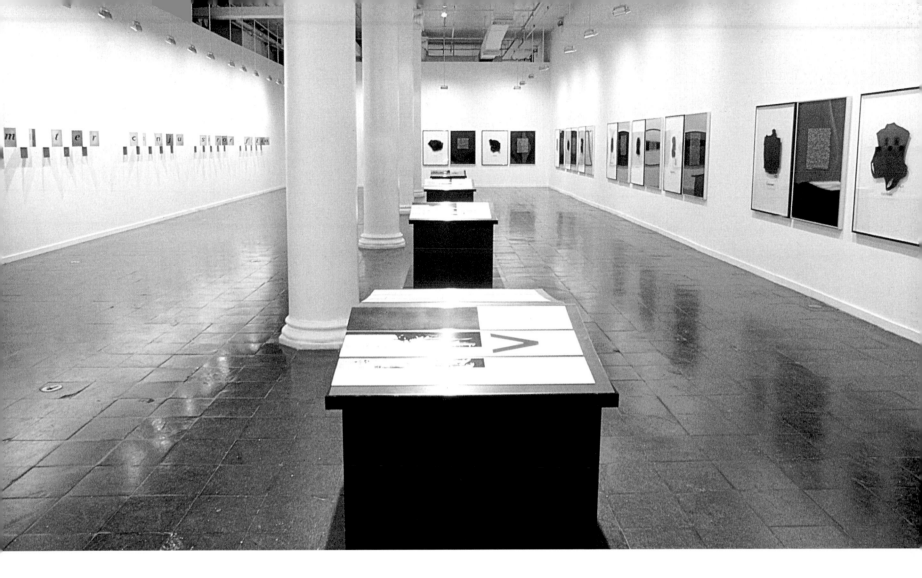

images unfolding on the cinema screen, but the flickering, fragmented frames of the editing machine; a passage very much at the disposal of the spectator to stop frame, rewind, push forward, it displays discernible openness, a radical potential for self-reflexivity. There is nevertheless a logic of that passage, of partition and naming, and in a sense there is a narrative organization of what is seen in the exhibition catalogue; its written (editorial/critical) commentary fixes the floating meaning, erodes the apparent polysemy of the exhibition's imaged discourse. Within a specific order of the book, the catalogue confers an authorship, an authority, on the exhibition events. In it, positions and statuses are assigned for 'agents' defined as artists, organizers, critics and 'the public'. The authors/organizers impose a declarative order on the exhibition's evasive discursivity (artists, it should be noted, are often the subjects of exhibition statements, but rarely the authors of its formulation). The catalogue constructs a specific reading, opens the space of a possible reworking or perhaps effects a closure; but it always has definite political consequences. This suggests that the catalogue is also an important site for interventions. Catalogue and exhibitions constitute what could be called a *diatext*, that is, two separate signifying systems which function together; more precisely, it is at the point of their intersection and crucially in their difference, that the production of a certain knowledge takes place.

The exhibition has a definite substantive duration. In its phenomenal form the installation is subject to the constraints of a definite site, it is only reproducible in a limited sense, but the catalogue remains. It is infinitely reproducible and moreover, it constitutes the determinant means of institutional control over the continued distribution of works of art. In this context, the absence of a catalogue also becomes significant. Artists generally maintain that the catalogue is more important than the

Interim
1984-89
Installation in four parts,
background left, **Potestas;**
background right, **Corpus;**
foreground, **Historia**
Dimensions variable
Installation, New Museum of
Contemporary Art, New York,
1990

Interim
1984-89
Installation in four parts,
background, **Corpus**; *foreground*,
Historia
Dimensions variable
Installation, New Museum of
Contemporary Art, New York, 1990

exhibition itself. It gives a particular permanence to temporary events, an authenticity in the form of historical testimony. Together with art books and magazines, exhibition catalogues constitute the predominant forms of receiving and, in a certain sense, possessing images of art. The exhibition remains the privileged mode of reception in terms of the viewer's access to the 'original' work, but far more often the reader's knowledge of art is based on reproductions in books and magazines. Critical theories of art founded on the notion of artisanal production fail to recognize that these historically specific means of organization, circulation, distribution, not only determine the reception – reading, viewing, reviewing, reworking – of artistic texts, but also have an effect on the signifying practices themselves. The phenomenon of artists' books, together with the emergence of specialist publishers, is now well known; this is often commented on, but rarely analysed in terms of the particular relations of representation it prescribes.

How is the work of art, now reproduced as photographic image, produced as the artistic text within the system of the book? What kind of readers and authors are positioned there? Obviously, there is the loss of material specificity – problems of black-and-white reproduction, aspect ratios, etc. – the characteristic homogenizing tendency of the book; but the difference between the reproduction in the catalogue and the original in the exhibition is not merely a question of photographic techniques. It is a question of particular practices of writing, of the gaps, omissions and points of emphasis through which certain images are outlined and others erased. The authorial discourse (organizer, critic or artist) constructs a pictorial textuality which pertains more to the readable than to the visible.

In this sense it would be appropriate to speak of quoting rather than illustrating artistic texts (although this is not to say they are essentially quotable). At one level the signifying structure of the pictorial quotation has something in common with the press photograph in so far as it presumes to 'record' the exhibition events or to identify the object to which the reproduction supposedly refers. This process of identification appears to be immediately fixed by the denominative function of the linguistic text which accompanies it: name, title, dimensions, medium. More crucially, however, it depends on a certain cultural knowledge, as Barthes suggested, a body of techniques and practices already read as art.[30] This reading is grounded in the academic discourse of Fine Art and circumscribed by the limits of its traditional regimes: Architecture, Painting and Sculpture.

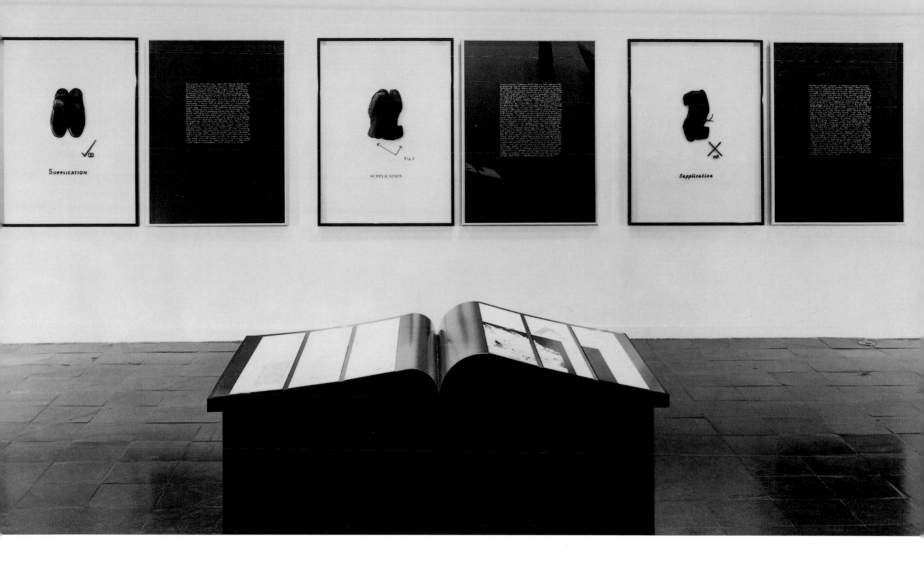

The quotation subscribes to a form of pictorial rhetoric which defines those regimes (and the varied practices they subsume) in terms of medium: thus, painting's pictorial quality, its one-dimensionality, is signified by the correspondence of frame to edge of photograph; video by the framing edge of the monitor and the 'grain' of an electronically transmitted image; sculpture's three-dimensionality by lighting or architectural setting; performance, similarly, by an establishing shot (i.e., performer in context of audience, camera, etc.); photography also relies on an installation shot or the repetition of units to signify its fine art context. But the pictorial quotation seems to be subject to a double imperative which repeats the dilemma of modernist criticism; while identifying the art object in terms of medium, at the same time it must establish the unique and individuating style of a particular artist's work. Hence there is also the 'artistic photograph': the detail, the interesting composition which displaces the record. It gives the appearance of transgression, but effectively it is a fragment, a metonymy, enveloped by the all-pervasive pictorial metaphor, addressing the reader with continued reference to the grand regime of Painting.

However, if the work of art is extracted from the discursive system in which it is established as statement, as event, then it is possible not only to construct a rather utopian view of the pictorial text as essentially concerned with a single picture, but also to assume, as Raymond Bellour does in 'The Unattainable Text', that unlike the filmic text 'the pictorial text is in fact a quotable text'.[31] The concept of pictorial quotability suppresses the diversity of artistic practices in so far as it foregrounds a particular system of representation, the painting. Moreover, when he adds, 'From the critical point of view it has one advantage that only painting possesses: one can see and take in

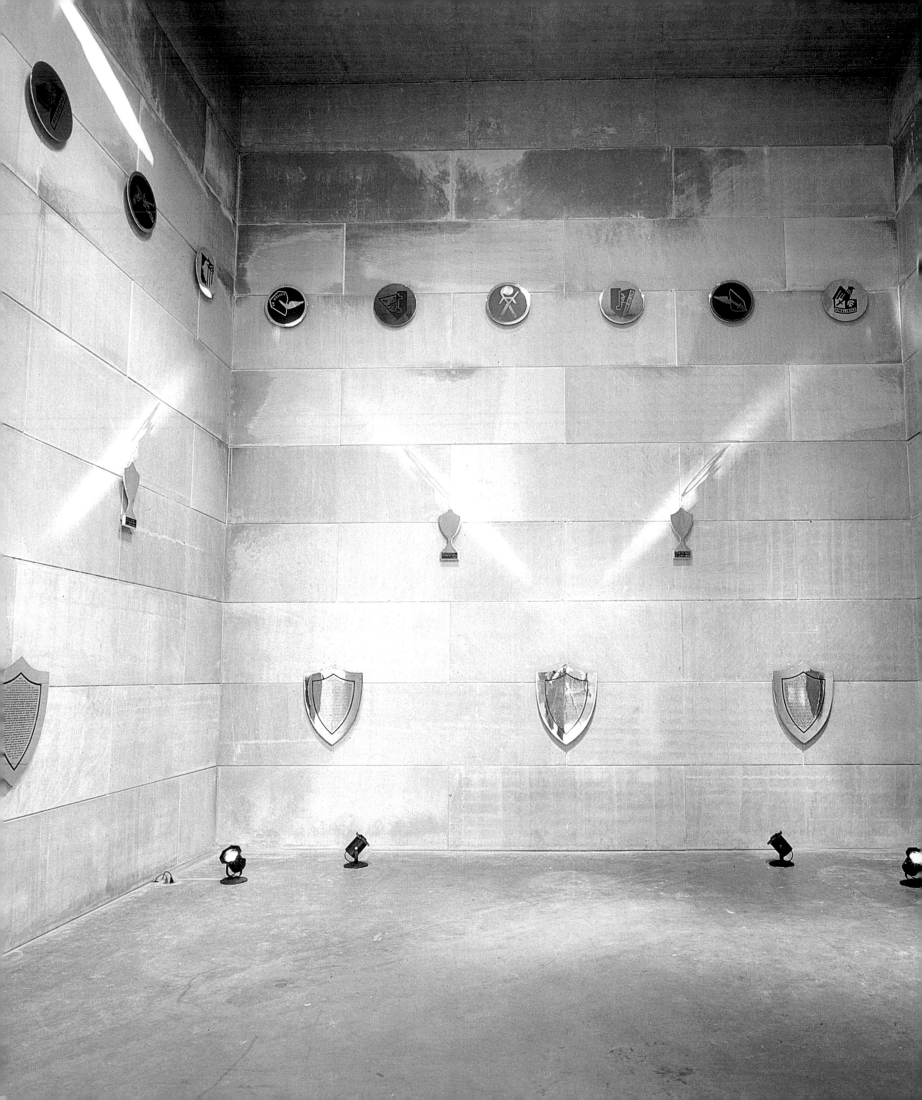

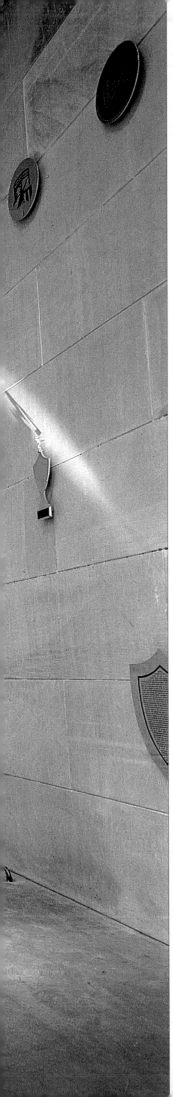

the work at one glance', another problem is posed: precisely what forms of painting possess this advantage of being taken in at a glance? Here Bellour's perceptual emphasis implicates his arguments with those of modernist criticism by constructing a similar object, namely, the purely visual, uniquely flat, abstractionist painting which illustrates Greenberg's pictorial paradigm.

Consequently, even if, at the centre of that paradigm, it is not the truth of an author but that of the signifier itself which is sought, as long as the site of that search is designated as the object or even the system 'Painting', a problem remains. On the one hand the pictorial text, with reference to the object, is too easily attained – taken in at a glance; on the other hand, as Damisch described it, pictorial textuality is constituted in a divergence between the register of the visible and that of the readable, 'A divergence by way of which it is appropriate, in relation to the system Painting to pose the question of the signifier'. But since the signifier cannot be produced or even recognized by way of a position of exteriority, the effect of painting, like that of the dreamwork, is created 'outside any relation of interpretation'.[32] The truth of painting, like that of the signifier, is the impossibility of knowing it. And the pictorial text remains in a certain sense unknowable, impossible, unattainable. That is why it now seems more appropriate, in relation to the signifying system of the artistic text, to pose, not the question of the signifier but that of the *statement:* as Foucault suggests, 'to situate these meaningful units in a space in which they breed and multiply'.[33]

29 See Hubert Damisch, 'Eight Theses For (or Against?) a Semiology of Painting', *enclitic* 3, no. 1, Spring, 1979, pp. 1–15

30 See Roland Barthes, 'Rhetoric of the Image', *Image-Music-Text*, trans. Stephen Heath, Hill and Wang, New York, 1977

31 Raymond Bellour, 'The Unattainable Text', *Screen* 16, no. 3, London, Autumn, 1975, pp. 21–22

32 Hubert Damisch, op. cit., pp. 14–15

33 Michel Foucault, *The Archaeology of Knowledge*, Pantheon Books, New York, 1972, p. 100, trans. A.M. Sheridan Smith

Screen, Vol. 22, No.3, 1981, London, pp. 41-62. Re-printed in *Art After Modernism: Rethinking Representation*, ed. Brian Wallis, The New Museum of Contemporary Art in association with David R. Godine, New York and Boston, 1984, pp. 86-103 and in *Imaging Desire, Mary Kelly Selected Writings*, MIT Press, Cambridge, Massachusetts, 1996

Gloria Patri
1992
31 units
Dimensions variable
Installation, Ezra and Cecile
Zilkha Gallery, Wesleyan
University, Middletown,
Connecticut, 1992

Desiring Images/Imaging Desire (extract) 1984

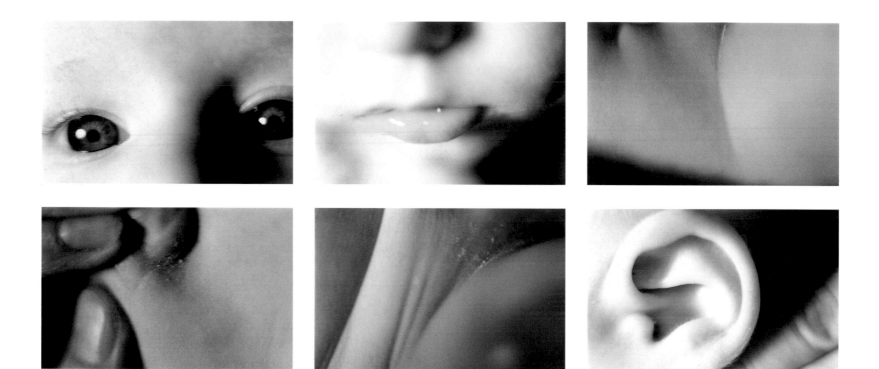

'In this matter of the visible', said Lacan, 'everything is a trap'.[1] The field of vision is ordered by the function of images, at one level, quite simply by linking a surface to a geometric point by means of a path of light; but at another level, this function seems more like a labyrinth. Since the fascination in looking is founded on separation from what is seen, the field of vision is also, and most appropriately, the field of desire. Here the viewer enters the realm of lost objects, of vanishing points determined, not by geometry, but by what is real for the subject; linked not to a surface but to a place – the unconscious; not by means of light but by the laws of primary process.

In this matter of images of women then, it would seem that everything is doubly labyrinthine. Desire is embodied in the image which is equated with the woman who is reduced to the body which in turn is seen as the site of sexuality and the locus of desire … a familiar elision; almost irresistible it would seem judging from the outcome of so many conference panels and special issues devoted to this theme. Nevertheless, it is a dangerous and circuitous logic that obscures a certain 'progress'; a progression of strategies, of definitions made possible within feminist theory by the pressure of a political imperative to formulate the 'problem' of images of women as a question: how to change them. The legacy is not a through-route, but a disentangling of paths that shows more clearly their points of intersection and draws attention to the fact that it is not obligatory to start over again at the beginning.

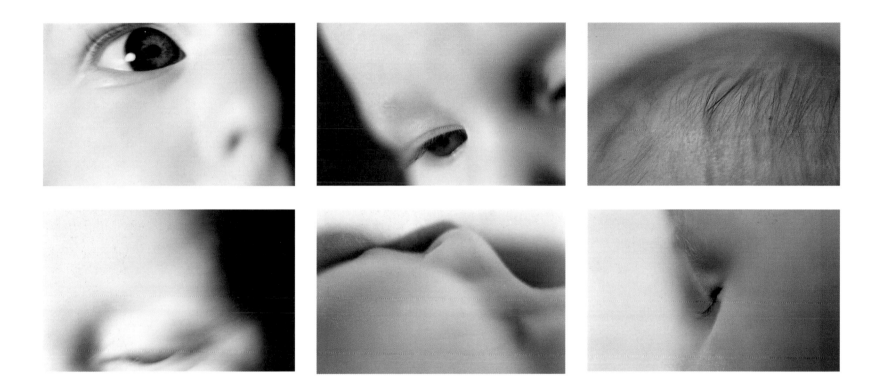

Discourses of the body and of sexuality, for instance, do not necessarily coincide. Within the modernist paradigm, it is not the sexual body, but the phenomenological (Husserlian) body that takes precedence; what belongs to me, my body, the body of the self-possessing subject whose guarantee of artistic truth is grounded in 'actual experience', often deploying the 'painful state' as a signature for that ephemeral object. Thus, the contribution of feminists in the field of performance has been, exactly, to pose the question of sexuality across the body in a way which focuses on the construction of the sexed subject, and at the same time problematizes the notion of the artist/auteur. The body is decentred, radically split, positioned; not simply my body, but his body, her body. Here, no third term emerges to salvage a transcendental sameness for aesthetic reflection. Yet, these artists continue to counterpose a visible form and a hidden content; excavating a different order of truth – the 'truth' of the woman, her original feminine identity. Although the body is not perceived as the repository of this truth; it is seen as a hermeneutic image; the enigma of femininity is formulated as a problem of imagistic mis-representation which is subsequently resolved by discovering a true identity behind the patriarchal façade.

The enigma, however, only seems to encapsulate the difficulty of sexuality itself and what emerges is more in the order of an underlying contradiction than an essential content. The woman artist sees her experience as a woman particularly in terms of the

'feminine position', that is, as the object of the look, but she must also account for the 'feeling' she experiences as the artist, occupying what could be called the 'masculine position' as subject of the look. The former she defines as the socially prescribed position of the woman, one to be questioned, exorcized or overthrown, while the implication of the latter (that there can be only one position with regard to active looking and that is masculine) cannot be acknowledged and is construed instead as a kind of psychic truth – a natural, instinctual, pre-existent and possibly unrepresentable femininity.[2] Often, the ambivalence of the feminist text seems to repudiate its own claim to essentialism; it testifies instead to what extent masculine and feminine identities are never finally fixed, but are continually negotiated through representations. This crisis of positionality, this instability of meaning revolves around the phallus as the term which marks the sexual division of the subject in language. Significantly, Lacan describes the woman's relation to the phallic term as a disguise, a masquerade.[3] In being the phallus for the other, she actively takes up a passive aim, becomes a picture of herself, erects a facade. Michèle Montrelay suggests 'that the woman will disguise herself with the lack, throwing into relief the dimension of castration as trompe-l'oeil'.[4] Behind the facade, finally, there is not 'true' woman to be discovered. Yet, there is a dilemma: the impossibility of being, at once, both subject and object of desire.

Clearly, one (so-called post-feminist) response to this impasse has been to adopt a strategy of disavowal. It appears in the guise of a familiar visual metaphor: the androgyne. She *is* a picture; an expressionistic composite of looks and gestures which flaunts the uncertainty of sexual positioning. She refuses the lack, but remains the object of the look. In a sense, the fetishistic implications of not-knowing merely enhance the lure of the picture, effectively taming the gaze (a *dompte-regard*, as Lacan proposes), rather than provoking a de-construction. Another (and perhaps more politically motivated) tactic has been to assume self-consciously the 'patriarchal facade'; to make it an almost abrasive and cynical act of affirmation. By producing a representation of femininity in excess of conventional codes, it shatters the narcissistic structure which would return the woman's image to her as a moment of completion. This can induce the alienating effect of a mis-recognition, but the question persists: how can she represent herself as subject of desire?

The (neo-)feminist alternative has been to refuse the literal figuration of the woman's body, creating significance out of its absence. But this does not signal a new form of iconoclasm. The artist does not protest against the 'lure' of the picture. In another way, however, her practice could be said to be blasphemous in so far as she

seeks to appropriate the gaze behind it (the place of gods, of auteurs and evil eyes). In her field of vision femininity is not seen as a pre-given entity, but as the mapping out of sexual difference within a definite terrain, a moment of discourse, a fragment of history. With regard to the spectator, it is a tactic of reversal, attempting to produce the woman, through a different form of identification with the image, as the subject of the look […]

Desire is caused not by objects, but in the unconscious, according to the peculiar structure of fantasy. Desire is repetitious, it resists normalization, ignores biology, disperses the body. Certainly, desire is not synonymous with images of desirable women; yet, what does it mean, exactly, to say that feminists have refused the 'image' of the woman? First, this implies a refusal to reduce the concept of the image to one of resemblance, to figuration or even to the general category of the iconic sign. It suggests that the image, as it is organized in that space called the picture, can refer to a heterogeneous system of signs – indexical, symbolic and iconic. And thus, that it is possible to invoke the non-specular, the sensory, the somatic, in the visual field; to invoke, especially, the register of the invocatory drives (which, according to Lacan, are on the same level as the scopic drives, but closer to the experience of the unconscious), through 'writing'. Secondly, it should be said that this is not a hybrid version of the 'hieroglyph' masquerading as a 'heterogeneity of signs'. The object is not to return 'the feminine' to a domain of pre-linguistic utterance; but rather, to mobilize a system of *imaged discourse* capable of refuting a certain form of 'culturally overdetermined' scopophilia. But why? Would this release the 'female spectator' from her hysterical identification with the male voyeur?

Again, the implications of suggesting that women have a privileged relation to narcissism or that fetishism is an exclusively male perversion should be re-considered. Surely, the link between narcissism and fetishism is castration. For both the man and the woman this is the condition for access to the symbolic, to language, to culture; there can be no privileged relation to madness. Yet there *is* difference. There is still that irritating asymmetry of the Oedipal moment. There is Freud's continual emphasis on the importance of the girl's attachment to her mother. And there is Dora.[5] What *did* she find so fascinating in the picture of the Sistine Madonna? Perhaps, above all, it was the possibility of seeing the woman as subject of desire without transgressing the socially acceptable definition of her as the mother. To have the child as phallus; to be the phallic mother; to have the pleasure of the child's body; to have the pleasure of the maternal body experienced through it; perhaps, in the figure of the Madonna, there was a duplication of identification and desire that only the body of another woman could sustain.

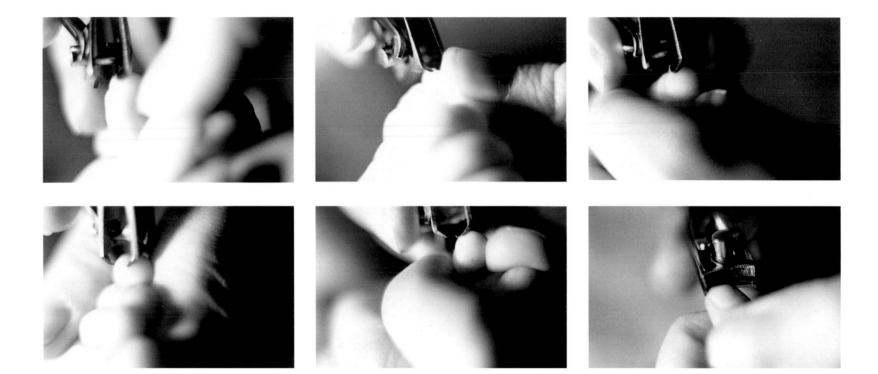

Primapara, Manicure/Pedicure Series
1974
10 black and white photographs
7.5 × 11 cm each

For both the man and the woman, the maternal body lines the seductive surface of the image, but the body *he* sees is not the same one *she* is looking at. The woman's relation to the mother's body is a constant source of anxiety. Montrelay claims that this relation is often only censored rather than repressed. As a consequence the woman clings to a 'precocious femininity', an archaic oral-anal-vaginal or *concentric* organization of the drives which bars her access to sublimated pleasure (phallic *jouissance*).[6] Similarly, with regard to the artistic text, and if pleasure is understood in Barthes' sense of the term as a loss of preconceived identity, rather than an instance of repletion; then it *is* possible to produce a different form of pleasure for the woman by representing a specific loss – the loss of her imagined closeness to the mother's body. A critical, perhaps disturbing sense of separation is effected through the visualization of exactly that which was assumed to be outside of seeing; precocious, unspeakable, unrepresentable. In the scopic register, she is no longer at the level of concentricity, of repetitious demand, but of desire. As Lacan points out, even the eye itself belongs to this archaic structure since it functions in the field of vision as a lost object.[7] Thus, the same movement which determines the subject's appearance in language, that is, symbolic castration, also introduces the gaze. And the domain of imaged discourse.

Until now the woman as spectator has been pinned to the surface of the picture, trapped in a path of light that leads her back to the features of a veiled face. It seems

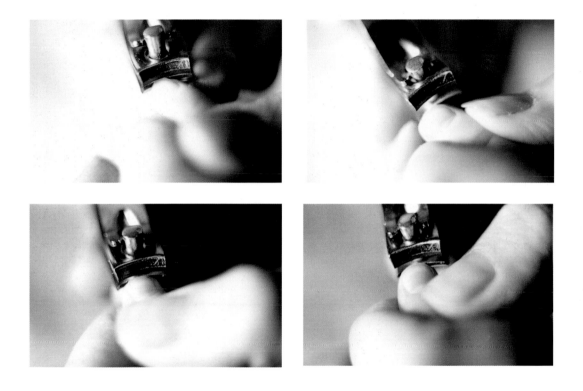

important to acknowledge that the masquerade has always been internalized, linked to a particular organization of the drives, represented through a diversity of aims and objects; but without being lured into looking for a psychic truth beneath the veil. To see this picture critically, the viewer should be neither too close nor too far away.

1 Jacques Lacan, 'The Line and Light', *The Four Fundamental Concepts*, ed. M. Masud, trans. R. Khan, Hogarth Press, London, 1977, p. 93

2 Mary Kelly, 'Re-Viewing Modernist Criticism', *Screen*, Vol. 22, No. 3, London, 1981, pp. 53-56. Republished in this volume pp. 112-19

3 See Jacques Lacan, 'The Signification of the Phallus', 1958, *Feminine Sexuality*, eds. Juliet Mitchell, Jacqueline Rose, Macmillan, London, 1982

4 Michèle Montrelay, 'Inquiry into Feminity', *m/f*, no. 1, London, p. 92

5 See Sigmund Freud, 'Fragment of an Analysis of a Case of Hysteria', 1901, Standard Edition, Vol. VII, trans. James Strachey, Hogarth Press, London, 1968

6 Michèle Montrelay, op. cit., pp. 86-99

7 Jacques Lacan, 'What is a Picture', *The Four Fundamental Concepts*, op. cit., p. 118

First presented as a paper at the conference 'Desire' at the Institute of Contemporary Arts, London, 1983. Published in *Wedge*, no. 6, New York, 1984 and re-published in *Instabili: la question du sujet*, La Galerie Powerhouse, Centre d'information Artexte, Montreal, 1990, pp. 24-28, and in *Imaging Desire, Mary Kelly Selected Writings*, MIT Press, Cambridge, Massachusetts, 1996.

*right, opposite and following
pages,* **Interim Part I: Corpus**
(details, **Extase**)
1984–85
Laminated photo positive,
silkscreen, acrylic on Plexiglas
6 of the 30 panels,
90 × 122.5 cm each

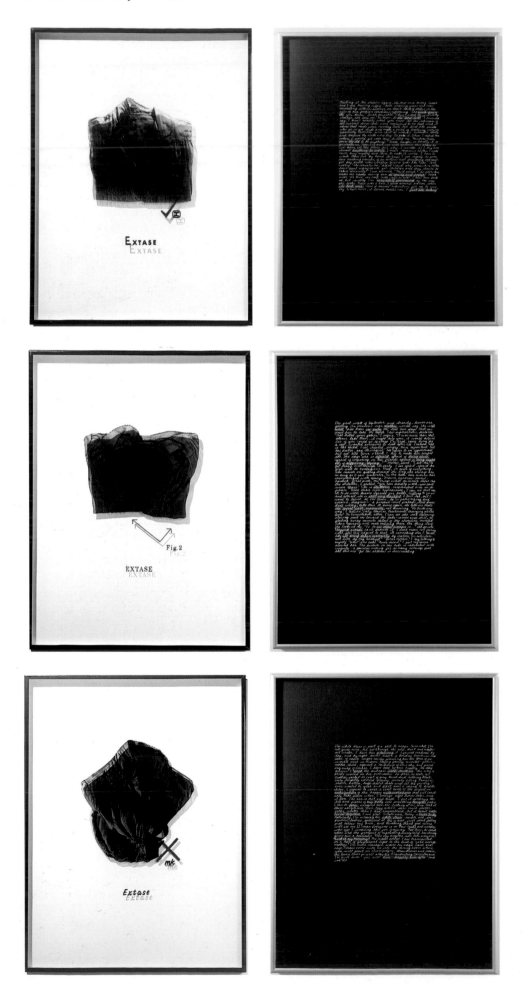

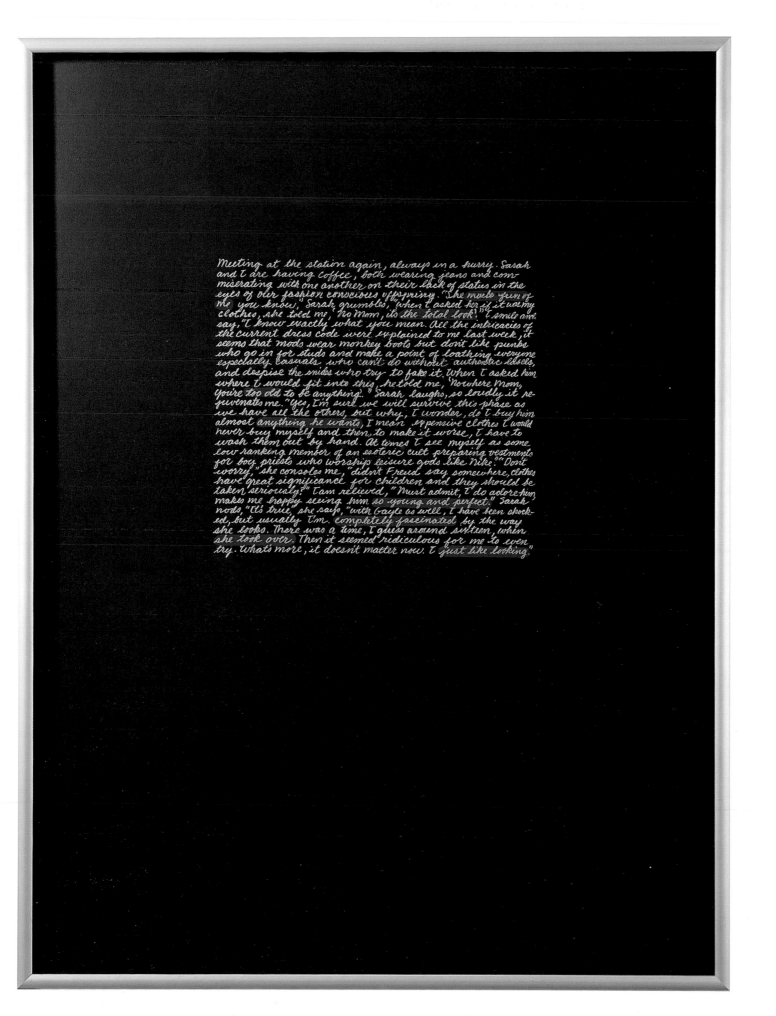

Meeting at the station again, always in a hurry. Sarah and I are having coffee, both wearing jeans and commiserating with one another on their lack of status in the eyes of our fashion conscious offspring. "She made fun of me you know," Sarah grumbles, "when I asked her if it was my clothes, she told me, 'no Mum, its the total look'." I smile and say, "I know exactly what you mean. All the intricacies of the current dress code were explained to me last week, it seems that mods wear monkey boots but don't like punks who go in for studs and make a point of loathing everyone especially casuals who can't do without authentic labels, and despise the snides who try to fake it. When I asked him where I would fit into this, he told me, 'Nowhere Mum, you're too old to be anything'." Sarah laughs, so loudly it rejuvenates me. "Yes, I'm sure we will survive this phase as we have all the others, but why, I wonder, do I buy him almost anything he wants, I mean expensive clothes I would never buy myself and then, to make it worse, I have to wash them out by hand. At times I see myself as some low ranking member of an esoteric cult preparing vestments for boy priests who worship leisure gods like Nike.""Don't worry," she consoles me, "didn't Freud say somewhere, clothes have great significance for children and they should be taken seriously." I am relieved, "Must admit, I do adore him, makes me happy seeing him so young and perfect." Sarah nods, "Its true," she says, "with Gayle as well, I have been shocked, but usually I'm completely fascinated by the way she looks. There was a time, I guess around sixteen, when she took over. Then it seemed ridiculous for me to even try. What's more, it doesn't matter now. I just like looking."

The first week of September and already, leaves are falling. An ominous sign, mother would say. She is not well, has been in pain the last two days. Can't convince her to take the tablets. She's superstitious, declares, "That killed your father." I argue, "It was more than that, please take them, it might help you, it would help me too if you could go to sleep. I'm tired, came home for a rest, wanted someone to look after me. Instead she is the child. Feel cheated, angry, then repentant. Call the doctor, say it's urgent. He agrees to an appointment but not till four o'clock. I try to make her comfortable. She says she is afraid, afraid of being alone, afraid of imposing on her friends, afraid of being neglected, of suffering, dying..." "Mother, don't," I ask her to get ready even though it's early. I am afraid, afraid her fear will be contagious. Then, in spite of everything, she insists on getting dressed the way she always has as long as I can remember, "to the teeth." Her auburn hair immobilized with spray, brown eyebrow-pencil, lipstick—coral pink, the crisp white summer dress. And the stilettos. I protest, "you can hardly walk, you can't wear those." She is stubborn, resplendent even in defiance. More than mere appearance, I can see that now, it's to do with heroes dressed for battle, willing to go on. And after all, she is still very beautiful. I love her, but I want to leave. At the clinic, he is patronising and evasive, diagnosis—a pinched nerve perhaps, don't know, don't worry, take this. At home again, she tells me that's the worst part, insecurity, not knowing. "No truth anyway," I lecture, "only theories, treatments, changing all the time." No consolation either. I can see she isn't listening, staring past me toward the lake—serene and still, reflecting every minute detail of the shoreline, inviting like a memory and more enticing than the thing itself. She looks at me, "To be an older woman is..." she pauses, "beyond words, can't describe it. I don't mean not feeling well, you can adjust to that, it's something else I think, like not being taken seriously by doctors or solicitors, not even by my analyst." "Dora's mother," I say, talking to myself. "Who?" she asks. "Never mind," I put my arms around her. The picture on the lake is saturated with magenta—a familiar ending for so many evenings just like this one. Yet the stillness is disconcerting.

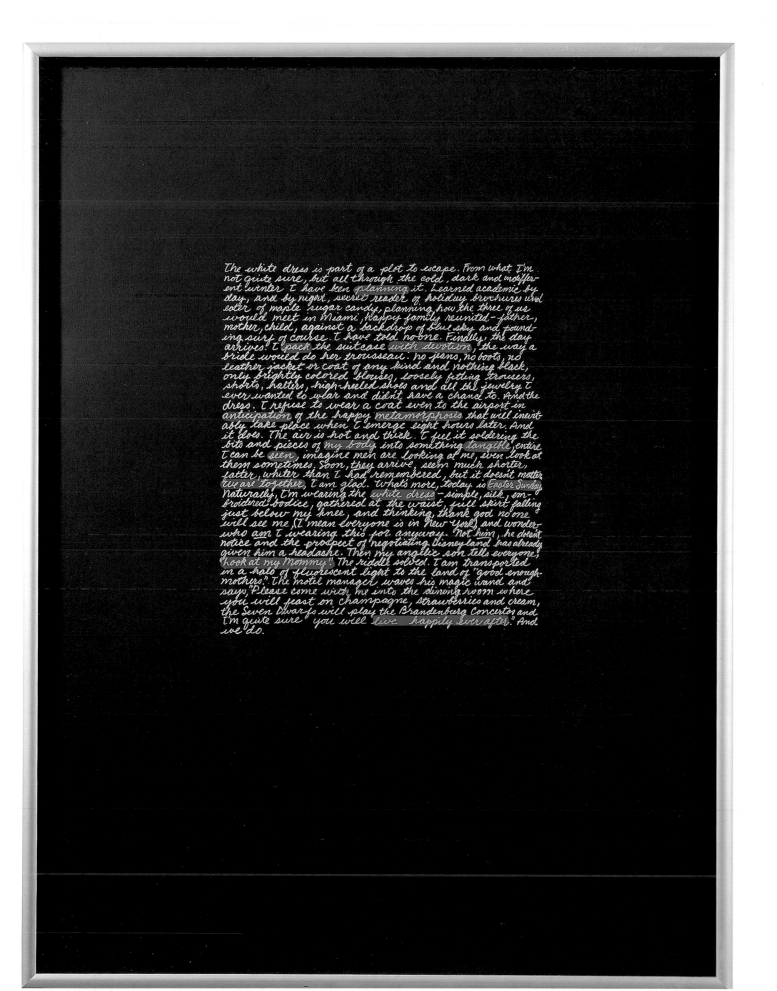

The white dress is part of a plot to escape. From what I'm not quite sure, but all through the cold, dark and indifferent winter I have been planning it. Learned academic by day, and by night, secret reader of holiday brochures and eater of maple sugar candy, planning how the three of us would meet in Miami, happy family reunited — father, mother, child, against a backdrop of blue sky and pounding surf of course. I have told no one. Finally, the day arrives. I pack the suitcase with devotion, the way a bride would do her trousseau: no jeans, no boots, no leather jacket or coat of any kind and nothing black, only brightly colored blouses, loosely fitting trousers, shorts, halters, high-heeled shoes and all the jewelry I ever wanted to wear and didn't have a chance to. And the dress. I refuse to wear a coat even to the airport in anticipation of the happy metamorphosis that will inevitably take place when I emerge eight hours later. And it does. The air is hot and thick. I feel it soldering the bits and pieces of my body into something tangible, entire. I can be seen, imagine men are looking at me, even look at them sometimes. Soon, they arrive, seem much shorter, fatter, whiter than I had remembered, but it doesn't matter. We are together, I am glad. What's more, today is Easter Sunday. Naturally, I'm wearing the white dress — simple, silk, embroidered bodice, gathered at the waist, full skirt falling just below my knee, and thinking, thank god no one will see me (I mean everyone is in New York), and wondering who am I wearing this for anyway. Not him, he doesn't notice and the prospect of negotiating Disneyland has already given him a headache. Then my angelic son tells everyone, "Look at my Mommy." The riddle solved. I am transported in a halo of fluorescent light to the land of "good enough mothers". The motel manager waves his magic wand and says, "Please come with me into the dining room where you will feast on champagne, strawberries and cream, the Seven Dwarfs will play the Brandenburg Concertos and I'm quite sure you will live happily ever after." And we do.

Conversation with Griselda Pollock (extract) 1989

[…] **Griselda Pollock** Something that does particularly interest me about the practice of making art is the process of thinking about the forms of things. One of the things I'm fascinated by in your work, Mary, is how carefully the formats, the forms, the physical appearance, the aesthetic dimension are thought through. On so many occasions your work has been described in terms of the theory that it seems to deploy. People consider it difficult, over-theoretical, hence distancing. Yet to me your work reveals so much consideration of the experience of the work as something that you engage with on many, many levels. I'd be interested in the decisions you make about the making of your art. At the moment you're going through the process of thinking out the next two parts of *Interim* and your calculations are an area that I find extremely interesting.

Mary Kelly **First of all, it's not such a comfortable position to be involved in a practice of writing as well as a visual practice of art, because this became rather unfashionable in the 1980s, after that moment, in the late 1960s and early 1970s, when part of the so-called Conceptual Art project was for artists to take control over all the levels of reception of the work. There was much more writing.**

But there wasn't a lot of writing by women. I remember this very distinctly, being kind of confrontational with people like Art and Language, and very definitely engaging with someone like Joseph Kosuth, and I thought, 'If women don't do that – make this critical overview – then their work will not have the kind of presence that it needs to, historically'. But towards the end of the 1970s, as everyone knows all too well, when the postmodern debate emerged, and then consolidated around the revival of more traditional practices, artists made a very self-conscious effort *not* to talk about their work. Now, if you do talk about the work, then people automatically think you're not visual. That's a product of a particular moment. I'm just trying to put it into a historical perspective. It's not always like that. You can go right through history and see that there are moments when artists were assumed to be articulate and other moments when they were not. And certainly it's around the re-establishing of the *expressive* moment, a particular kind of painting which valorizes what's considered to be something outside of the written or spoken forms of linguistic signs, that you get that emphasis. I think it's probably underlying the approach to my work that would say it's more engaged in the ideas than the making of it. But for me it's a combined process.

As I've emphasized before, when I speak about it, my way of working is a visualization and a theorization simultaneously. In fact, I usually don't write something about it until afterwards, and I work out the problems, or engage in the debates that I'm

interested in, partly as a visual means, and this is not very easy to describe. I'm sorry I have to resort to some kind of essentialism here, but how do you describe a feeling for certain materials, how you make that translation? It's interesting to see how much the whole idea of metaphor is central to what causes visual pleasure. One of the examples that I could think of, in terms of what was very pleasurable for me in making it, was in the second part of *Interim Part II: Pecunia*. I based it on the greeting card. I was very fascinated by this idea. I usually take things from popular culture that initially interest me, and there was a certain look, size, scale and everything to this card which you wouldn't just literally appropriate, but which I wanted to re-present some way. I came up with an idea that would be an all-in-one, folded piece of steel, starting on the wall, attached to the wall, coming out, and then opening up. Just the economy of that – the fact that it wasn't like a book leaning backwards on a podium. It just had that look of the card, but it took on another whole dimension of meanings by the translation into that material. But the shape in itself wasn't enough. The shape was not good enough. I tried a lot of different processes because I didn't want to go to the extreme of enamelling it. Obviously I could create the colours of the greeting cards and the flashy surfaces and I might get, also, the metaphor for a car or a refrigerator or something, which would be good, but that seemed to be too close. It didn't allow something else I needed – another level of associations to do with money, which was the theme of the piece. Finally, after trying some different galvanizing and iodizing processes, we came up with one kind of zinc process, which made the steel look iridescent. It's actually a very cheap process that they use to keep things from rusting; in fact, it has the quality of brass or copper – a kind of mix. So it also had the *sentiment*; that look of sentimentality of the cards, but it got the other level. When I saw it, when it came back from the metal company, I jumped up and down, after just the day before reaching the lowest possible ebb when I saw the first result of another process. If you're involved in a construction of meaning that's tying together form with content, then it's primarily the ideas that you're working with that are prompting you to take on the problems of different media.

So, it's not as though I get stylistically attached, or make a particular media my trademark. That's definitely not what it's about. It's finding the most appropriate thing for each one of the sections, which means there's a lot of so-called visual research which has to be done on each section. I'd just mastered the screen printing and knew how the Plexiglas worked and then I had to understand what the steel was like. You couldn't possibly, in my case, use the same means in the second piece that you used in

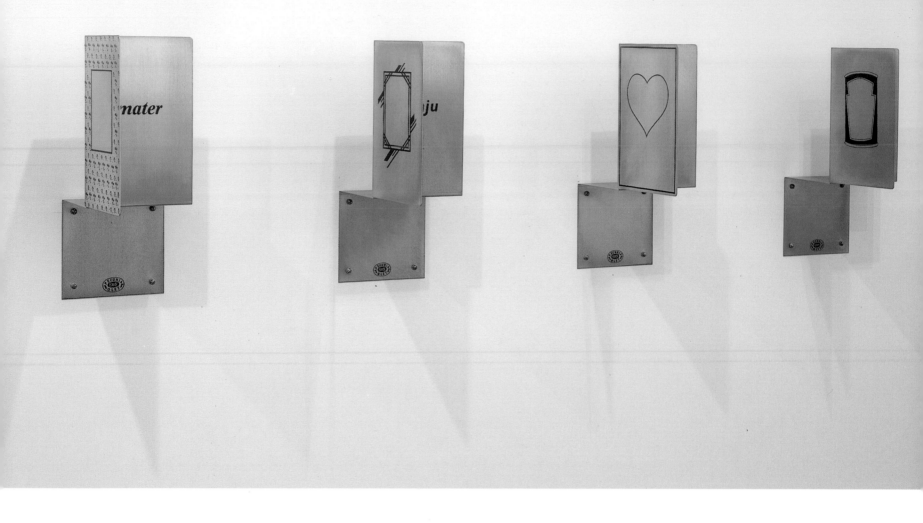

above, **Pecunia Minor**
1989
Silkscreen on galvanized steel
4 units, 40 × 16 × 29 cm each

opposite, **Interim Part II: Pecunia**
(detail, **Soror**)
1989
Silkscreen on galvanized steel
1 of the 20 units,
40 × 16 × 29 cm each
Collection, Vancouver Art Gallery

the first, because the first was about the body and about the image and needed that reflective surface, and the second was about something else. I could say, just extending that, that I couldn't possibly, in *Interim*, use found objects the way I did in *Post-Partum Document*. People would say after *Documentation VI* (the one that I cast on the slates), 'Well, why don't you do a lot of these?' Everyone wanted to buy them. I have found it almost impossible to make a one-off work outside of a series that would be something to be sold in its own right. I'm only saying that because I'm trying to describe how integrated this is, as a project and as a process […]

Pollock I was talking last night[2] about the possibilities for formulating languages in which we can talk about the formal processes of art-making in non-mystical terms. Traditional notions of the aesthetic and form have a very suspect ideological relationship in general but also to questions of sexuality, because they cover over those signifying and psychic processes on which Kristeva's theory of the semiotic has begun to provide a handle.

Again, to go back to the theory of linear time,[3] it's not a question of a 'before' or 'after'. You have to hypothesize the basis on which you're going to arrive at the structures necessary for the artwork's realization. But once you have structures, their bases don't come before; they are dialectically involved in being the conditions of the structure, and also the condition of the change and transformation of them. So, Kristeva's theory, in the territory of aesthetic practice of literature, poetry, art and music, works precisely at all those thresholds and boundaries. Forms are definitively part of the Symbolic and part of culture, but they may have a different set of exchanges, with the constant and necessary components of all language at both their formal level and the level at which they articulate with the drives, the psychic freight underlying formal meaning.

She wanted her _and_ she
wanted all of her clothes.

Kelly **There is a difficulty with this because there is something so fundamental about the process that she describes; that is to say that the child's first experience of the mother's body as this array of sound and colour, and the space that the mother's word occupies there, being perhaps the founding moment of something like a metaphorical relation. You can say that underlies all art work. There's something just too fundamental about it to be very useful, I think. Your question provokes me to remember this, but also it's available to apply to absolutely everything. So I think I was more interested in saying, given this, what do you actually do with it? What specific use does the artist make of that kind of potential? […]**

Pollock I find that the process of writing has the same sense of 'recognition', but also the sense of _discovery_. It's not clear, when you are writing, what you are writing. So it's not that there's a discreteness about the visual and then you write about it. But what you're describing seems to be a process of constant interaction and exchange. Now, there are certain kinds of mysticisms that go with that, which have come to be represented in 'studio conversations'. For example, people imagine having a conversation with the canvas, interactively, and it feeds back. This ignores the question of who was actually the site of this exchange, the localization of it, which is _you_ as a subject. This connects with the notion that I was trying to work out in _Vision and Difference_, with regard to Mary Cassatt and Berthe Morisot, as some kind of general theory for myself. There are certain ways in which we study women artists, for example, and we go along with the assumptions that, because they're women, we should start searching their canvases for certain qualities. And to some extent, I still hang on to the idea that as women they are different. There's something there; and I've got to find a way to find out what it is.

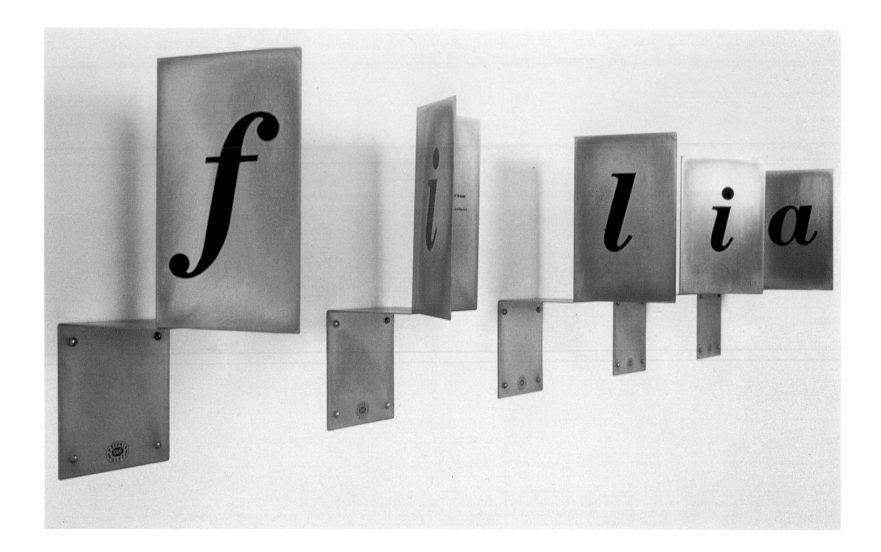

Interim Part II: Pecunia
(detail, **Filia**)
19895
Silkscreen on galvanized steel
5 of the 20 units,
40 × 16 × 29 cm each
Collection, Vancouver Art Gallery

But it's more in the sense that the studio is an arena of performance, of enactment, with these processes of exchange, and something gets put into the canvas which then acts as a representation back to the person who's painting it; it produces a social image of what they've been doing, which then becomes constitutive of a certain kind of self-knowledge and awareness. So I'm qualifying the kind of 'recognition' of some things which we might be slightly mystical about – that works, that's it, that's perfect, that's lovely – and I think you can get at much more by theorizing about the *processes* of pleasure.

This would propel us into the territory of 'the imaginary', which is where things appear simplistically as either good or bad. The imaginary operates antithetically to this notion of having a theory about the process and practice, which is why this kind of theory so consistently emphasizes studio work or any other kind of cultural work as a *practice*, because you say, 'Here's an institution or here's a scenario; here's a social space in which social actions are taking place with social materials, very highly specialized, very intensely enacted'. But what is it that you are recognizing that works when Mary jumps up and down? It's not because she's having a pure moment of visual recognition. It's because all of these complicated processes have found a signifying *form* and in that form what you recognize is the sense of a sufficiently rich, metaphoric language to hold the many levels that have been spinning round in a chaotic, pre-articulated correspondence.

Kelly **The reason perhaps that I was using metaphor to describe this is because of the group that I've been working with – we've just recently been using these distinctions**

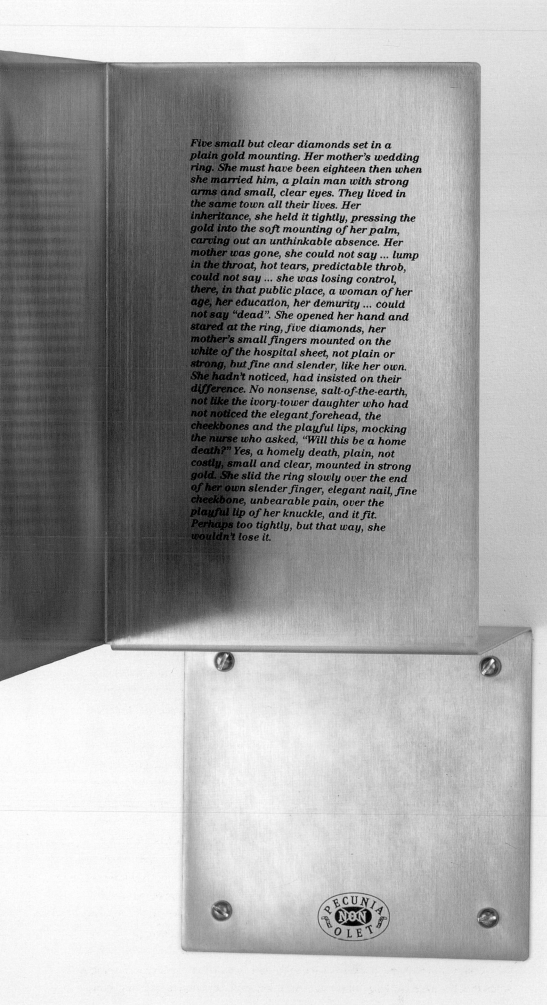

Five small but clear diamonds set in a plain gold mounting. Her mother's wedding ring. She must have been eighteen then when she married him, a plain man with strong arms and small, clear eyes. They lived in the same town all their lives. Her inheritance, she held it tightly, pressing the gold into the soft mounting of her palm, carving out an unthinkable absence. Her mother was gone, she could not say ... lump in the throat, hot tears, predictable throb, could not say ... she was losing control, there, in that public place, a woman of her age, her education, her demurity ... could not say "dead". She opened her hand and stared at the ring, five diamonds, her mother's small fingers mounted on the white of the hospital sheet, not plain or strong, but fine and slender, like her own. She hadn't noticed, had insisted on their difference. No nonsense, salt-of-the-earth, not like the ivory-tower daughter who had not noticed the elegant forehead, the cheekbones and the playful lips, mocking the nurse who asked, "Will this be a home death?" Yes, a homely death, plain, not costly, small and clear, mounted in strong gold. She slid the ring slowly over the end of her own slender finger, elegant nail, fine cheekbone, unbearable pain, over the playful lip of her knuckle, and it fit. Perhaps too tightly, but that way, she wouldn't lose it.

PECUNIA N&N OLET

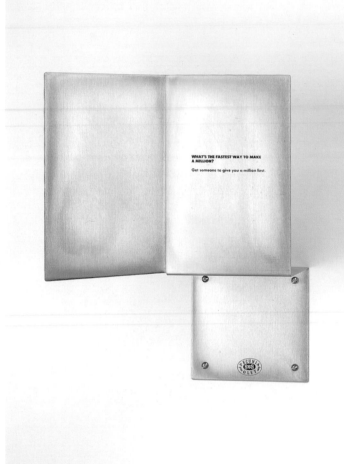

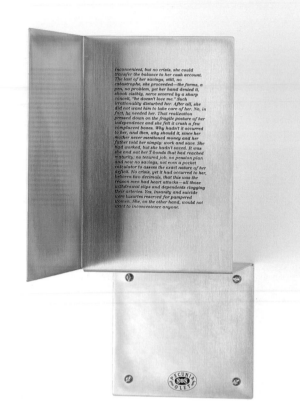

WHAT'S THE FASTEST WAY TO MAKE A MILLION?

Get someone to give you a million first.

Inconvenient, but no crisis, she could transfer the balance to her cash account. The last of her savings, still, no catastrophe, she proceeded—the forms, a pen, no problem, yet her hand denied it, shook visibly, nerve severed by a sharp conceit, "he doesn't love me." Such irrationality disturbed her. After all, she did not want him to take care of her. No, in fact, he needed her. That realization pressed down on the fragile posture of her independence and she felt it crush a few complacent bones. Why hadn't it occurred to her, and then, why should it, since her mother never mentioned money and her father told her simply: work and save. She had worked, but she hadn't saved. It was she and not her T-bonds that had reached maturity; no tenured job, no pension plan and now no savings, not even a pocket calculator to assess the exact nature of her deficit. No crisis, yet it had occurred to her, between two decimals, that this was the reason men had heart attacks—all those withdrawal slips and dependents clogging their arteries. Yes, insanity and suicide were luxuries reserved for pampered women. She, on the other hand, would not want to inconvenience anyone.

Interim Part II: Pecunia
(details, **Filia**)
1989
Silkscreen on galvanized steel
4 of the 20 units,
40 × 16 × 29 cm each
Collection, Vancouver Art Gallery

between metonymy and metaphor, following Jakobson and Lacan – emphasizing them as two axes within language. And certainly it's appropriate in terms of visual language to talk about that. When Lacan describes metaphor as a process by which, momentarily, you make sense out of nonsense, that describes the jumping up and down to me. When you say all these things come into play for at least that moment, some kind of meaning takes place. Of course, one could explore the other axis too. Another feeling that's very common is that even though you jump up and down at one point, you're never satisfied with the work; *never* satisfied. That places you within the axis of metonymy or desire, which is also very productive to examine in terms of who you really are desiring to speak to in the work.

This is another thing that I've often had to consider when people ask the question about audience. I could say in a strategic way who my audience was, and I always said there was no such thing as a general, mass audience; that I directed it specifically at a certain group. First of all, it was feminists, then it was mothers, then it was artists engaged in critical practices; three overlapping circles and where they met, you might have the ideal audience, but then you'd have it spreading out in these three directions. Well, I had to admit, as we're pursuing this kind of psychic dimension of this production, that out of this centre of an ideal audience, if you like, there would be very specific women, for me. For instance, with the first part of *Corpus*, when I'd made the prototype for it, but before I'd actually finished the work, I met with that small group and we went over the work.

It was a very special kind of experience because I wanted to confirm this for myself,

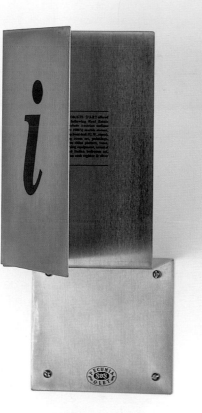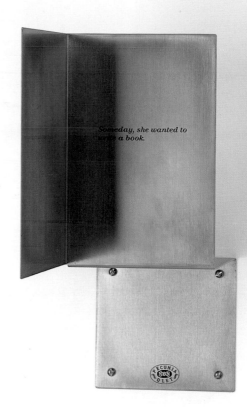

because I knew that this had been so important in the way the piece had taken shape, but I also wanted to tie it to something that Craig Owens said about his horror at going around art schools and discovering that more and more students, rather self-consciously, admitted that they were making their work for a certain patron or a particular collector. I think that level of desire in a work and who you're actually aiming this for *is* important, because if the one person you're desiring to please means that your strategy is one aimed at the private sector, as Craig has suggested, then we've lost the *public* domain. We've lost the sense of a 'public' for art. For me this is very directly linked to the whole project of history painting or 'picturing' – as we're trying to decide on a new way of terming this, because it can't be history 'painting', so maybe it can be history 'picturing' – and really, recuperating something of the effort of that work prior to the modern period, where artists actually worked in the public domain.

2 The previous evening, Griselda Pollock had given a public lecture at Robson Square Auditorium entitled 'Feminism, Painting and History'.

3 This is a reference to an article which Pollock had assigned as pre-reading for the seminar and which was discussed the first evening – Julia Kristeva's 'Women's Time' (see in this volume, pp. 102–05).

Mary Kelly and Griselda Pollock in Conversation at the Vancouver Art Gallery, ed. Judith Mastai, Vag Document, Vancouver Art Gallery, 1989.

Magiciens de la Mer(d)

Recent excavations of the Hudson River have yielded more than one hundred and fifty thousand artefacts from the late twentieth century – primarily, the period immediately preceding the Great Earthquake of 2001. Connoisseurs and scholars of Le Postmoderne have often wondered why the production of art was so prolific on this small island in the North Atlantic. Considering its precarious geography, as well as the political turmoil that prevailed there at that time, the propensity for such activity would seem improbable. After all, the larger territory of which it was a part (then known as the United Estates) had been at war almost continually since 1942. One explanation forwarded is that the existence of professional armies, involving few men and conflicts in far places, enabled the island people to continue their daily lives without interference. Another reason cited is *l'esprit de l'âge*. Many accounts of the 1980s for example, invoke an image of rampageous energy. Frantic trading at inflated prices is described poetically as 'bullish' and in the realm of new ideas, the theory and practice of pleasure – referred to by the islanders as 'fun' – is said to have engendered an enthusiasm for the arts of self-expression. Still another stated cause is patronage; an unusual form existed which included numerous public (now obsolete) as well as private patrons of the arts. Although preoccupied with war, they still appreciated art and artists and supported them by commissioning the finest works recovered from l'Époque Postmoderne. Until 1992, these men of means resided on the island and consequently this afforded opportunities to artists living there; after that, the economic centre shifted to the newly unified territories east of the Atlantic and creative futures followed suit.

L'art Postmoderne était décidément secular, often licentious and, at time, even anti-humanist. In their work, it was not uncommon for the island artists to include, in addition to the representation of mythological figures and important patrons, the ordinary objet trouvé. In fact, among the excavation's principal findings is a unique collection of tin cans. Of particular interest is *La boite en fer blanc #6* (Fig. 289) which has been mistakenly attributed to the Proto-Postmoderne master of the soup can genre, Andrew (known as Handy) Warhol. However, according to the carbon analysis, the soup was clearly Heinz not Campbell's and a reduction of the lead component in the tin, clearly places it within the ecological imperatives of Postmodernité. Hence, some critics link La Boite to Le Basket, a work assigned to younger artists called 'The Koons'. This would be consistent with the Carbon test, but what about the signifying possibilities of tin? The formal emphasis is more in keeping with the cans of Kasper Kohns (or Johns). But then, this prompts the question: why beer not soup? (It should be noted also that the former, being less healthful, reflects a typically Moderne, rather than Postmoderne, attitude towards the management of stress.) Indeed, another problem arises concerning the label which, being in Latin, is unlikely to represent alcoholic contents. The translation of the signifier 'olet' (smell) has provoked the speculation that

Fig. 289. La Hudson boite en fer blanc #6, *c.* 2001

Magiciens de la Mer(d)
1991
Colour photograph for artist's
project, *Artforum*, January, 1991
20 × 25.5 cm

the tin contains unseemly items.

The Cult of Dejecta can be traced to an earlier era and to the Italian innovator of container art, Cannzoni, who, it is claimed, preserved his own feces in this manner. The socio-psycho-symbolic significance of such actions has been the subject of a major controversy. Some take the view of Apter and Les Anciens who portray it as a symptomatic consequence of a repression, namely, l'érotisme anal. Within the sphere of global finance, argent sec replaced not only barter but the stickiness of coins. Thus capital no longer 'smells'; yet once it is demystified, for instance by suppression of the 'non', we realize that money (or 'pecunia') still stinks. All the same, this does not explain the meaning of the coprophilic trace that haunts La Boite. Alternatively, Weiss et al. describe this inclination towards perversité as an inversion of the concept of the Kantian sublime. Counter-sublime, he says, marks our disgust with base materiality and thus entails a rediscovery of the body's waste.

On this account (and keeping in mind the carbon analysis), *La boite* should be assigned to someone working with the Micturitionists, a Post-Postmoderne movement of the 1990s. The corrosive pleura of the can is clearly indicated by its colour, and moreover it is altogether likely that the can enclosed not only this sublime substance, but a crucifix. A work resembling this description is referred to in surviving documents of 1989. An odd outbreak of iconoclasm is reported then. Apparently small men who feared the apotropaic power of art attempted to outlaw the veneration of large ones.

In any case, *La Hudson boite* breaks all the rules. The sheer conception of the piece is an achievement. A tremendous vertical dynamic is created by reflected light which floods the surface, forcing the gaze upwards and finally, forms a halo at the top of the tin. The contrast of delicate figure against the metallic ground are *senza tempo* tinte-sets, as it were, a spiritual stage where the scatological drama unfolds.

Ultimately, to whom we attribute *La boite* must remain uncertain. Due to the impermanence of their materials and the erosion of most signatures, few artists of that time are now well known. Unlike the patrons, whose assignations, having been engraved in stone or etched on metal plaques, are well preserved and faithfully recorded. (See appendix iii).

Two additional hypotheses, although improbably, bear mention. One concerns the uses of religious reliquary, in the work. This points to central themes in Native island art, but nonetheless, there is no evidence of exhibitions which included it among the excavation's trouvaille. The other pertains to data which suggests that nearly half of the practitioners of l'art perverse were of the female sex. Several had included textual systems in their oeuvre. One, in fact, was rumoured to have had a penchant for both Latin and dejecta, but alas, no names survived.

Artist's project, *Artforum*, New York, January, 1991

Klaus Ottmann How do you see your work in relation to that of other artists working predominantly with text?

Mary Kelly **In the genre of conceptual work, including, say, Lawrence Weiner's propositions, Jenny Holzer's aphorisms, or even Richard Prince's jokes, text takes a form that is not essentially narrative. The textual material can be recycled in a lot of different media, but the overall 'look' remains the same. What I want is a specific relation between the meaning of the text, its materiality, and the site. You could say I'm interested in the narrative organization of space. Each project negotiates this differently.**

Ottmann Could you say more about what you mean by 'project' and how the theorization of your work relates to its visualization?

Kelly **I believe that all the strategies used to get away from composition – like the readymade, the overall, systems, series or even certain concepts – extended the limits of the formalist paradigm but did not necessarily break with it. I feel that one way of structuring the work, which is anti-compositional and also anti-formalist, is to emphasize the project nature of it: the *ideas*. It's not about style. I want the visual effect to be cumulative, a delayed but significant insight rather than the instant recognition of forms.**

Ottmann Your latest project, *Gloria Patri*, seems to be as much a continuity of questions raised in your previous works as a departure from them.

Kelly **Well, I see it as a departure in some respects; for example, as an installation, it's much more integrated. I thought of it as a complete piece, whereas the previous projects consisted of a number of different sections. The way the work looks has also changed, the unification of materials, that kind of consolidation, visually, was important for me.**
 But, yes, as far as continuity is concerned, there's probably even more I could talk about because all of the works do seem to emerge from a certain form of questioning. For example, in *Post-Partum Document*, I was looking at the intricacies of maternal desire, but I found at the end of it, I had to ask: what happens at another moment in a woman's life? How would femininity be constructed for her outside that privileged relation? This was what I tried to deal with in the next project, *Interim*. Then, when I was finishing its last section, *Potestas*, which concerns the problem of difference and

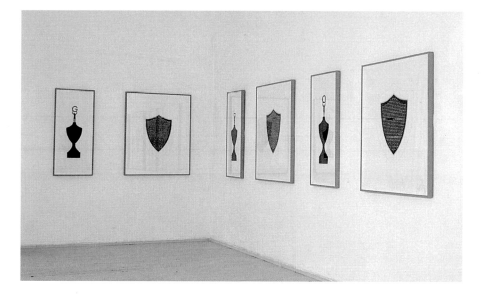

Gloria Patri
1992
Graphite rubbing on vellum
5 shields, 122.5 × 101 cm each; 6
trophies, 113 × 55 cm each
Installation, Knoll Galerie,
Vienna, 1996

power, I began to think about the inadequacy of certain kinds of theorization of, say, the masquerade, the objectification of the woman, images of women. The whole question of power seemed to involve thinking about the construction of masculinity rather than femininity, for the woman. I also felt it had been altogether too easy to say that men have a less difficult role in the Oedipal scenario. I mean, it might also be appropriate to think about the man's relation to the feminine term. So this was on the agenda when I started work on *Gloria Patri*. But then it was really put in place by the events of the Persian Gulf War. This is what I think of as the ethnographic material; events observed and recorded – not literally recorded, but noted in my sketchbook for about two or three years before I even start a project. So during the war, it was mostly what I heard on television. There was a very interesting but eerie kind of distance involved in watching that spectacle … watching the commentators, watching the soldiers making their comments on it. I just kept track of those comments and thought about it. Now I can see the pathological structuring of masculinity that this specific condition – the Gulf War – provoked.

Ottmann What I found interesting in that particular piece is that it's about the failure of masculinity and its authority, while, at the same time, there is, particularly in this country, a resurgence of cultural conservatism and masculine ideals.

Kelly Yes, there is this facade of militarism, which I find particularly ludicrous, given the tendency towards demilitarization in the world generally, but maybe this is also a moment when you can see the production of masculinity as parody. During the war the troops were encouraged to take up this kind of macho identity, yet there was something very transparent about it, a sense of being overwhelmed by the technological spectacle.

The way individual soldiers had to negotiate this identity was very revealing. Some of their statements, like 'Not enough gees and gollies to describe it', don't exactly project the image of someone who is in control. When I wrote the stories, which appear on the five shields, I didn't want to refer to the war itself, nothing that obvious, just the everyday, to see how fragile yet persistent the fantasy of mastery can be. Even though the narrative is parodic, to a certain extent, it's also empathetic; you understand how difficult it is to assume this position, how it is eroded by the social and economic order of things. This may seem like a big leap, but I had in mind a painting by Géricault that depicts an officer in Napoleon's army who seems as though he's about to fall from his horse. Norman Bryson has referred to it as an image of failed masculinity. It shows the scene of panic and, interestingly, perhaps a crisis of national identity and imperial

　　　Artist's Writings

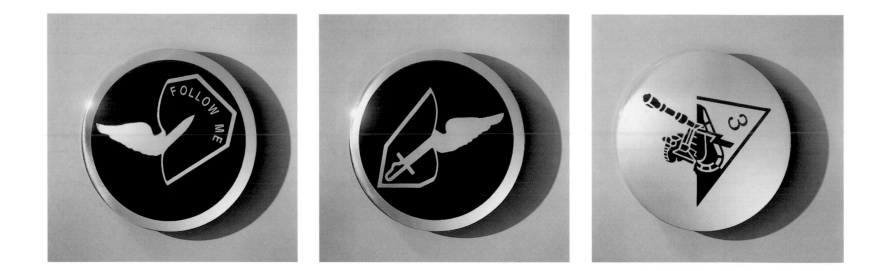

Gloria Patri
1992
Screenprint on polished
aluminium
6 of 20 discs, ø 43 × 6 cm each

power not unlike our own. I wanted to capture this precarious moment of falling. So, in the installation, at a distance, you see this facade of polished aluminium, but when you get up close, in the space of reading, the spectacle is dispersed. Theoretically, I don't think this is about the masquerade but about the notion of 'display' [...]

Ottmann I was surprised that your definition of masquerade is synonymous with the feminine because, in my understanding, masquerade has always had more to do with men attempting to enter the realm of femininity [...]

Kelly In psychoanalytic theory the concept originated with Joan Rivière's famous article, 'Womanliness as Masquerade'. When I use the term masculine/feminine, I'm thinking more of a psychic structure along these lines rather than the anthropological notion of 'roles'. It doesn't have to do with biological gender but with a kind of positioning of the subject in relation to, I suppose, the object of desire. When I call it feminine, I just mean that the masquerade functions in that position psychically, in the space of passivity and silence assigned to the object of the look. I don't mean this just in the literal sense of spectacle or how you make yourself visible. At the level of the unconscious, masquerade can refer to a gesture, a symptom, or something like masochism that, according to [Michèle] Montrelay, underpins the pathology of precocious femininity. But I do think there are implications at another level too, in terms of conscious acting out or mimicry. I'm thinking of the punk movement in the late 1970s and the early 1980s in England, and about how you mark the body with signifiers of Otherness, make yourself visible and in some sense, transgressively so. Maybe this applies to the whole question of national identity as well. The one who wears the costume is visibly marked as other, a kind of inscription of ethnicity as masquerade. And, returning to your comment on men entering the realm of femininity, what does this mean in terms of art? If you take the Surrealists, for example, the man as an artist assumes the masquerade in the sense that he identifies creative subjectivity with the feminine, even personifying the unconscious as the *femme enfant*, or the hysteric – Breton said she was the greatest discovery of the twentieth century.
 So this means that, in a way, the whole field of art is overdetermined by this assumption of transgressive femininity. You certainly don't need a woman artist. To be signified as such is like a double negative.

Ottmann How do you distinguish this notion of masquerade from the notion of display?

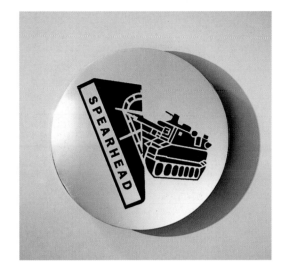 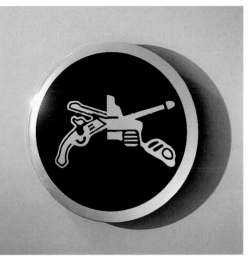 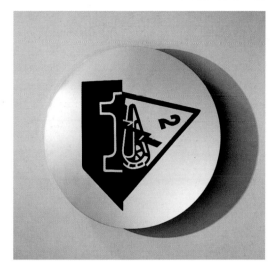

Kelly **First, I'm interested in the parallel that Lacan seems to draw between the function of masquerade for the woman and what he calls virile display for the man. But what intrigues me even more in his discussion of mimicry is the reference to camouflage, which describes not only the appearance of soldiers in war but the defensive strategy of the ego, becoming mottled, as he says, against a background. So I would say the display is a form of intimidation rather than seduction, more like a shield than a mask. It's not about making the body visible but about its obliteration, the way a uniform gives you a place within a coded hierarchy. [Klaus] Theweleit's description of the troop as a machine that annihilates its individual components was central to my understanding of the display. I visualized the installation as a form of armour. Although I'm not just concerned with a specific instance, like combat. I'm talking about a process of identification with a masculine ideal, how it's internalized and becomes problematic for women as well as men. At the most obvious level, if you have women demanding the right to go to the front, to wear the uniform, to kill the enemy, and gay men protesting about being excluded from the ROTC, then you have to ask, is this actually what we wanted to achieve in the name of equality?**

Ottmann This, of course, is the quintessential antinomy of feminist theory: whether to access the male model or denounce it and remain excluded from its realm of power.

Kelly **I'm not saying that there should be a valorization of femininity, something separate in terms of the woman's language or culture that remains untainted by the machinations of power. For me, masculine and feminine identities are completely contingent, not pregiven. Yet, having looked at the problem of femininity, as I have in previous work, that is, at a certain pathology that needed to be understood and distanced, I now feel we haven't thought at all about what it means to go through this trajectory, this critique of essentialism, and come out the other end upholding, at least unconsciously, the masculine ideal. We still haven't looked at the psychic structure of masculinity for the woman. So first of all, there's the question of understanding what the display means in relation to a social and psychic structure that defines men, and then, there's the way women mimic that structure.**

Journal of Contemporary Art, New York, Fall 1992, pp. ■■

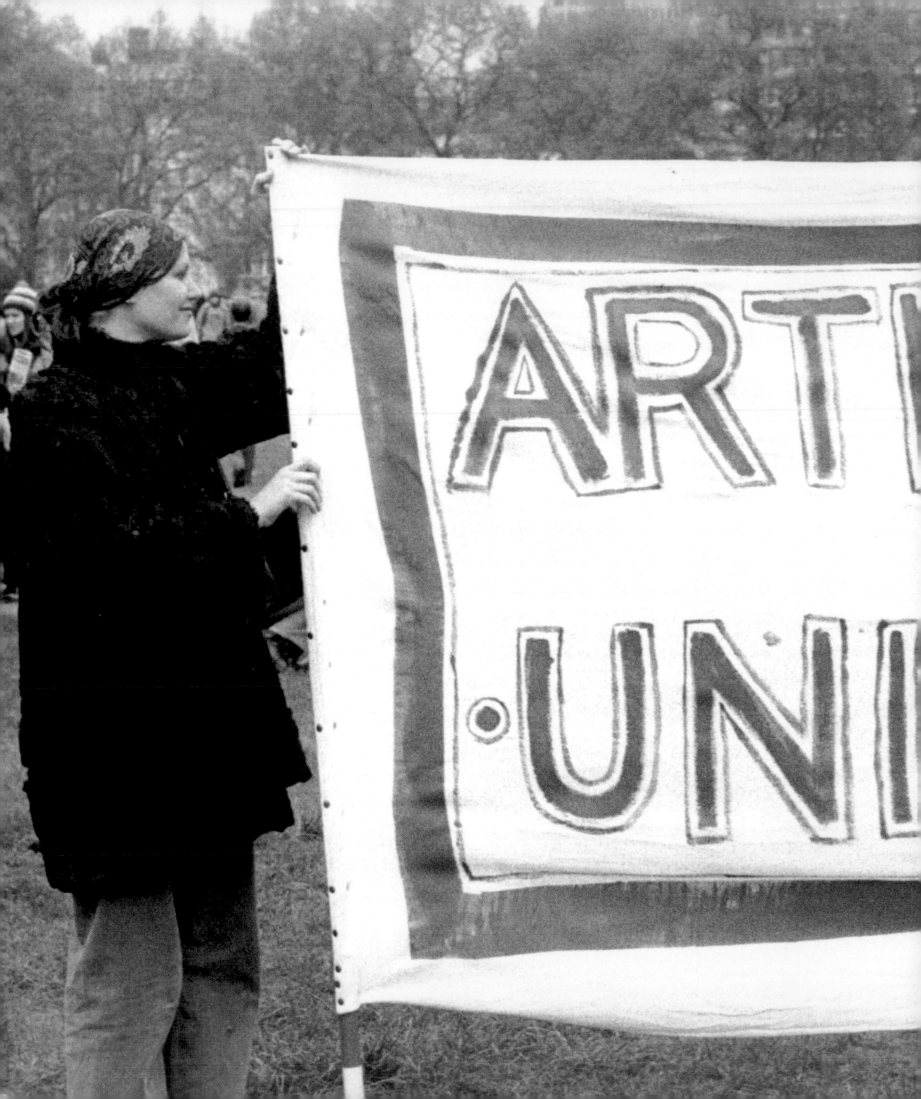

Contents

Chronology Mary Kelly Born 1941, Fort Dodge, Iowa, lives and works in Los Angeles, California

Selected exhibitions and projects
1959-78

1959–63
Studies Fine Art, **College of Saint Teresa**, Winona, Minnesota

1963–65
Studies Fine Art, **Pius XII Institute**, Florence, Italy

1965–68
Lives and works in Beirut, Lebanon

1968–70
Postgraduate Diploma, **St. Martin's School of Art**, London

1972–74
Chairman, Artists' Union, London

1975
'Sexuality and Socialization',
Northern Arts Gallery, Newcastle (group)

'Nightcleaners',
'Independent Filmmakers Festival'
Arnolfini Gallery, Bristol (group)

'Women and Work: A Document on the Division of Labour in Industry',
South London Art Gallery (group)

1976
'Post-Partum Document: Documentations I-III',
Institute of Contemporary Arts, London (solo)
Cat. *Footnotes and Bibliography, Post-Partum Document*, Institute of Contemporary Arts, London, text Mary Kelly

1977
'Post-Partum Document: Documentations I-V',
Museum of Modern Art, Oxford (solo)
Cat. *Footnotes and Bibliography, Post-Partum Document*, Museum of Modern Art, Oxford, text Mary Kelly

'Radical Attitudes to the Gallery',
Art Net, London (group)

Texts, 'Notes on Reading the Post-Partum Document'
Control Magazine, No 10, London; 'Women's Practice in Art', *Audio Arts*, No 2, London

1978
'Art for Society',
Whitechapel Art Gallery, London; **Ulster Museum**, Belfast (group)

'Hayward Annual '78',
The Hayward Gallery, London (group)
Cat. *Hayward Annual '78*, The South Bank Centre, London, text Sarah Kent

Selected articles and interviews
1959-78

Talk at the Hayward Annual, London, 1978

Delmar, Rosalind, 'Women and Work', *Spare Rib*, No 40, London

1976
Bray, Roger, 'On Show at ICA … Dirty Nappies!',
Evening Standard, London, 14 October
Cork, Richard, 'Big Brother — and Mary Kelly's Baby',
Evening Standard, London, 14 October
Tisdall, Caroline, 'Mary Kelly', *The Guardian*, London, 16 October
Mulvey, Laura, 'Post-Partum Document', *Spare Rib*, No 53, London
Kent, Sarah, 'Mary Kelly', *Time Out*, No 404, London

1977
Nash, Mark, 'Mary Kelly at the Museum of Modern Art', *Artscribe*, No 10, London, 1978

Evening Standard, London, 14 October, 1976

Kelly, Jane, 'Mary Kelly', *Studio International*, No 1, London

1978
Lucie-Smith, Edward, 'Spice of Life', *Evening Standard*, London, 18 May

Maloon, Terence, 'Mary Kelly', *Artscribe*, No 13, London
Kelly, Jane, 'Mary Kelly', *Studio International*, No 3, London

Selected exhibitions and projects
1978-81

1978–87
Lecturer in Fine Art, **Goldsmiths' College, University
of London**

1979
University Gallery, Leeds (solo)

New 57 Gallery, Edinburgh (solo)

'Un Certain Art Anglais',
A.R.C./Musée d'Art Moderne de la Ville de Paris (group)
Cat. *Un Certain Art Anglais*, A.R.C./Musée d'Art
Moderne de la Ville de Paris, text Mark Nash

'Feministische Kunste Internationaal',
Haags Gemeentemuseum, The Hague; **De
Oosterpoort**, Groningen, **Noodbrabants Museum**, 's
Hertogenbosch; **De Vleeshal**, Middleburg; **Le Vest**,
Alkmaar; **De Beyerd**, Breda; **Nijmeegs Museum**,
Nijmegen (group)
Cat. *Feministische Kunste Internationaal*, Haags
Gemeentemuseum, The Hague, text Din Pieters

'Europa '79',
Rüdiger Schöttle, Stuttgart (group)
Magazine, *Kunstforum*, Europa Edition, No 36, Mainz,
Germany

'Both Sides Now',
Artmesia Gallery, Chicago (group)

'Verbiage',
Kettle's Yard, University of Cambridge (group)

'Art, Politics, and Ideology',
Dartington College of Art, Totnes, Devon (group)

Texts, 'On Femininity', *Control Magazine,* No 11,
London; 'Post-Partum Document', *Kunstforum*, No 36,
Mainz; 'Documentation III', *Skira Annuel,* Skira S.A.,
Geneva

1980
'Issue',
Institute of Contemporary Arts, London (group)
Cat. *Issue*, Institute of Contemporary Arts, London,
text Lucy R. Lippard

Text, 'Sexual Politics', *Art and Politics*, Winchester
School of Art Press

1981
Anna Leonowens Gallery, Halifax, Canada (solo)

'Typisch Frau',
Bonner Kunstverein; Gallery Magers, Bonn (group)

'9th Kracow Meetings',
Biuro Wystaw Artystycznuch, Kracow (group)

Texts, 'Re-Viewing Modernist Criticism', *Screen*, Vol 22,
No 3, London; 'Feminist Art: Assessing the 70s and
Raising Issues for the 80s', *Studio International*, Vol

Selected articles and interviews
1978-81

1979

Coutourier, Michel, 'Un Certain Art Anglais', *French
Programme*, BBC Radio, London

1980
Cork, Richard, 'Collaboration without Compromise',
Studio International, No 990, London

Barry, Judith; Flitterman, Sandy, 'The Politics of Art
Making', *Screen*, Vol 21, No 2, London
Hunter, Alexis, 'Feminist Perceptions', *Artscribe*, No
25, London

1981

Selected exhibitions and projects
1981-84

195, No 991/12, London; 'Documentation VI', *Block*, No 4, London; 'Documentation IV', *Heresies*, No 12, New York; 'Documentation VI', *M/F*, Nos 5-6, London

1982
George Paton Gallery, Melbourne (solo)

University Art Museum, Brisbane (solo)

'Vision in Disbelief: The 4th Biennale of Sydney', **Art Gallery of New South Wales**, Sydney (group)

'Sense and Sensibility', **Midland Group Gallery**, Nottingham (group)
Cat. *Sense and Sensibility*, Midland Group Gallery, Nottingham, text Mary Kelly et al.

Text, 'Re-viewing Modernist Criticism', *Art After Modernism*, ed. Brian Wallis, New Museum of Contemporary Art, New York

1983
'The Revolutionary Power of Women's Laughter', **Protetch-McNeil**, New York; **Art Culture Resource Center**, Toronto; **Washington College Art Gallery**, Maryland (group)
Brochure, *The Revolutionary Power of Women's Laughter*, Protetch-McNeil, New York, text Jo Anna Isaak and artists

Texts, 'Beyond the Purloined Image', *Block*, No 9, London; 'Jenseites des entwendeten Bildes', *Archithese*, No 5, Zurich

Book, *Post-Partum Document*, Routledge & Kegan Paul, London

Curator, 'Beyond the Purloined Image', **Riverside Studios**, London
Brochure, *Beyond the Purloined Image*, Riverside Studios, London, texts Mary Kelly et al.

1984
'The Critical Eye/I', **Yale Center for British Art**, New Haven (group)

Selected articles and interviews
1981-84

Cowie, Elizabeth, 'Introduction to the Post-Partum Document', *M/F*, Nos 5-6, London
Iversen, Margaret, 'The Bride Stripped Bare by Her Own Desire', *Discourse*, No 4, Berkeley, California
Grace, Helen, 'From the Margins: A Feminist Essay on Women Artists', *Lip*, No 2, Melbourne

1982

Taylor, Paul, '"Vision in Disbelief", 4th Biennale of Sydney', *Artforum*, New York, October
Tulloch, Lee, 'Biennale of Sydney', *Artforum*, New York, October

Isaak, Jo Anna, 'Our Mother Tongue', *Vanguard*, Vol 2, No 3, Vancouver
Smith, Paul, 'Mother as the Site of Her Proceedings', *Parachute*, No 26, Montréal

1983
Weinstock, Jane, 'A Laugh, A Lass, and A Lad', *Art in America*, New York, Summer

Gourlay, Sheena, 'The Discourse of the Mother', *Fuse*, Toronto, Summer 1984
Osbourne, Caroline, 'The Post-Partum Document', *Feminist Review*, London, Winter 1984
Fraser, Andrea, 'On the Post-Partum Document', *Afterimage*, Rochester, New York, No 8, March 1986

Linker, Kate, 'Representation and Sexuality', *Parachute*, No 32, Montréal
Fisher, Jean, 'London Review', *Artforum*, New York, December
Iversen, Margaret, 'Post-Partum Document und die Lageder Post-Moderne', *Archithese*, No 5, Zurich
Freiberg, Freda, 'The Post-Partum Document: Maternal Archeology', *Lip*, No 7, Melbourne

1984
Gonzales, Shirley, 'British Center Mounts Intriguing Moderns Show', *New Haven Register*, 20 May

Selected exhibitions and projects
1984-86

Cat. *The Critical Eye/I*, Yale Center for British Art, New Haven, text John Paoletti and artists' projects by Victor Burgin, Gilbert and George, Mary Kelly, Richard Long, Bruce McClean, David Tremlett

'The British Art Show',
Birmingham City Museum and Art Gallery; Ikon Gallery, Birmingham; **Royal Scottish Academy**, Edinburgh; **Mappin Art Gallery**, Sheffield; **Southampton Art Gallery** (group)

Text, 'Desiring Images/Imaging Desire', *Wedge*, No 6, New York

1985
Artist-in-Residence, **New Hall, Cambridge University**

'Interim Part I: Corpus',
The Fruitmarket Gallery, Edinburgh; **Kettle's Yard Gallery**, University of Cambridge; **Riverside Studios**, London (solo)
Cat. *Interim*, Fruitmarket Gallery, Edinburgh et al., texts Laura Mulvey, Mary Kelly

'Difference: On Representation and Sexuality',
The New Museum of Contemporary Art, New York; **The Renaissance Society**; University of Chicago; **List Visual Art Center**, Massachusetts Institute of Technology, Boston; **Institute of Contemporary Arts**, London (group)
Cat. *Difference: On Representation and Sexuality*, The New Museum of Contemporary Art, New York, texts Craig Owens, Lisa Tickner, Jacqueline Rose, Jane Weinstock, Peter Wollen

Conference at Kettle's Yard, Cambridge, during Mary Kelly's artist-in-residency at New Hall, *l. to r.*, Norman Bryson, Mary Kelly, Margaret Iversen

1986
'Interim Part I: Corpus',
A Space, Toronto (solo)

'The Fairy Tale: Politics, Desire and Everyday Life',
Artists Space, New York (group)
Brochure, *The Fairy Tale: Politics, Desire and Everyday Life*, Artists Space, New York, texts Frederic Jameson et al.

Selected articles and interviews
1984-86

Zimmer, William, 'Sharp Images at Yale', *The New York Times*, 10 June
Russell, John, 'Art: What New Yorker Covers Say', *The New York Times*, 6 July

Linker, Kate, 'Eluding Definition', *Artforum*, New York, December
Bershad, Deborah, 'The Post-Partum Document', *Critical Texts*, Columbia University, New York

1985

Bain, Alice, 'Reflective Images', *The List*, Edinburgh, December
Gott, Richard, 'Interim Reflections', *The Guardian*, London, 2 June 1986
Iversen, Margaret, 'Difference on Representation and Sexuality', *M/F*, Nos 11-12, London
Kent, Sarah, 'Kelly's Eye', *Time Out*, No 19, London, 15-22 October 1986
Watney, Simon, 'Mary Kelly', *Artscribe*, No 62, London, March/April 1987

Smith, Paul, 'Difference in America', *Art in America*, New York, April
Smith, Roberta, 'Beyond Gender', *The Village Voice*, No 9, New York, 22 January
Welchman, John, 'Art or Society: Must We Choose?', *The Village Voice*, New York, 26 March

Neumaier, Diane, 'Post-Partum Document', *Exposure*, Albuquerque, Winter
Lewis, Mark, 'Concerning the Question of the Post-Cultural', *C*, Toronto, Winter
Pollock, Griselda, 'History and Position of the Contemporary Woman Artist', *Aspects*, No 28, Newcastle
Isaak, Jo Anna, 'Women: The Ruin of Representation', *Afterimage*, No 9, Rochester, New York, April
Paoletti, John, 'Mary Kelly's Interim', *Arts Magazine*, New York, October
Weinstock, Jane, 'A Post-Partum Document', *Camera Obscura*, Nos 13-14, Los Angeles

1986
Corbeil, Carol, 'Exhibition Encourages Laughter and Distance', *Toronto Globe and Mail*, 20 March
Hanna, Diedre, 'Kelly's Questioning Images', *Now*, No 28, Toronto, March
Gagnon, Monika, 'Texta Scientiae (The Enlacing of Knowledge): Mary Kelly's Corpus', *C*, Toronto, Summer

Selected exhibitions and projects
1986-87

'Identity/Desire: Representing the Body',
Collins Gallery, University of Strathclyde, Glasgow;
Crawford Center for the Arts, St. Andrews, Scotland;
McLaurin Art Gallery, Ayr, Scotland (group)
Cat. *Identity/Desire: Representing the Body*, Collins
Gallery, University of Strathclyde, Glasgow, et al.,
text Nigel Walsh

'Electro-media',
Public Access Project, Toronto (group)

Text, 'Interim', (5-part series), *The Guardian*, London,
2,9,16,23,30, June

1987
'Conceptual Clothing',
Ikon Gallery, Birmingham; **Harris
Museum and Art Gallery**, Preston; **Peterborough City
Museum and Art Gallery; Spacex Gallery**, Exeter;
**Stoke on Trent City Museum and Art Gallery;
Aberdeen Art Gallery; Huddersfield Art Gallery;
Cartwright Hall Art Gallery**, Bradford;**Camden Arts
Centre**, London (group)
Cat. *Conceptual Clothing*, Ikon Gallery, Birmingham,
texts Fran Cottell, Marian Schoettle

'State of the Art',
Institute of Contemporary Arts, London; **Laing Art
Gallery**, Newcastle (group)
Book, *State of the Art*, Chatto and Windus, London;
television series, *State of the Art*, Channel 4, London;
texts Sandy Nairne et al.

'The British Edge',
Institute of Contemporary Arts, Boston (group)
Cat. *The British Edge*, Institute of Contemporary Arts,
Boston, texts Elizabeth Sussman, David Joselit, Gillian
Levine, Julie Levinson

'Aspects of Voyeurism',
Whitney Museum of American Art at Phillip Morris,
New York (group)
Cat. *The Viewer as Voyeur*, The Whitney Museum of
American Art, New York, texts Andrea Inselmann et al.

'Propositions and Inquiries: Ideas, Concepts and
Language in Art',
Art Gallery of Ontario, Toronto (group)
Cat. *Inquiries: Language and Art*, Art Gallery of Ontario,
Toronto, text Christina Ritchie

Postmasters Gallery, New York (group)

Texts, 'Beyond The Purloined Image'; 'On Sexual
Politics and Art', *Framing Feminism*, eds. Rozsika
Parker, Griselda Pollock, Pandora Press, London; 'On
Difference, Sexuality and Sameness', *Screen*, Vol 28,
No 1, London; 'Invisible Bodies: On Interim', *New
Formations*, No 2, London

1987-89
Visiting Professor in post-studio, **California Institute
for the Arts**

Selected articles and interviews
1986-87

Mulvey, Laura, 'Mary Kelly in Conversation with Laura
Mulvey', *Afterimage*, No 8, Rochester, New York, March
Pollock, Griselda, 'What's the Difference', *Aspects*, No
32, Newcastle, Spring

1987

Smith, Paul, 'Terminal Culture? The British Edge', *Art in
America*, New York, September

The Viewer as Voyeur

Bentley Mays, John, 'When Society Sags, Art Pushes
the Limits', *The Globe and Mail*, Toronto, 23 May

Smith, Roberta, 'Group Show', *The New York Times*, 10
July

Selected exhibitions and projects
1987-90

1988
Henry McNeil Gallery, Philadelphia (solo)

'Interim Part I: Corpus',
LACE, Los Angeles; **Galerie Powerhouse**, Montréal
(solo)

'Modes of Address',
Whitney Museum of American Art Downtown, New
York (group)
Cat. *Modes of Address*, Whitney Museum of American
Art Downtown, New York, text Ingrid Periz

'Mixed Meaning',
Grossman Gallery, School of the Museum of Fine Art,
Boston (group)

1989
Postmasters Gallery, New York (solo)

Todd Madigan Gallery, California State University,
Bakersfield (solo)

'Interim Part I: Corpus',
C.E.P.A., Buffalo (solo)

'Fashioning Feminine Identities',
University Gallery, University of Essex, Colchester,
England (group)

Texts, 'On Interim, Part I', *Whitewalls*, No 23, Chicago,
Autumn; 'From Corpus', *Taking Our Time*, ed. Frieda
Forman, Pergamon Press, Oxford

1989-96
Director of Studies, **Whitney Museum Independent
Study Program**, New York

1990
'Interim',
The New Museum of Contemporary Art, New York ; **The
Power Plant**, Toronto; **Vancouver Art Gallery** (solo)
Cat. *Interim*, The New Museum of Contemporary Art,

Selected articles and interviews
1987-90

Rehberg, Andrea, 'The Deconstructing Difference Issue
of Screen', *Independent Media*, No 65, London, May
Bryson, Norman, 'III, Invisible Bodies: Mary Kelly's
Interim', *New Formations*, No 2, London
Cowie, Elizabeth, 'II, Invisible Bodies: Mary Kelly's
Interim', *New Formations*, No 2, London

1988
Sozanski, Edward, 'An Artist Who Mixes the Visual with
the Verbal', *The Philadelphia Enquirer*, 31 March
Marincola, Paula, 'Mary Kelly', *Artforum*, New York,
Summer

Welles, Elenore, 'Exhibitions', *Artweek*, Vol 19, No 25,
Los Angeles
Gravel, Claire, 'Bernard Paquet et Mary Kelly:
Psychoanalyse des contes de fées', *Le Devoir*, Montréal,
10 December

Hardy, Tom, 'Language in Art Since 1960', *Galeries
Magazine*, Paris, August/September

Iversen, Margaret, 'Fashioning Feminine Identity', *Art
International*, Paris, Spring
Wintman, Elaine, 'In the Interim', *Articles*, Vol 4, No 1,
Cal Arts, Los Angeles

1989
Hess, Elizabeth, 'The Good Mother', *The Village Voice*,
Vol 34, No 2, New York, 18 June

Scaffidi, Susan, 'Exhibit on Women Listening
Experience', *The Bakersfield*, California, 1 October

Fisher, Jennifer, 'Interview with Mary Kelly', *Parachute*,
No 55, Montréal
Schor, Mira, 'From Liberty to Lack', *Heresies*, 6, No 4,
New York, Issue 24
Pollock, Griselda, 'Mary Kelly and Griselda Pollock in
Conversation', *Vag Document I*, Vancouver Art Gallery,
June

1990
Friedman, Ann, 'Feminist (Con)Texts ', *Reflex*, Seattle,
September/October
Choquette, Linda, 'Artspeaking in Tongues', *Noise*,
Vancouver, June

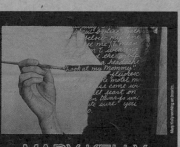

Selected exhibitions and projects
1990-91

New York, texts Norman Bryson, Hal Foster, Mary Kelly, Griselda Pollock, Marcia Tucker

'The Decade Show',
Museum of Contemporary Hispanic Art; The New Museum of Contemporary Art; The Studio Museum in Harlem, New York (group)

'Word as Image – American Art 1960–1990',
Milwaukee Art Museum; Oklahoma City Art Museum; Contemporary Arts Museum, Houston (group)

'In Her Image',
Barbara Toll Fine Art, New York (group)

Text, 'Pecunia Olet', *Top Stories*, No 29, New York

1991
Knoll Galeria, Budapest (solo)

Knoll Galerie, Vienna (solo)

in
her
image

POLLY APFELBAUM
BARBARA BLOOM
KATHE BURKHART
HELEN CHADWICK
MEG CRANSTON
JEANNE DUNNING
JAN HASHEY
MARY KELLY
ANN PRESTON
LAURIE SIMMONS
LAURA STEIN
LINDSAY WALT

JUNE 20-JULY 20
OPENING WED JUNE 20 5 TO 7 PM
BARBARA TOLL FINE ARTS
146 GREENE ST NY 10012 TEL 212 431 1788

'1991 Biennial',
Whitney Museum of American Art (group)

'The Realm of the Coin',
Hofstra University, Long Island, New York (group)

'Gender and Representation',
Zoller Gallery, Pennsylvania University (group)

'Shocks to the System',
The South Bank Centre, London; **Northern Centre for Contemporary Art**, Sunderland; **Towner Art Gallery**, Eastbourne; **Royal Albert Memorial Museum**, Exeter; **Ikon Gallery**, Birmingham; **City Museum Plymouth**;

Selected articles and interviews
1990-91

Lacey, Liam, 'A Window on Women's Experience', *Globe and Mail*, Toronto, 31 May
Sweet, David, 'Mary Kelly – New Museum', *Artscribe*, London, Summer
Askey, Ruth, 'A Brief Moment of Women', *Artweek*, Vol 21, No 25, Seattle, 2 August
McLerran, Jennifer, 'The Lady Vanishes', *Artspace*, Seattle, November/December
Cottingham, Laura, 'Thoughts are Things What is a Woman', *Contemporanea*, New York, September
Edelstein, Susan, 'Mary Kelly', *Kinesis*, Vancouver, June
Pollock, Griselda, 'Interventions in History', *Women Artists Slide Library Journal*, No 33, London, March/April
Shottenkirk, Dena, 'Mary Kelly', *Artforum*, New York, May
Hess, Elizabeth, 'Herstory', *The Village Voice*, New York, 13 March
Swan, Claudia, 'Aesthetic Archive', *Elle*, New York, March
Sundell, Margaret, 'Mary Kelly', *7 Days*, New York, 28 March
Taylor, Kate, 'Interim, A Text Heavy Probe into the Female Identity', *The Globe and Mail*, Toronto, 16 March 1991
Adams, Parveen, 'The Art of Analysis', *October*, No 58, MIT Press, Cambridge, Massachusetts, Fall 1991
Apter, Emily, 'Fetishism, Visual Seduction and Mary Kelly's Interim', *October*, No 58, MIT Press, Cambridge, Massachusetts, Fall 1991

1991

Rollig, Stella, 'Mary Kelly at Knoll Gallerie', *Kunstpresse*, Vienna, 3 June
Braun, Kerstin, 'Embleme der Sehnsucht' (Between Madness and Laughter), *Camera Austria* 37, Vienna
Borchardt-Birbaumer, Brigitte, 'Grafiken – auch solche mit Witz', *Wiener Zeitung*, Vienna, 4 June
Fischer, Judith, 'Gefangen im Netz des männlichen Blicks', *Der Standard*, Vienna, 1 August
Kala, Gabriele, 'Spröde Botschaften', *Die Furche*, No 22, Vienna, 30 May

The Decade show

Frameworks
of Identity
in the 1980s

MUSEUM OF
CONTEMPORARY
HISPANIC ART
16 de mayo hasta el
19 de agosto de 1990

THE NEW MUSEUM
OF CONTEMPORARY
ART
12 de mayo hasta el
19 de agosto de 1990

THE STUDIO
MUSEUM
IN HARLEM
18 de mayo hasta el
19 de agosto de 1990

Selected exhibitions and projects
1991-92

Maclaurin Art Gallery, Ayr (group)

Text, 'Interim. Part I. Extase', *The Female Body*, ed.
Laurence Goldstein, The University of Michigan Press;
'Re-presenting the Body', *Psychoanalysis and Cultural
Theory*, ed. James Donald, St. Martin's Press, New York;
'Pecunia Olet', *TOP Top Stories*,ed. Anne Turyn, City
Lights Books, San Francisco

Artist's Project, 'Magiciens de la Mer(d)', *Artforum*,
New York, January

1992
'Interim',
Mackenzie Art Gallery, Regina, Saskatchewan (solo)

'Gloria Patri',
Herbert F. Johnson Museum of Art, Cornell University,
Ithaca; **Ezra and Cecile Zilkha Gallery**, **Center for the
Arts**, Wesleyan University, Middletown (solo)
Cat. *Mary Kelly: Gloria Patri*, Herbert F. Johnson
Museum, Ezra and Cecile Zilkha Gallery, text Klaus
Ottmann

'Effected Desire',
Carnegie Museum of Art, Pittsburgh (group)
Cat. *Effected Desire*, Carnegie Museum of Art,
Pittsburgh, text Robert Raczka

'Mis/taken Identities',
University Art Museum, Santa Barbara; **Western
Gallery**, Western Washington University, Bellingham;
Museum Folkwang, Essen, Germany; **Forum
Stadtpark**, Graz, Austria; **Neues Museum Weserburgh
Bremen im Forum Langenstrasse**, Bremen, Germany;
Louisiana Museum of Modern Art, Humlebaek,
Denmark (group)
Cat. *Mis/taken Identities*, University Art Museum,
Santa Barbara, text Abigail Solomon-Godeau

'So Order So Nicht Sein',
Forum Stadtpark, Graz, Austria (group)

'Cross Section',
The World Financial Center, New York (group)

'Women's Art at Newhall',
Cambridge University (group)

Text, 'Interim', *Now Time*, No 2, Art Press, D.A.P.
Publications, Los Angeles

Selected articles and interviews
1991-92

Pollock, Griselda, 'Mary Kelly in Conversation with
Griselda Pollock', *Parachute*, No 62, Montréal
Isaak, Jo Anna, 'What's love got to do, got to do with
it?: Woman as the Glitch in the Postmodernist Record',
American Imago, Vol 48, No 3, Johns Hopkins
University Press, Baltimore
Iversen, Margaret, 'The Deflationary Impulse:
Postmodernism, Feminism and the Anti-Aesthetic', *ICA
Documents 10*, London

1992

Laurence, Robin, 'Going to the Wall with Complex
Concepts', Visual Arts, *The Weekend Sun*, Vancouver, 25
September 1993
Randolph, Adrian; Rosenthal, Angela, 'Die
Inszenierung einer Pathologie der Mannlichkeit: Mary
Kelly's *Gloria Patri*', *Frayen Kunst Wissenschaft*, No 16,
Mannheim, 6 January 1993
Higonnet, Anne, 'Mary Kelly at the Zilkha Gallery', *Art
in America*, No 6, New York, June

Odom, Michael, 'Effected Desire', *New Art Examiner*,
Chicago, March 1993
Odom, Michael, 'Art', *In Pittsburgh*, October

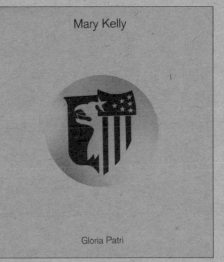

Mary Kelly

Gloria Patri

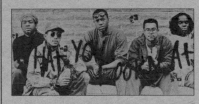

Bartens, Gisela, 'Aufgeblätterte Fiktionen', *Kultur*, 18
October, Austria

Glasgow, Faith, 'Artists Brighten up New Hall
Cambridge', *Financial Times*, London, 2 October
Rendell, Clare, 'A Gentle Kick Up the Macho Rump', *The
Spectator*, London, 24 October

Ottmann, Klaus, 'Mary Kelly', *Journal of Contemporary
Art*, Vol 5, No 2, New York, Fall
Mulvey, Laura, 'Impending Time: Mary Kelly's
"Corpus"', *Lapis*, Madrid
Iversen, Margaret, 'Shaped by Discourse, Dispersed by

Selected exhibitions and projects
1992-93

1993
'Gloria Patri',
Institute of Contemporary Arts, London;
Contemporary Art Gallery, Vancouver; **Milwaukee Art Museum**, University of Wisconsin (solo)

Postmasters Gallery, New York (solo)

'Camera Politic',
The Pittsburgh Center for the Arts, Pittsburgh, Pennsylvania; **La Sala Mendoza**, Caracas, Venezuela; **The Contemporary Arts Center**, Cincinnati, Ohio; **Mendel Art Gallery**, Saskatoon, Saskatchewan (group)
Cat. *Camera Politic*, John Weber Gallery, New York, texts Robert A. Sobieszek, Carlo Frua, Joyce Nereaux

'Empty Dress',
Independent Curators Incorporated, New York; **Neuberger Museum**, Purchase, New York; **Virginia Beach Center for the Arts**; **University Gallery**, University of North Texas; **Mackenzie Art Gallery**, Regina, Saskatchewan; **The Gallery**, Stratford, Ontario; **Selby Gallery**, Ringling School of Art & Design (group)
Cat. *Empty Dress*, Independent Curators Incorporated, New York, text Nina Felshin

'I Am the Enunciator',
Thread Waxing Space, New York (group)

'Songs of Retribution',
Richard Anderson Gallery, New York (group)

'Abjection in American Art',
Whitney Museum of American Art, New York (group)
Cat. *Abjection in American Art*, Whitney Museum of American Art, New York, text Leslie C. Jones

'Contacts/Proofs',
Jersey City Museum (group)

Selected articles and Interviews
1992-93

Desire: Masquerade and Mary Kelly's Interim', *Camera Obscura*, No 27, Los Angeles
Lind, Maria, 'Mary Kelly', *Bang Magazine*, No 3, Stockholm
Weilbull, Nina, 'Mary Kelly's Corpus', *Divan*, Quarterly for Psychoanalysis and Culture, Stockholm

1993
Januszczak, Waldemar, 'Hit 'Em With All You Got, Kelly Girl', *The Guardian*, London, 10 May
Feaver, William, 'Review', *The Observer*, London, 9 May
MacRitchie, Lynn, 'Review', *The Financial Times*, London, 8 May
Pollack, Jill, 'Artist Reels in Man's Masculine Sanction', *The Vancouver Courier*, 3 October
Lee, James-Jason, 'Mary Kelly, Contemporary Art Gallery, Vancouver', *Parachute*, No 73, Montréal, 1994
Auer, James, 'War Brings Out Creativity for Installation Artist Kelly', *Milwaukee Journal*, 9 January, 1994
Iversen, Margaret, 'Mary Kelly in Conversation with Margaret Iversen', *Talking Art*, Institute of Contemporary Arts, London

Levin, Kim, 'Mary Kelly', *The Village Voice*, New York, 26 January
Cotter, Holland, 'Mary Kelly', *The New York Times*, 5 February
de Bruyn, Eric, 'Mary Kelly: Glori Patri, Postmasters, New York', *Forum International*, Vol 4, No 17, Belgium, March
Ayerza, Josefina, 'Mary Kelly', *Flash Art*, No 68/69, Milan, 1994
Periz, Ingrid, 'Mary Kelly', *Art + Text*, Sydney, May

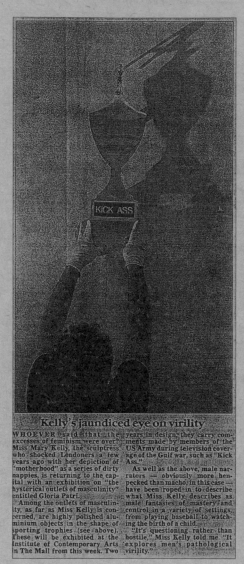

Kelly's jaundiced eye on virility

WHOEVER said that the excesses of feminism were over? Miss Mary Kelly, the sculptress who shocked Londoners a few years ago with her depiction of 'motherhood' as a series of dirty nappies, is returning to the capital with an exhibition on "the hysterical outlets of masculinity" entitled Gloria Patri.

Among the outlets of masculinity, as far as Miss Kelly is concerned, are highly polished aluminium objects in the shape of sporting trophies (see above). These will be exhibited at the Institute of Contemporary Arts in The Mall from this week. Two years in design, they carry comments made by members of the US Army during television coverage of the Gulf war, such as "Kick Ass."

As well as the above, male narrators — obviously more henpecked than macho in this case — have been roped in to describe what Miss Kelly describes as male fantasies of mastery and control in a variety of settings, from playing baseball to watching the birth of a child.

"It's questioning rather than hostile," Miss Kelly told me. "It explores men's pathological virility."

Sunday Telegraph, London, 4 April 1993

Selected exhibitions and projects
1993-94

'Ciphers of Identity',
Fine Arts Gallery, University of Maryland, Baltimore
County; **Ronald Feldman Fine Arts**, New York; **Art
Museum**, University of Southern Florida, Tampa
(group)
Cat. *Ciphers of Identity*, Fine Arts Gallery, University of
Maryland, Baltimore, text Maurice Berger

Texts, 'Interim', *Camera Austria International*, No
43/44, Vienna; 'Scatological Ejaculations, or, Letting
Loose and Hitting 'em with all We've Got', *Art Journal*,
Vol 52, No 3, New York; 'Gloria Patri: Two Narratives',
Assemblage 20, MIT Press, Cambridge, Massachusetts;
'Artist Contribution: Gloria Patri', *Forum International*,
Vol IV, No N19, Belgium; 'Not Enough Gees and Gollies',
Women's Art Magazine, No 542, London; 'The Smell of
Money', *Fetishism as Cultural Discourse*, eds. Emily
Apter, William Prety, Cornell University Press, Ithaca,
New York; 'Post Partum Document, Documentation 6',
*Atlas de l'Art – La Modernité (1940-1990 L'autre Moitié
de l'art)*, Encyclopaedia Universalis, France

1994

'Interim, Post Partum Document IV, VI',
Galleri F 15, Alby, Norway; **Uppsala Konstmuseum**,
Sweden; **Helsinki City Art Museum**, Finland (solo)

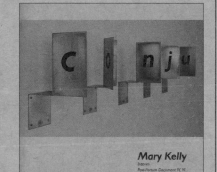

'Written/Spoken/Drawn in Lacanian Ink',
Thread Waxing Space, New York (group)

'Nine Months: Art and Pregnancy',
Howard Yezerski Gallery, Boston (group)

'Voicing Today's Visions',
Mary Delahoyd Gallery, New York (group)

'One Hundred Hearts Benefit',
The Contemporary, New York (group)

Texts, 'Gloria Patri', *Camera Obscura*, No 31, Los
Angeles; 'On Display: Not Enough Gees and Gollies to
Describe it', *Whitewalls*, No 33/34, Chicago

Selected articles and interviews
1993-94

Nguyen, Phuong, 'Who Do You Think You Are?' *Times*,
Tampa, Florida, 9 September 1994
Marger, Mary Ann, 'A Lesson in Values', *Times*, Tampa,
Florida, 9 September 1994
Milani, Joanne, 'Look Way Past Skin Deep Through Eyes
of Artists', *Tribune*, Tampa, Florida, September 1994
Milani, Joanne, 'Show's Art Shatters an Array of
Stereotypes', *Tribune*, Tampa, Florida, 20 September

Jaundice, K., 'Mary Kelly', *Sunday Telegraph*, London, 4
April
Pollock, Griselda, 'Trouble in the Archives', *Womens Art
Magazine*, No 54, London

1994

Grahn-Hinnfors, Gunilla, 'En kvinna med makt',
Göteborgs-Posten, 8 October
Kivirinta, Marja-Terttu, 'Euroopan sielu, Amerikan
ruumis feministitaiteen pioneerin Mary Kellyn taidette
ensi kertaa Helsingissa', *Helsingin Sanomat*, Helsinki,
8 January
Lunde, Hege, 'En Modern Kvinnes Rost', Kultur,
Arbeiderbladet, Oslo, 13 April
Lars Elton, 'Allmenn intimitet?' *Klassekampen*, Norway,
20 April
Stafne, Anne Lise, 'En Kvinnestemme pa Galleri F 15',
Aftenposten, Oslo, 11 April
Blom, Ina, 'Mary Kelly og Feminismen', *Aftenposten*,
Oslo, 27 April
Kildahl, Merete, 'Kivnne for sin utstilling', *Moss
Dagblad*, Norway, 9 April
Bentzrud, Inger, 'Kvinnekunst fra bleier til krig',
Dagbladet, Norway, 8 April
Warberg-Knoll, Helge, 'Tankekunstner', *Moss Avis*,
Norway, 8 April
Wachtmeister, Marika, 'Mary Kelly—ett konstnärskap
om kvinnligt ochmanligt', *Femina*, Stockholm, 12
December

Stapen, Nancy, 'Nine Months: When Motherhood's the
Muse', *The Boston Globe*, 21 July
Silver, Joanna, 'Show Delivers Unique Look at
Pregnancy', *Boston Herald*, 21 July

Apter, Emily, 'Essentialism's Period', *October*, No 71,
MIT Press, Cambridge, Massachusetts, Winter

mary kelly
interim, post partum document IV, VI

MENACÉ
MENACÉ

9.12.1994 - 15.1.1995

helsingin kaupungin taidemuseo
helsingfors stads konstmuseum

Selected exhibitions and projects
1994-96

1995
'The Masculine Masquerade: Masculinity and Representation,
MIT List Visual Arts Center, Cambridge, Massachusetts (group)
Cat. *The Masculine Masquerade: Masculinity and Representation*, MIT List Visual Arts Center, Cambridge, Massachusetts, texts ed. Andrew Perchuk, Helaine Posner

'Division of Labor: Women's Work in Contemporary Art',
The Bronx Museum of the Arts, New York; **The Museum of Contemporary Art**, Los Angeles (group)
Cat. *Division of Labor: Women's Work in Contemporary Art*, The Bronx Museum of the Arts; New York, texts Lydia Yee, Mary Kelly et al.

'Desiring Authors Enveloping Myths',
Bernard Toale Gallery, Boston (group)

'Temporarily Possessed',
The New Museum of Contemporary Art, New York (group)

'Social Strategies in the 1970s',
The Tate Gallery, London (group)

'Anti-Slogans',
Cairn Gallery, Nailsworth, Gloucestershire, England (group)

'Laughter Ten Years After',
Ezra and Cecile Zilkha Gallery, Center for the Arts, Wesleyan University, Middletown; **Houghton House Gallery**, Hobart and William Smith Colleges, Geneva; **Fine Arts Gallery**, University of Maryland, Baltimore; **Institute of Contemporary Arts**, Philadelphia (group)
Cat. *Laughter Ten Years After*, Hobart and William Smith College, Geneva, text Jo Anna Isaak

'Auf Den Leib Geschrieben',
Kunsthalle, Vienna (group)
Cat. *Auf Den Leib Geschrieben*, Kunsthalle, Vienna, texts Brigitte Huck, Monika Faber

Texts, 'Feminist Issues', Roundtable with Hal Foster, Simon Leung, Mary Kelly, Silvia Kolbowski, Liz Kotz, Mignon Nixon, *October*, No 71, MIT Press, Cambridge, Massachusetts, Winter; '(P)age 49: On the Subject of History', *Feminist Art Criticism*, ed. Katy Deepwell, Manchester University Press

1996
Knoll Galerie, Vienna (solo)

Konstmuseet, Malmö (solo)

Postmasters Gallery, New York (solo)

Selected articles and interviews
1994-96

Apter, Emily, 'Out of the Closet', *Art Journal,* Vol 52, No 4, New York
Murray, Tim, 'Televisual Fears and Warrior Myths: Mary Kelly Meets Dawn Dedeaux', *Camera Obscura,* No 32, Los Angeles, January

1995
Israel, Nico, 'The Masculine Masquerade', *Artforum*, No 2, New York, October

Lord, M.G., 'Women's Work Is (Sometimes) Done', *The New York Times*, 19 February
Cotter, Holland, 'Feminist Art, 1962 Until Tomorrow Morning and International', *The New York Times*, 17 March

1996
Kravagna, Christian, 'Gloria Patri, Knoll Galerie', *Kunstforum*, No 134, Cologne, May-September

Rous, Rita, 'Interview with Mary Kelly, Gloria Patri – patologi utan namngivare', *Paletten*, No 225/26, Gothenborg, Sweden

Selected exhibitions and projects
1996-97

'Now Here',
Louisiana Museum of Modern Art, Humlebaek,
Denmark (group)
Cat. *Now Here*, Louisiana Museum of Modern Art,
Humlebaek, Denmark, texts Iwona Blazwick et al.

'Body as Membrane (Kroppen Som Membran)',
Kunsthallen Brandts, Klaedefabrik, Odense,
Denmark; **The Nordic Arts Centre**, Helsinki (group)
Cat. *Body as Membrane (Kroppen Som Membran)*,
Kunsthallen Brandts, Klaedefabrik, Odense, texts Mary
Kelly et al.

'Sexual Politics',
Armand Hammer Museum of Art and Cultural Center,
Los Angeles (group)

'Making Pictures: Women and Photography, 1975 –
Now',
Nicole Klagsbrun, New York (group)

Book, *Imaging Desire: Mary Kelly Selected Writings*, MIT
Press, Cambridge, Massachusetts

Text, 'Miming the Master', *Paletten*, Gothenborg,
Sweden, No 225/26

1997
'Social Process/Collaborative Action: Mary Kelly
1970-75',
Charles H. Scott Gallery, Emily Carr Institute of Art
and Design, Vancouver (solo)
Cat. *Social Process/Collaborative Action: Mary Kelly
1970-75*, Charles H. Scott Gallery, Emily Carr Institute
of Art and Design, Vancouver, texts Judith Mastai,
Peter Wollen, Griselda Pollock, Rosalind Delmar, Mary
Kelly

Knoll Galeria, Budapest (solo)

Postmasters Gallery, New York (solo)

'Critical Images: Conceptual Art from the 1960s to the
Present',
Leslie Tonkonow, New York (group)

'Minimal Politics',
Fine Art Gallery, University of Maryland, Baltimore;
Institute of Contemporary Art, Boston; **Cleveland
Center of Contemporary Art; Cincinnati Center of
Contemporary Art; Wexner Center**, Columbus, Ohio
Cat. *Minimal Politics*, Fine Art Gallery, University of
Maryland, Baltimore, text Maurice Berger

MAKING PICTURES:
WOMEN AND PHOTOGRAPHY, 1975-NOW

Part II: December 14 - January 18, 1997
Reception: Saturday December 14, 6-8PM

Eleanor Antin
Tina Barney
Jennifer Bolande
Jennifer Bornstein
Sophie Calle
Sarah Charlesworth
Elaine Lustig Cohen
Nancy Davenport
Moyra Davey
Jenny Gage
Nan Goldin
Bonnie Gordon
Dana Hoey
Candida Höfer
Valérie Jouve
Mary Kelly
Karen Knorr
Sylvia Kolbowski
Barbara Kruger
Louise Lawler
Annette Lemieux
Sherrie Levine
Annette Messager
Elaine Reichek
Lorna Simpson
Amy Steiner
Carrie Mae Weems

NICOLE KLAGSBRUN
80 MERCER ST NEW YORK 10013 PHONE 212- 925 51 57 THURS - SAT 11-6

SOCIAL PROCESS/COLLABORATIVE ACTION:
MARY KELLY 1970–1975

EDITED BY JUDITH MASTAI

Selected articles and interviews
1996-97

Vine, Richard, 'Part 1: Louisiana Techno-Rave', *Art in
America*, New York, October
Fricke, Harald, 'NowHere', *Artforum*, No 3, New York,
November
Godfrey, Tony, 'NowHere', *Burlington Magazine*,
London, Autumn
Lind, Maria, 'NowHere', *Freize*, Issue 30, London,
September/October

Moller, Hanne, 'The Body as Membrane', *Week-End
Redak.*P1, Danmarks Radio, Odense

1997
Scott, Michael, 'Turning Outrage into Art', *The Weekend
Sun*, Vancouver, 1 March

**BODY AS MEMBRANE
JUNE 13—JULY 30 1996
CAROLEE SCHNEEMANN—ORLAN
MARY KELLY—EIJA-LIISA AHTILA
KIRSTEN JUSTESEN—RENÉE COX
NATALIA LL—ANNIE SPRINKLE
ALISON KNOWLES—JOAN JONAS
VALIE EXPORT—JAYNE PARKER
ELKE KRYSTUFEK—HELI REKULA**
THE NORDIC ARTS CENTRE—POHJOISMAINEN TAIDEKESKUS
HELSINKI—FINLAND

Apter, Emily, 'Just Because You're a Man', *Make*, No 75,
London, April

Bibliography

Adams, Parveen, 'The Art of Analysis', *October*, No 58, MIT Press, Cambridge, Massachusetts, Fall 1991

Apter, Emily, 'Fetishism, Visual Seduction and Mary Kelly's Interim', *October*, No 58, MIT Press, Cambridge, Massachusetts, Fall 1991

Apter, Emily, 'Essentialism's Period', *October*, No 71, MIT Press, Cambridge, Massachusetts, Winter 1994

Apter, Emily, 'Out of the Closet', *Art Journal*, Vol 52, No 4, New York, 1994

Apter, Emily, 'Just Because You're a Man', *Make*, No 75, London, April 1997

Ayerza, Josefina, 'Mary Kelly', *Flash Art*, No 68/69, Milan, 1994

Barry, Judith; Flitterman, Sandy, 'The Politics of Art Making', *Screen*, Vol 21, No 2, London, 1980

Berger, Maurice, *Minimal Politics*, Fine Art Gallery, University of Maryland, Baltimore, 1997

Bershad, Deborah, 'The Post-Partum Document', *Critical Texts*, Columbia University, New York, 1984

Blom, Ina, 'Mary Kelly og Feminismen', *Aftenposten*, Oslo, 27 April 1994

Braun, Kerstin, 'Embleme der Sehnsucht' (Between Madness and Laughter), *Camera Austria* 37, Vienna, 1991

Bray, Roger, 'On Show at ICA ... Dirty Nappies!', *Evening Standard*, London, 14 October 1976

de Bruyn, Eric, 'Mary Kelly: Gloria Patri, Postmasters, New York', *Forum International*, Vol 4, No 17, Belgium, March 1993

Bryson, Norman, 'III, Invisible Bodies: Mary Kelly's Interim', *New Formations*, No 2, London, 1987

Bryson, Norman, *Interim*, The New Museum of Contemporary Art, New York, 1990

Chadwick, Whitney, *Women, Art and Society*, Thames and Hudson, New York, 1990

Cork, Richard, 'Big Brother – and Mary Kelly's Baby', *Evening Standard*, London, 14 October, 1976

Cork, Richard, 'Collaboration without Compromise', *Studio International*, No 990, London, 1980

Cotter, Holland, 'Mary Kelly', *The New York Times*, 5 February 1993

Cottingham, Laura, 'Thoughts are Things What is a Woman', *Contemporanea*, New York, September 1990

Cowie, Elizabeth, 'Introduction to the Post-Partum Document', *M/F*, Nos 5-6, London, 1981

Cowie, Elizabeth, 'II, Invisible Bodies: Mary Kelly's Interim', *New Formations*, No 2, London, 1987

Delmar, Rosalind, 'Women and Work', *Spare Rib*, No 40, London, 1975

Delmar, Rosalind, *Social Process/Collaborative Action: Mary Kelly 1970–75*, Charles H. Scott Gallery, Emily Carr Institute of Art and Design, Vancouver, 1997

Feaver, William, 'Review', *The Observer*, London, 9 May 1993

Fisher, Jean, 'London Review', *Artforum*, New York, December 1983

Fisher, Jennifer, 'Interview with Mary Kelly', *Parachute*, No 55, Montréal, 1989

Foster, Hal, *Interim*, The New Museum of Contemporary Art, New York, 1990

Fraser, Andrea, 'On the Post-Partum Document', *Afterimage*, Rochester, New York, No 8, March, 1986

Friedman, Ann, 'Feminist (Con) Texts', *Reflex*, Seattle, September/October 1990

Frua, Carlo, *Camera Politic*, John Weber Gallery, New York, 1993

Gagnon, Monika, 'Texta Scientiae (The Enlacing of Knowledge): Mary Kelly's Corpus', *C*, Toronto, Summer, 1986

Gourlay, Sheena, 'The Discourse of the Mother', *Fuse*, Toronto, Summer 1984

Grace, Helen, 'From the Margins: A Feminist Essay on Women Artists', *Lip*, No 2, Melbourne, 1981

Hess, Elizabeth, 'The Good Mother', *The Village Voice*, Vol 34, No 2, New York, 18 June 1989

Hess, Elizabeth, 'Herstory', *The Village Voice*, New York, 13 March 1990

Higonnet, Anne, 'Mary Kelly at the Zilkha Gallery', *Art in America*, No 6, New York, June 1992

Hunter, Alexis, 'Feminist Perceptions', *Artscribe*, No 25, London, 1980

Isaak, Jo Anna, 'Our Mother Tongue', *Vanguard*, Vol 2, No 3, Vancouver, 1982

Isaak, Jo Anna, *The Revolutionary Power of Women's Laughter*, Protetch-McNeil, New York, 1983

Isaak, Jo Anna, 'Women: The Ruin of Representation', *Afterimage*, No 9, Rochester, New York, April 1985

Isaak, Jo Anna, 'What's love got to do, got to do with it?: Woman as the Glitch in the Postmodernist Record', *American Imago*, Vol 48, No 3, Johns Hopkins University Press, Baltimore, 1991

Isaak, Jo Anna, *Laughter Ten Years After*, Hobart and William Smith College, Geneva, 1995

Iversen, Margaret, 'The Bride Stripped Bare by Her Own Desire', *Discourse*, No 4, Berkeley, California, 1981

Iversen, Margaret, 'Post-Partum Document und die Lageder Post-Moderne', *Archithese*, No 5, Zurich, 1983

Iversen, Margaret, 'Difference on Representation and Sexuality', *M/F*, Nos 11-12, London, 1985

Iversen, Margaret, 'Fashioning Feminine Identity', *Art International*, Paris, Spring 1988

Iversen, Margaret, 'The Deflationary Impulse: Postmodernism, Feminism and the Anti-Aesthetic', *ICA Documents 10*, London, 1991

Iversen, Margaret, 'Post Modernism & the Re-readings of Modernity', *Angelus Novus*, University of Essex Symposium Anthology, 1991

Iversen, Margaret, 'Shaped by Discourse, Dispersed by Desire: Masquerade and Mary Kelly's Interim', *Camera Obscura*, No 27, Los Angeles, 1992

Iversen, Margaret, 'Mary Kelly in Conversation with Margaret Iversen', *Talking Art*, Institute of Contemporary Arts, London, 1993

Januszczak, Waldemar, 'Hit 'Em With All You Got, Kelly Girl', *The Guardian*, London, 10 May 1993

Kelly, Jane, 'Mary Kelly', *Studio International*, No 1, London, 1977

Kelly, Mary, *Footnotes and Bibliography, Post-Partum Document*, Institute of Contemporary Arts, London, 1976

Kelly, Mary, *Footnotes and Bibliography, Post-Partum Document*, Museum of Modern Art, Oxford, 1977

Kelly, Mary, 'Notes on Reading the Post-Partum Document', *Control Magazine*, No 10, London, 1977

Kelly, Mary, 'Women's Practice in Art', *Audio Arts*, No 2, London, 1977

Kelly, Mary, 'On Femininity', *Control Magazine*, No 11, London, 1979

Kelly, Mary, 'Post-Partum Document', *Kunstforum*, No 36, Mainz, 1979

Kelly, Mary, 'Documentation III', *Skira Annuel*, Skira S.A., Geneva, 1979

Kelly, Mary, 'Sexual Politics', *Art and Politics*, Winchester School of Art Press, 1980

Kelly, Mary, 'Re-Viewing Modernist Criticism', *Screen*, Vol 22, No 3, London, 1981

Kelly, Mary, 'Feminist Art: Assessing the 70s and Raising Issues for the 80s', *Studio International*, Vol 195, No 991/12, London, 1981

Kelly, Mary, 'Documentation VI', *Block*, No 4, London, 1981

Kelly, Mary, 'Documentation IV', *Heresies*, No 12, New York, 1981

Kelly, Mary, 'Documentation VI', *M/F*, Nos 5-6, London, 1981

Kelly, Mary, 'Beyond the Purloined Image', *Block*, No 9, London, 1983

Kelly, Mary, 'Jenseites des entwendeten Bildes', *Archithese*, No 5, Zurich, 1983

Kelly, Mary, *Post-Partum Document*, Routledge & Kegan Paul, London, 1983

Kelly, Mary, et al., *Beyond the Purloined Image*, Riverside Studios, London, 1983

Kelly, Mary, 'Reviewing Modernist Criticism', *Art After Modernism*, ed. Brian Wallis, New Museum of Contemporary Art, New York, D. R. Godine, Boston, 1984

Kelly, Mary, 'Desiring Images/Imaging Desire', *Wedge*, No 6, New York, 1984

Kelly, Mary, *Interim*, Fruitmarket Gallery, Edinburgh et al., 1985

Kelly, Mary, 'Interim' (5 part series), *The Guardian*, London, 2, 9, 16, 23, 30, June, 1986

Kelly, Mary, 'On Sexual Politics of Art', *Framing Feminism*, Pandora Press, London, 1987

Kelly, Mary, 'On Difference, Sexuality, and Sameness', *Screen*, Vol 28, No 1, London, 1987

Kelly, Mary, 'Invisible Bodies: On Interim', *New Formations*, No 2, London, 1987

Kelly, Mary, 'On Interim, Part I', *Whitewalls*, No 23, Chicago, Autumn 1989

Kelly, Mary, 'From Corpus', *Taking Our Time*, ed. Frieda Forman, Pergamon Press, Oxford

Kelly, Mary, *Interim*, The New Museum of Contemporary Art, New York, 1990

Kelly, Mary, 'Pecunia Olet', *Top Stories*, No 29, New York, 1990

Kelly, Mary, 'Interim. Part I. Extase', *The Female Body*, The University of Michigan Press, 1991

Kelly, Mary, 'Re-presenting the Body', *Psychoanalysis and Cultural Theory*, St. Martin's Press, New York, 1991

Kelly, Mary, 'Pecunia Olet', *Top Stories*, City Lights Books, San Francisco, 1991

Kelly, Mary, 'Magiciens de la Mer(d)', *Artforum*, New York, January 1991

Kelly, Mary, 'Interim', *Now Time*, No 2, Art Press, D.A.P. Publications, Los Angeles, 1992

Kelly, Mary, 'Interim', *Camera Austria International*, No 43/44, Vienna, 1993

Kelly, Mary, 'Scatological Ejaculations, or, Letting Loose and Hitting 'em with all We've Got', *Art Journal*, Vol 52, No 3, New York, 1993

Kelly, Mary, 'Gloria Patri: Two Narratives', *Assemblage* 20, MIT Press, Cambridge, Massachusetts, 1993

Kelly, Mary, 'Artist Contribution: Gloria Patri', *Forum International*, Vol IV, No 19, Belgium, 1993

Kelly, Mary, 'Not Enough Gees and Gollies', *Women's Art Magazine*, No 542, London, 1993

Kelly, Mary, 'The Smell of Money', *Fetishism as Cultural Discourse*, eds. Emily Apter, William Prety, Cornell University Press, Ithaca, New York, 1993

Kelly, Mary, 'Post Partum Document, Documentation 6', *Atlas de l'Art – La Modernité (1940–1990 l'autre Moitié de l'art)*, Encyclopaedia Universalis, France, 1993

Kelly, Mary, 'Gloria Patri', *Camera Obscura*, No 31, Los Angeles, 1994

Kelly, Mary, 'On Display: Not Enough Gees and Gollies to Describe it', *Whitewalls*, No 33/34, Chicago, 1994

Kelly, Mary, *Division of Labor: Womens Work in Contemporary Art*, The Bronx Museum of the Arts, New York, 1995

Kelly, Mary, 'Feminist Issues', Roundtable with Hal Foster, Simon Leung, Silvia Kolbowski, Liz Kotz, Mignon Nixon, *October*, No 71, MIT Press, Cambridge, Massachusetts, Winter 1995

Kelly, Mary, '(P)age 49: On the Subject of History', *Feminist Art Criticism*, ed. Katy Deepwell, Manchester University Press, 1995

Kelly, Mary, *Imaging Desire: Mary Kelly Selected Writings*, MIT Press, Cambridge, Massachusetts, 1996

Kelly, Mary, 'Miming the Master', *Paletten*, Gothenborg, Sweden, No 225/26

Kelly, Mary, *Social Process/Collaborative Action: Mary Kelly 1970–75*, Charles H. Scott Gallery, Emily Carr Institute of Art and Design, Vancouver, 1997